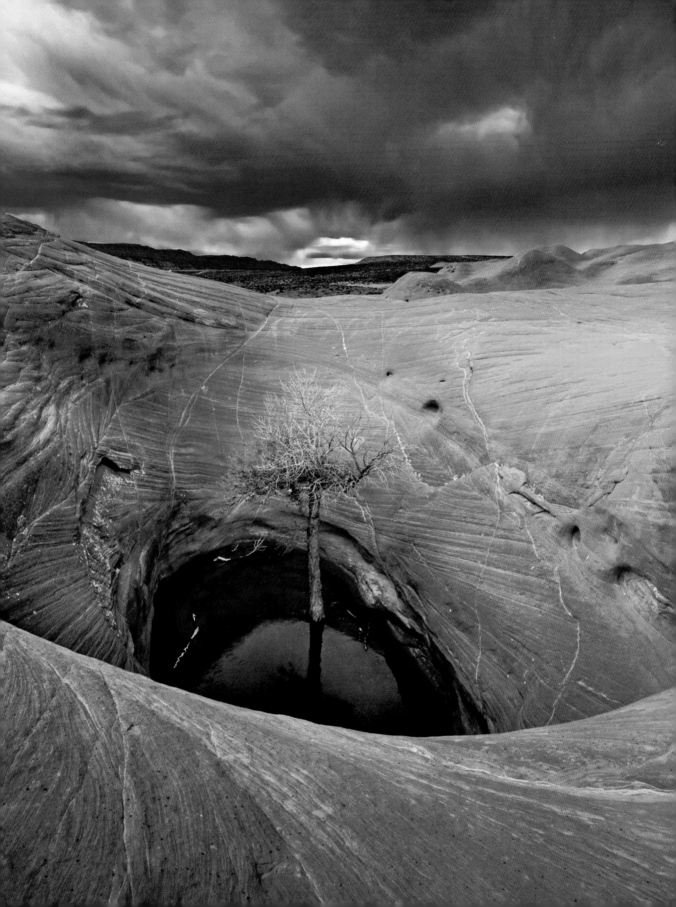

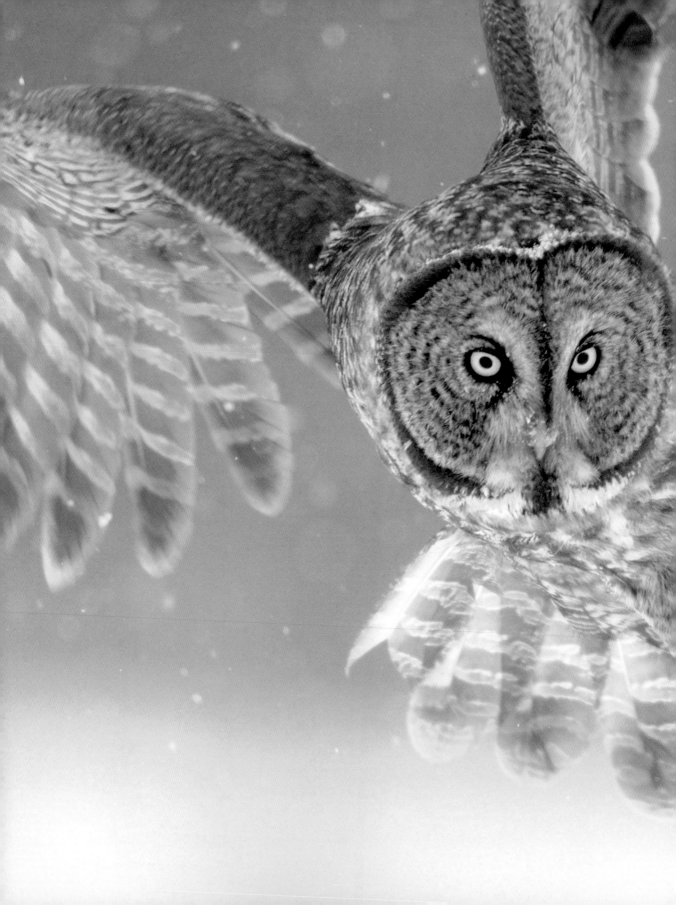

POPULAR PHOTOGRAPHY

TAKE YOUR BEST SHOT
ESSENTIAL TIPS & TRICKS FOR SHOOTING AMAZING PHOTOS

MIRIAM LEUCHTER

weldon**owen**

CONTENTS

INTRODUCTION

We live in a world of photographs. They surround us: on billboards, in magazines, and scattered around just about every room in our homes. We share photos with friends online and zap them to each other's mobile phones. More and more of us carry cameras of one sort or another with us every day. In the 21st century, we are all photographers.

Yet too often, the pictures we envision before snapping the shutter disappoint us when we look at them later. The color didn't come out right, the details got lost, the subject was too far away, or we simply missed the moment. Our own photos rarely resemble the polished images we're so used to seeing everywhere we look.

But it's not as hard as you might think to shoot photos like the pros. If you love taking pictures and want to take your photographs to the next level, this book—full of wisdom and expertise from contributors and staff at *Popular Photography* magazine—is for you.

First, we'll introduce you to some of photography's key technical concepts. Then we'll dive into three chapters divided loosely by subject—people, places, and things—that are full of specific tips. Finally, we'll give you some ideas for altering and editing images with software after you've shot them. Feel free to skip around, dipping in and out as the spirit moves you.

To make the most of the ideas and information in this book, use a DSLR—a digital camera with manual controls and a tiny, reflexive mirror that lets you compose your shots precisely—for the best combination of versatility and creative control. As you get deeper into photography, you'll probably want more tools, such as off-camera flashes or other lights, supports to hold the camera steady, an array of lenses and filters to help capture the images you want, and image-editing software to adjust your photographs after you shoot.

But the quality of your photography depends on more than your gear. It depends on your eye and your mind—the effort you bring to transforming your vision into images. To become a photographer instead of just a person with a camera, you need to experiment: Shoot from a variety of perspectives and vantage points, get closer to your subject and then draw back, look at how your picture changes when you use a faster or slower shutter speed, try the same scene with deep and shallow focus, alter the tones to make them richer or more monochromatic.

It's up to you. Whether you want to exercise your creativity, document major events, record your travels, or capture the beauty of nature or the human face and form, this book brings the right tools and techniques within your reach. Now go out and take your best shot.

Miriam Leuchter

Editor, *Popular Photography*

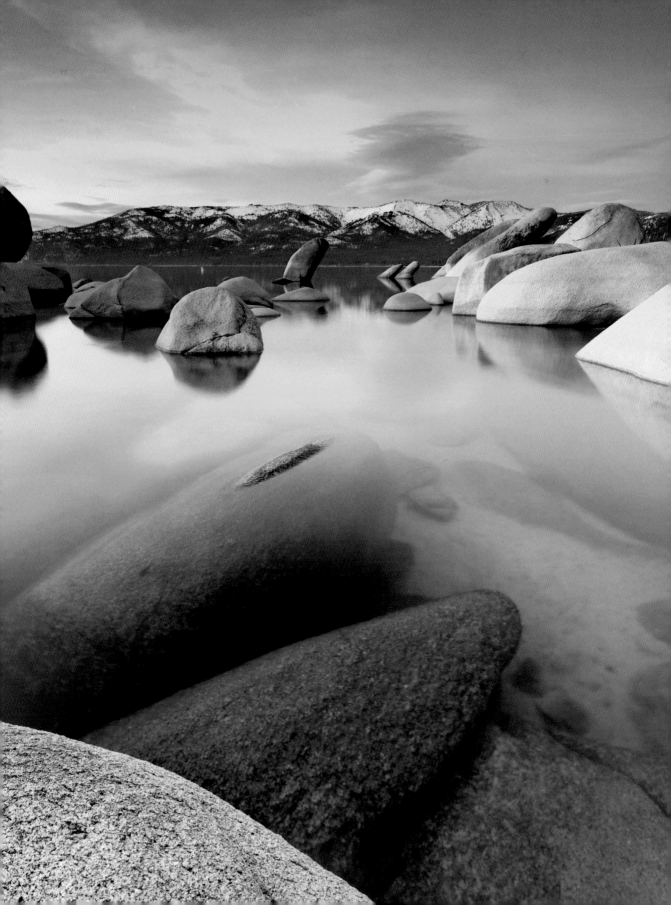

MEET YOUR CAMERA

Digital single-lens reflex cameras (DSLRs) are the camera of choice for dedicated shooters. What makes them so special? A small mirror inside that allows precise framing, and the variety of specialized lenses you can choose from. If you're new to DSLRs, the buttons and dials may

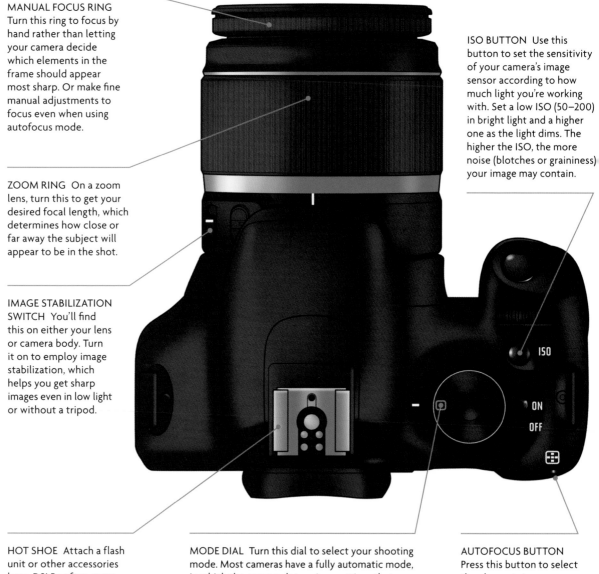

MANUAL FOCUS RING
Turn this ring to focus by hand rather than letting your camera decide which elements in the frame should appear most sharp. Or make fine manual adjustments to focus even when using autofocus mode.

ZOOM RING On a zoom lens, turn this to get your desired focal length, which determines how close or far away the subject will appear to be in the shot.

IMAGE STABILIZATION SWITCH You'll find this on either your lens or camera body. Turn it on to employ image stabilization, which helps you get sharp images even in low light or without a tripod.

ISO BUTTON Use this button to set the sensitivity of your camera's image sensor according to how much light you're working with. Set a low ISO (50–200) in bright light and a higher one as the light dims. The higher the ISO, the more noise (blotches or graininess) your image may contain.

HOT SHOE Attach a flash unit or other accessories here. DSLRs often come with a small cover to protect the hot shoe when it's not in use.

MODE DIAL Turn this dial to select your shooting mode. Most cameras have a fully automatic mode, in which the camera determines settings that control the exposure (how much light is allowed to enter the lens and for how long), a fully manual mode in which you control exposure settings yourself, and everything in between.

AUTOFOCUS BUTTON Press this button to select the elements in a scene you want to appear in sharpest focus.

For advice on achieving incredible depth of field as in Joshua Cripps' photo on the previous page, see shot 63.

seem confusing—but understanding how to use them lets you be more creative with your shots. At left, learn about some key DSLR controls (models vary, so study your manual before shooting). Below, learn how an image right before your eyes gets transformed into a digital photo.

[4] VIEWFINDER Looking through the viewfinder, you'll see a right-side-up version of the exact image that's entering the lens and reflecting off the reflex mirror. This lets you decide how to frame and compose your shot.

[3] PENTAPRISM This pentagon-shaped prism bounces the image around (to flip it out of reverse) before directing it toward the viewfinder.

[2] REFLEX MIRROR This mirror reflects the image entering the lens through a focusing screen and toward the pentaprism. At this point, the image is reversed.

[5] SHUTTER The shutter is a mechanical curtain between the lens and the image sensor. When you press the shutter button, this curtain opens, and the reflex mirror pivots up and out of the way—allowing the image to hit the sensor.

[6] IMAGE SENSOR When light reaches the sensor after passing through the shutter, this device covered with light-sensitive cells (pixels) measures its intensity and color. It then converts that data into digital form. Presto: Your camera has captured an image.

[1] LENS This detachable light-focusing device has a circular opening that widens or narrows to control the amount of light that enters (the size of the opening is called the aperture). Once rays of light enter through the lens, they hit the reflex mirror.

CHOOSE A DIGITAL CAMERA

Digital cameras vary in how much control they give over various settings. A point-and-shoot does everything but click the shutter, for okay-but-standard images. More advanced cameras are trickier to learn to use, but can make more unique photos—a DSLR is your best bet.

Point-and-shoot This camera adjusts all its settings automatically, offering no manual control.

Advanced compact This slightly larger option offers various modes for shooting, and sometimes manual control.

Electric-viewfinder ultrazoom While similar to an advanced compact, this choice has a built-in zoom lens with a large range.

Interchangeable-lens compact (ILC) An ILC has a larger sensor than other compacts and allows you to use various lenses.

DSLR (full-frame) This is the industry standard, due to its reflex-mirror construction and range of available lenses.

DSLR (smaller sensor) With the same functions as a full-frame, it has a smaller sensor size that's specific to the brand.

Digital range finder A bright, oversize viewfinder gives you total control over framing and focusing your shots.

Medium-format DSLR This functions like a full-frame DSLR but its larger sensor creates much more detailed images.

Medium-format with digital back This choice can shoot film as well as digital. Its sensor is larger than a full-frame DSLR's.

Large-format view camera With a sensor even larger than a medium-format camera's, it captures amazing detail.

Whether you need to dangle your camera from a railing for a particular perspective, keep your shaky hands from blurring an image during exposure, or hang a backdrop that will make your subject pop, there's a piece of supportive equipment for every occasion.

Tripod This invaluable three-legged stand steadies your camera to help you capture sharp images.

Tabletop tripod A mini tripod is helpful when you need a support but can't bring too much heavy gear along.

Bendable support Its flexible legs can be wrapped around objects, making it more versatile than other tripods.

Monopod Hold this one-legged support under your camera to help get steady shots when you can't use a tripod.

Clamp This can latch onto nearly anything—from a tabletop to a railing—to support a camera or light gear.

Ball head On to a tripod, it allows the camera to move. Different types of heads allow panning and other functions.

L-bracket This lets you attach an accessory flash to the side of the camera. You'll have mobility without head-on flash.

Boom stand The arm atop this stand gives versatility in positioning and can support more than one piece of gear.

Backdrop stand Drape or clamp paper or fabric onto this adjustable support to create a smooth-hanging background.

Light stand Use this device to support and position various studio lights or modifiers such as diffusers and reflectors.

IDENTIFY ESSENTIAL SKILLS

Shooting your own professional-quality photographs that will wow your friends and satisfy your creative instincts isn't as hard as you might think. The pros get good results consistently because they know all the right moves, but you can learn them, too—you just need to practice up on the

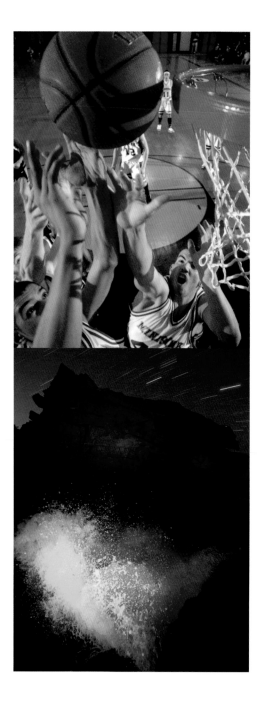

 USE SUNLIGHT Sunlight can be challenging because you'll have less control over the light's quality, direction, and color—besides choosing the time of day in which you're shooting. But in certain environmental situations, it's simply the only type of light that can produce the effects you want. Plus, without lighting equipment, you'll have freedom to explore a location.

 WORK WITH STUDIO LIGHTS With practice, adding artificial light—whether continuous sources or strobes—can make your images look more natural. You can use them outside the studio, too, but you'll have to bring along a lot of gear to shoot on location.

 MODIFY LIGHT Whether using natural light, artificial light, or both, you can alter light's effects by changing its direction, color, and intensity with a wide variety of reflectors, diffusers, and other modifiers. Some of these attach to the front of or around studio lights, while others are separate pieces of equipment.

 USE AN ACCESSORY FLASH A separate flash helps you avoid the harsh flattening effect that a built-in flash can create. You can mount the flash to your camera's hot shoe, or use an L-bracket or hold it away from the camera so its light shines in from the side. Or use a sync cord or remote trigger to fire the flash from farther away. From an angle, the effect will be subtler and more flattering.

 SUPPORT YOUR CAMERA When you need to keep your camera completely still for a long exposure, balance it in a precarious spot, or steady a heavy lens, various supports will help. Consider options such as tripods, monopods, bendable supports, and more for your arsenal.

tricks of the trade. Look to these icons to find out which skills and techniques each featured photograph in this book will give you an opportunity to practice. Once you've learned these skills, you'll be well on your way to master-photographer status.

 HANDHOLD THE CAMERA When you can't bring a tripod or you want spontaneity, there are ways to reduce shake and get sharp, precisely framed images. Place your left hand under the lens, often the heaviest part of the camera. Put your left foot in front of your right to create a stable base. Try tucking your left elbow against your body and resting the edge of the camera body on your left shoulder. Press the shutter gently as you exhale. It will feel awkward at first, but you'll notice the difference in your photos.

 FOCUS MANUALLY In tricky situations such as low light, close-up shooting, or focusing past foreground elements, it's safer not to rely on your camera's autofocus. To take matters into your own hands, switch your camera to manual-focus mode, look through the viewfinder, and adjust the focus ring until the element(s) you want in clearest focus look sharp to your eye.

 USE FILTERS A variety of filters can be fitted to your camera to adjust the amount of light entering the lens, alter the color of the light that enters, or add other effects. Some filters help achieve the correct color balance and exposure, while others may cut glare from a reflective surface or help you control or deepen the colors in your images.

SHOOT IN CONTINUOUS MODE This mode (also called burst) lets your camera take several photos in quick succession with only one push of the shutter button. Burst is especially helpful when you're shooting moving or unpredictable subjects such as kids, animals, or performers. It will give you plenty of options and a better chance of getting a great shot.

 BRACKET EXPOSURES Great for challenging lighting situations, this technique lets you capture an image at multiple exposure settings so you'll have exposure options to choose from. To do it manually, set what you believe is the right exposure, take the shot, then reshoot at one stop below and above that initial exposure setting. Or employ your camera's autobracketing function, which will shoot a fast burst of images at different exposure settings with just one click.

 PROTECT YOUR GEAR Photographing in certain environments and under certain conditions will require you to take careful precautions toward protecting your camera and other equipment (and yourself!). The gear—including underwater housings, rain hoods, and blower brushes—runs the gamut from affordable to very pricey, but acquiring the protection you need is worth it. You'll be protecting your most important investments—your camera and your photos.

 FIRE REMOTELY When you want to photograph yourself, shoot from a spot where you can't stand, or capture action without getting run over, this technique lets you fire your camera's shutter from a distance. One type of remote trigger attaches to your camera with a cable. Another (called a radio-remote trigger) is wireless and can be used from a distance. For special circumstances, there are devices that use sound or motion to trip the shutter.

 EDIT WITH SOFTWARE Processing images with software—from altering color to cropping and beyond—will help you get the most out of your photographs. See the section on software (83) for information on the most useful ways to tweak your images.

COMPREHEND COMPOSITION

What's the difference between a quick snapshot and a photo you'd hang on your wall or publish? Composition: the careful arrangement of items in the frame. A successful composition both highlights key visual elements and artfully represents a photographer's view of the world.

FILL YOUR FRAME

A solid rule of thumb for learning to compose dynamic shots is to use every area of your frame—fill it with your subject as well as other elements that add visual balance to your picture. To achieve this tighter view, take a step or two closer to your subject, use a zoom lens, or crop your image later.

But watch out for stray visual elements near the edges, which can get cut off in weird ways—if this happens, crop them out later. And look out for the direction of people, animals, or vehicles moving through the scene: Whether they're facing or heading toward the center of an image or toward the outside of the frame will have a big impact on how static or energetic your image winds up feeling.

An exception to the frame-filling edict is purposely composed negative space (the space around the subject of an image). When used artfully, negative space draws attention to the point of interest—consider the way the eagle in Hector Martinez's photo (81) is framed so dramatically against the sky.

KNOW THE RULE OF THIRDS

This compositional rule is based on the idea that placing elements in a photograph at certain off-center points adds visual tension and interest. To follow it, first envision your image as if it were a tic-tac-toe board: divided into nine equal parts by two vertical and two horizontal lines. (You can even set your camera to superimpose a grid over your camera's LCD monitor for help framing while you shoot.)

Whether using a superimposed grid or imagining one, frame so that important elements—such as the horizon line or a portrait subject's eyes—land on or near the grid lines and the points where the lines intersect (as in shot 59).

LOOK FOR LEADING LINES

As you compose your shot to accentuate the key visual elements, keep in mind that your viewer's eye naturally follows lines, be they straight, curved, zigzag, or spiral. Roads, fences, and linear patterns in the natural landscape can guide the viewer's eye into an image. Strong diagonals will lead the eye straight into the image; a curved shape will prompt a meandering appreciation of the elements in the frame, as in the photo at right.

LAYER PICTORIAL ELEMENTS

Photos translate the three-dimensional world into a two-dimensional image. Unless you're going for an abstract, flattened effect, you'll want to create a sense of the missing dimension—depth—through composition, lighting, and focus.

In environmental shots, whether indoors or out, draw the eye deep into the frame by including picture elements in the foreground, middle ground, and background. Reinforce this depth with your lighting; include a full range of light and dark in the picture, as in Kerrick James's shot of wildflowers (70).

For portraits and other photos that keep attention on a particular subject, limit your visual elements and choose an unobtrusive background. To separate your subject from the background further, light it more brightly or limit depth of field so that the background goes soft or even blurs out. (For more on depth of field, see section 7.)

FIND PATTERNS AND SYMMETRY

Another way to make a subject stand out from a background is to look for repeating patterns and shapes and symmetrical forms. These make great photo subjects themselves, bordering on abstraction, and are quite pleasing to the eye. But you can also use them to set off contrasting subjects in the foreground, adding depth to your photo without distracting from its focus. Notice how the skateboarder in Ben Bergh's photo (entry 21) pops from a subtly dynamic background made up of repetitive V-shapes.

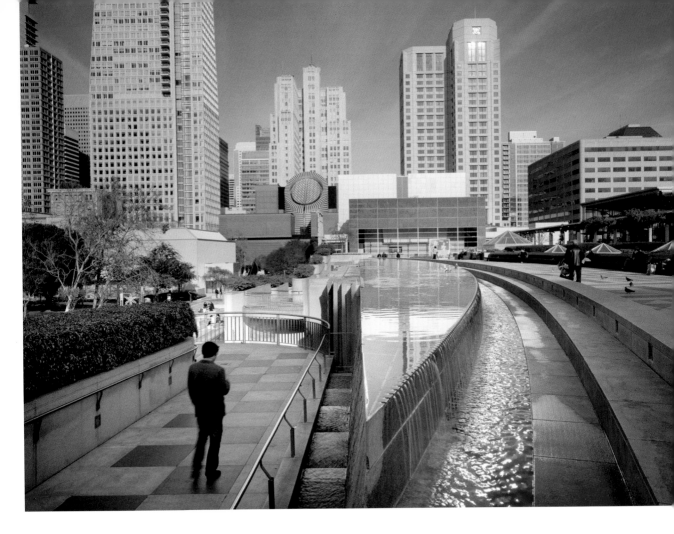

TAKE A POINT OF VIEW

Photographing from a standing position will provide a view that appears normal, and sometimes that's just what you want. But consider other vantage points as well. Shooting from an even slightly higher angle makes your subject seem smaller and possibly more vulnerable or poignant, depending on what it is (see entry 34). The opposite can also be true: Shooting from ground level can make even a small, unobtrusive subject (like the bunny in entry 29) seem large and imposing. When you're shooting, move around and see how your changing perspective alters your relation to what's shown in the frame.

CHANGE ORIENTATION AND SHAPE

One of the easiest things you can do to vary your photos is to pivot your camera to shoot vertically. This orientation is traditional for portraits, but try it with landscapes, pets, sports, and anything else.

The photo above is a great example of how to use leading lines to construct a compelling composition: The curving concrete draws the visual energy toward that spot of yellow, then up toward the tops of the skyscrapers that fill the top one-third of the frame.

Also consider the shape of your frame. DSLRs have rectangular imaging sensors, but their aspect ratios (the proportion of width to height) differ by brand and model. Full-frame cameras have sensors the same size as a traditional 35mm frame of film, with a 3:2 aspect ratio. Others are smaller but with similar proportions, and some have Four Thirds sensors, with a 4:3 ratio. (For more on sensor size, see section 8.) Some cameras let you change the aspect ratio, but it's best to capture the biggest image you can, then crop the image yourself if you want to.

And crop you should. Depending on the image you want, you may choose to retain the original framing, trim a little off the edges, make your image perfectly square, or slice it into a long panorama.

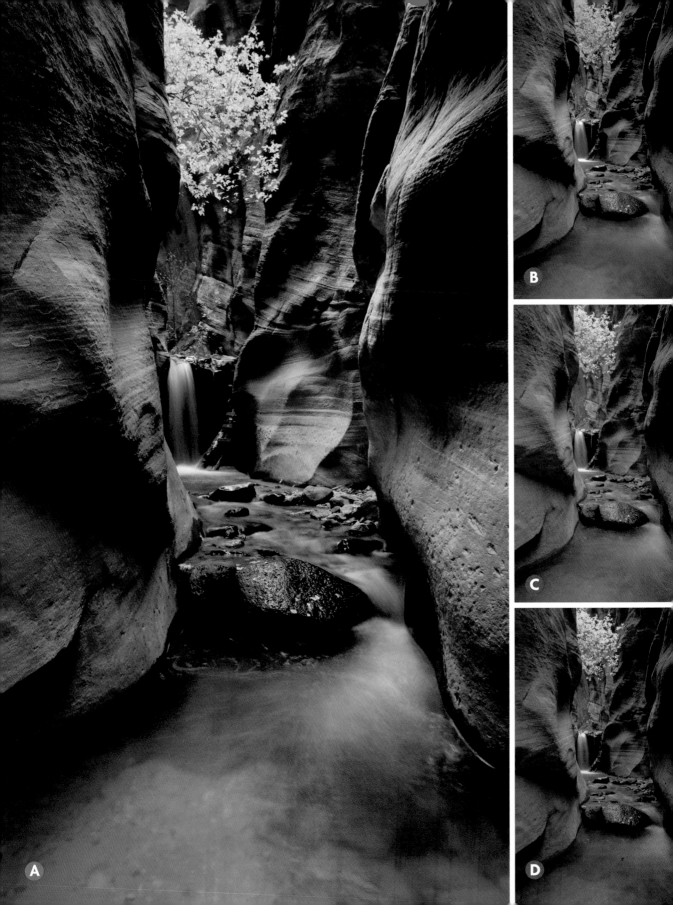

Digital photography gives you the freedom to make choices—and compare results—both during and after a shoot. One of the most dramatic elements you can control is color: our visual perception of different types of light. Here are some ways to control color in your images.

COMMUNICATE WITH COLOR

There's a saying in photography: "If you can't make it good, make it big—and if you can't make it big, make it red." Tongue in cheek, sure, but it points to a truth: Color matters. From energetic red to calming blue, each color carries its own visual connotations and emotional impact. Also consider tone (the degree of darkness or lightness of a color). Then you can choose to shoot colors that speak to you, and adjust their subtlety or boldness to further suit your vision.

Your DSLR offers tons of choices for capturing color. You can set different saturation levels (which affect the intensity of colors) and even mimic types of film and film processing, such as black-and-white or sepia. These settings can be fun to play with.

However, at *Popular Photography*, we prefer to use neutral settings and shooting modes that capture and store images as RAW files (the digital photo format that contains all of the image and color data from your camera's sensor). This prevents your camera from compressing or processing images as you shoot, which would cause you to lose some image data. (For more on RAW, see sections 7 and 83.) Using neutral settings to capture all the digital information possible will give you the most control over color in your final images, and you can alter or tweak color with software later.

USE WHITE BALANCE

Even when it looks white to your eye, all light has color. Early and late in the day, sunlight shines reddish gold, while at midday it can look blue. Different types of artificial lights have color, too: Tungsten lightbulbs cast a yellow tint, while fluorescents tend toward green.

Our brains adjust to differences in color temperature so efficiently that we barely notice them and can easily tell when something's white, even if it's given a bluish or yellowish tint by certain types of light. Your camera needs some help with this, though, which is the role of its white balance setting. This adjusts colors for each shot to render them as closely as possible to the colors you see with your eyes. Use auto white balance to have your camera adjust it automatically, or set it yourself through the menu on your LCD or a dedicated button on the camera.

It's safe to use auto white balance most of the time, as your camera can usually get it right. But if you set it yourself, you'll have an array of settings to choose from, usually including some variation of daylight, shade, overcast, tungsten, fluorescent, and flash. Each adjusts an image to balance color for the type of light it's named for. For example, the tungsten setting cools colors to adjust for the warm light of tungsten bulbs, adding blue to an image. You can also adjust white balance manually, which is useful in mixed lighting.

You can use these white balance settings not just to neutralize the color of light, but to creatively alter or enhance it: On a sunny day, for example, you might use the shade setting (which warms colors to compensate for the blue light of open shade) to boost the yellow in an image even further. You can also apply these settings to RAW files later with software.

GO MONOCHROME

Converting an image to black-and-white can give it a nostalgic feel or provide a sense of depth. It also lets you sidestep some technical problems such as inaccurate color and minimize others such as noise (uneven graininess and areas of discolored dots).

High-contrast lighting (which creates a large range of bright and dark tones in an image) and very low-contrast lighting (which makes a smaller range of tones) both look better in black-and-white. And to emphasize texture, line, shape, and pattern, monochrome is perfect (see shot 23).

At left, image A shows the most true-to-life white balance (which was done manually)—that is, the colors resemble the warm and cool tones the naked eye would see. Image B's colors were cooled down by the tungsten setting, as were C's by daylight. Image D's warm yellow tint was created with a cloudy or shade setting.

LEARN THE ELEMENTS OF EXPOSURE

Getting photographs that reveal a subject with the right level of detail, sharpness, and amount of contrast depends on exposure (how quickly and for how long each image is inscribed on the sensor), which is controlled by three factors: aperture size, shutter speed, and ISO.

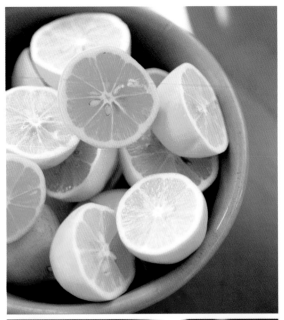

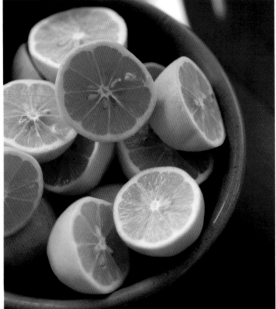

UNDERSTAND LIGHT LEVELS

A camera is essentially just a box with a hole on one side and a light-sensitive medium (film or digital sensor) on the other. Taking a picture lets light through the hole to leave an image on the recording medium.

Capture too much light, and the image will be overexposed: Washed out, with details disappearing in highlights. With too little light, the image is underexposed: Details disappear into darkness. The correct exposure—determined by the size of the hole, the length of time it's open, and the sensitivity of the sensor—will give you the optimum balance of highlights, midtones, and shadows, with plenty of detail all the way through.

When you shoot in automatic mode, the camera balances the relationship between the hole's size (aperture), the time it's open (shutter speed), and sensor sensitivity (ISO). But you can also use modes (such as aperture-priority and shutter-priority) that let you set any one of those three factors manually and allow the camera to adjust the other two accordingly. You can also control all three at once (in fully manual mode) or use exposure compensation, which allows you to make incremental adjustments after you've set your exposure.

MEASURE YOUR LIGHT

In order to determine the right settings for a good exposure, your camera (or you, with a handheld light meter) will have to measure the light in the scene. A DSLR gives you choices when it comes to measuring the light. You can opt for spot-weighted metering (to expose a small area properly in mixed lighting or backlighting), center-weighted metering (great for evenly illuminated scenes), and evaluative metering

Parts of the lemons in the top photo at left are overexposed, meaning their details appear washed out by too much light. In the underexposed bottom photo, textures disappear in darkness.

(best for scenes with a wide range of tones). Which to use depends on the scene and your preferences. For the best exposure in most situations, use evaluative metering and adjust exposure manually as needed.

To see the results of your camera's light-meter reading, refer to its histogram (a graph of the range of tones in an image that's located on or near your camera's LCD). If the graph shows peaks on the right side (which represents highlights), your image may be overexposed. If it peaks on the left side (which represents shadow), it may be underexposed. An even distribution with a peak in the middle often indicates a proper exposure.

| Large aperture f/2 | Medium aperture f/8 | Small aperture f/22 |

SET THE APERTURE

The hole that lets light into the camera is actually governed by the lens—the lens's diaphragm expands and contracts to let in more or less light, and the size of the opening is referred to as its aperture.

Aperture is measured in f-stops. The higher the number, the smaller the opening: f/2 is a big aperture, f/22 a small one. Besides controlling the amount of light that enters, the aperture also affects depth of field, or how deep a plane of the scene appears in focus—in short, how much of a scene is rendered distinctly and clearly without blurring or fuzziness. A smaller aperture yields very deep focus; a larger one captures an image with a shallow area of focus (for more on this, see section 8).

At the smallest aperture of any lens, the image tends to go a little soft, so if maximum sharpness is important to you, shoot at intermediate apertures, at least one or two f-stops below the highest number.

CHOOSE A SHUTTER SPEED

The shutter opens and closes to control how long light reaches the sensor for each exposure. In bright sun, it will only need to open for a tiny fraction of a second

for enough light to stream in—probably somewhere between 1/60 to 1/1000 sec, depending on the aperture and ISO. In dim light, you'll need to use a much slower speed, perhaps measured in full seconds, to allow enough light to enter the lens. Slow shutter speeds may blur a moving subject, however, since the sensor records what happens while the shutter is open. To keep a moving subject from blurring, you'll have to use a shutter speed short enough that the camera doesn't record any motion. And at these slower speeds, even your own motion may create blur by jostling the camera. Use your camera's image stabilization system or a tripod to prevent this.

USE THE RIGHT ISO

The sensitivity of your camera's sensor is determined by the ISO setting. Most DSLRs go from ISO 100 past ISO 6400. The brighter the light in your scene, the lower the ISO you need. As the light dims, you have to shoot at ever-higher ISOs to get a good exposure, especially when you're handholding the camera.

The problem with high ISOs is digital noise, which shows up in shadow areas as discolored dots and uneven rough graininess. Smaller sensors and higher megapixel counts also create more noise. To combat it, keep ISO down to 400 or lower and adjust aperture and shutter speed accordingly, or use noise reduction in image-processing, although this reduces resolution.

IMPROVE EXPOSURE

Nailing exposure may not seem easy at first. To troubleshoot exposure issues, set your camera to capture RAW files rather than JPEGs, and adjust exposure with software after you shoot. (For more on editing with software, see section 83.) Another option is to try your camera's autobracketing setting, which takes a fast burst of images at different exposures. You can choose the exposure you like best.

Then there's high-dynamic-range (HDR) imaging, which merges multiple photographs—made either by processing a single RAW image at various settings or by shooting a bracket—into a single image. This combination gives a larger range of tones, from highlights to shadows, than is possible with a single exposure. Many cameras have a setting that lets you create HDR images as you shoot. Done subtly, HDR makes a scene with difficult lighting look natural; with a heavy hand, it can create vibrant, glowing scenes.

UNDERSTAND LENSES

It's all in the lens: how close or far away the subject in an image appears to be, how much of a scene is in focus, and how wide an angle of view an image shows. Without interchangeable lenses, you would have very limited control over the look of your photographs.

COMPREHEND FOCAL LENGTH

To put it as simply as possible, a lens concentrates light and directs it toward the sensor in your camera. But the distance a lens requires between itself and the film or sensor in order to capture the subject in focus varies; this distance is called focal length. Lenses with short focal lengths take in a very wide angle of view, while those with long focal lengths have a narrow view.

The focal length at which you shoot makes a big difference in how your images look. For instance, a lens with a very long focal length (a telephoto lens) not only seems to bring distant subjects closer, magnifying them in the frame, but also appears to compress space so that the distance between picture elements seems smaller. And magnifying a subject greatly (which can also be done by moving closer, as with a macro lens) reduces an image's depth of field significantly.

What defines a "normal" focal length? A natural-looking perspective from a not-too-close, not-too-far distance. Usually, a natural perspective can be accomplished by shooting with a lens that's a little longer than the diagonal measurement of the camera's image sensor. So with a full-frame DSLR (its sensor usually measures 24 by 36 mm), a 50mm lens produces a normal perspective. However, different cameras have different sizes of image sensors, which means that they capture different amounts of a scene. So matching up your sensor size with the right lens for the look you want can pose something of a challenge.

The photo at left, with more depth of field, shows the effect of a shorter focal length. The other shows the effect of longer focal length, as with a telephoto lens.

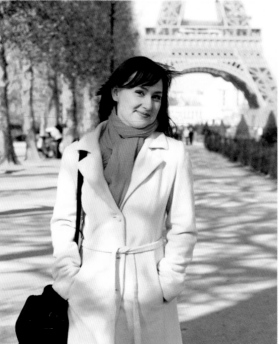
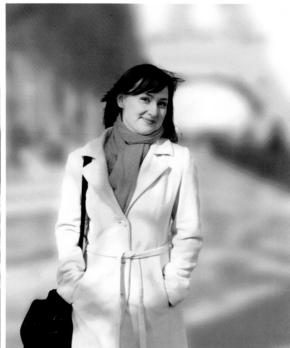

- ● Full frame
- ● APS-C
- ● Four Thirds
- ● Large compact cameras
- ● Small compact cameras

MATCH A LENS WITH YOUR SENSOR SIZE

Consider your sensor size before choosing a lens. A tiny sensor will take in only a small amount of a scene, while a bigger sensor will take in a much larger area of a scene. So in order for a camera with a small sensor and a camera with a large sensor to take photographs capturing an equal amount of a scene, a camera with a smaller sensor would need a lens with a shorter focal length (and its wide angle of view) to compensate. A camera with a bigger sensor would need a lens with a longer focal length.

This means that the same lens may have a different effective focal length depending on the sensor size of the camera to which it is attached. This is something to think about when you're shopping for lenses for your DSLR or ILC. A DSLR will contain a full-frame sensor, an APS-C-sized sensor (slightly smaller than full-frame), or a Four Thirds sensor (slightly smaller than that). Current ILCs have either an APS-C or Four Thirds sensor. In buying a lens, not only should you choose one optimized for your sensor size, but it must be equipped with the correct mount for your camera.

Each rectangle above represents the amount of a scene a particular sensor size would capture. The larger a camera's sensor, the more of a scene the same lens would capture.

UNDERSTAND LENS SPEED

Besides focal length, lenses are defined by their maximum aperture size: the widest you can make the hole that lets light in. Lenses with large maximum apertures, f/2.8 and below, are called "fast"—probably because they allow you to shoot at faster shutter speeds by letting in a lot of light quickly. Not only do fast lenses allow you to shoot in lower light, but also their large apertures let you limit a photo's depth of field more effectively.

Many zoom lenses, especially those sold in kits with DSLRs, have maximum apertures that cover a range. A typical kit lens covers 18–55mm with a designation of f/3.5–5.6. This range tells you that the maximum aperture of the lens is f/3.5 at its widest focal length and f/5.6 at its longest—meaning its maximum aperture size changes depending on how close or far its zoom is adjusted.

Some lenses (called "normal") render depth perception so that it appears the same as it does to the unaided eye—but other lenses alter this perspective for effect. The two main lens categories are zoom (which can shoot at many focal lengths) and prime (which has a fixed focal length).

Kit zoom A zoom lens can shoot at many different focal lengths, and most DSLRs are sold bundled with one.

All-in-one zoom It offers a range of focal lengths from wide angle to telephoto, often with a large maximum aperture.

Normal prime This refers to a 50mm lens on a camera with a full-frame sensor, or a 25–35mm lens on a smaller sensor.

Telephoto prime With a single long focal length, it magnifies distant subjects, making them appear closer and larger.

Telephoto zoom It magnifies distant subjects and flattens space like a telephoto prime, but has variable focal lengths.

Macro This lens is made for close-up focusing and intense magnification of even the tiniest subjects.

Wide-angle It has a short focal length and captures a wider angle of view than you could see without moving your eyes.

Fisheye This lens captures an extremely wide angle of view, but is known to cause curvilinear distortion.

Ultrawide-angle It captures the widest possible angle of view without adding curvilinear distortion.

Tilt-shift It can tilt its angle relative to the subject's plane to adjust depth of field and correct perspective distortion.

Selective focus The lens swivels and tilts, letting you focus manually on a very small area for spot control over DOF.

Fine-tune a lens's effect with filters and other add-ons. A filter screws or drops onto the front of the lens to help you control color, exposure, and the like, while a number of other accessories attach between your camera body and lens to add effects such as enhanced magnification.

UV A protective filter that blocks ultraviolet sun rays, it protects the front of a lens but doesn't affect the image.

Polarizing This filter cuts glare and reflections and deepens green and blue—it's great for foliage and blue sky.

Neutral-density (ND) This reduces light passing through a lens to allow for slow shutter speeds or wide apertures.

Split neutral–density It gives the effect of an ND filter on just half the image to balance light and dark areas of a scene.

Infrared It blocks visible light to record only light that's below the visible spectrum to create dreamy, ghostly images.

Reversing ring Use this ring to mount your lens to the camera backward, magnifying without using a macro lens.

Teleconverter This secondary lens extends focal length when mounted between the camera and the lens.

Extension tube Fit this tube between a lens and camera body for greater magnification in close-up photography.

Filter holder Interchangeable special-effects filters fit into the same adjustable holder for different lenses.

Lenshood Attach this accessory to the front of a lens to shield it from light shining in, preventing glare and lens flare.

Macro bellows A system that allows intense and precise magnification (even without a dedicated macro lens).

Photography is all about light—focused by your camera's lens, it inscribes the image on your DSLR's sensor. Be it natural sunlight or artificial illumination, the light you choose quite literally shapes and defines your subject and creates your photographs.

LIGHTING BASICS

First, it's important to understand the qualities of different kinds of light and how they affect a subject in a photograph. Whether the light is natural, such as sunlight, or artificial, such as that from a flash, it comes in essentially two forms: hard and soft. Light appears hard when it is focused in a narrow beam or when the light source is far from the subject. Hard light delivers sharp shadows and high contrast and (when it comes from the side) emphasizes texture.

Soft light is produced by putting a subject very close to a light source or using a very broad light source. It reduces shadows and contrast and suppresses texture. The broader the light source and the closer it is to your subject, the softer the light. Softness increases when light is diffused (scattered and spread out), whether by cloud cover or by translucent fabric. And bouncing light off a large, white matte surface diffuses and softens the beam, too.

NATURAL LIGHT

"Keep the sun at your back" is a photographic adage. There are times when that's good advice, but your photos are often better off when sun is coming from the side. Sidelighting sharpens the lines on an image, deepening them and adding character, as in Harrison Scott's photo of Disney Hall (66).

Even when you're shooting in sunlight, you can still alter the quality of light in your images. For softer shadows, shoot portraits and nature scenes when the sky is overcast, or position a diffusion panel between the sun and your subject. To reduce contrast, use a reflector to bounce light into shadowed areas in more direct light.

In the photo at left, the contrast between bright light on the left side of the subject's face and the shadows on his right cheek and temple show the effects of hard light.

DON'T FEAR THE FLASH

The built-in flash on your DSLR makes a good starting point for taking control of your lighting. Next, add an accessory flash. You can place it in your camera's hot shoe (the groove on top of your camera that lets it sync) or fire it off the camera, using either a sync cord or a remote trigger. A flash unit with a tilting or swiveling head will give you more control over the direction of the light.

Try flash during the day, even in sun, to tone down harsh shadows by adding what's called fill light, as pro Tim Kemple does (50). You'll find a fill-flash mode in your camera's settings; to reduce its intensity, use flash exposure compensation.

As much as possible, avoid using direct flash in low light: It will either overwhelm your subject or create severe shadows. You can diffuse the light by buying modifiers specifically built for flash or with do-it-yourself tricks such as rubber-banding white paper over the flash head. Better yet, soften the light by bouncing it off white walls or ceilings for a more natural look (see 31). Practice is key, so spend time getting to know your camera and flash settings so you can reduce or increase the light according to your picture's needs.

DECIDE BETWEEN CONTINUOUS LIGHTS AND STROBE

Whether you're considering portable accessory flashes, as discussed above, or larger studio lights, you have to make the basic choice between flash (strobe) and continuous lights (also called hot lights, although the category also includes cool-burning LEDs and fluorescent bulbs).

Continuous lights stay on the whole time you're shooting, rather than flashing with the shutter. This lets you see their effects on how your subject looks so you can tweak the light carefully. But if your subject is in motion and you want to freeze it, you'll need a strobe to add enough light for a fast shutter speed. With a tightly controlled, static subject, either type will work.

ADD AND MODIFY LIGHT

What's the most important thing to control in order to capture images that deliver the moods and atmospheres you want? The lighting. Everything about the color, intensity, distribution, and directionality of light in a photograph affects its overall feel and impact. And with so many

Accessory flash This flash syncs with your shutter release and can attach to your camera's hot shoe or be used remotely.

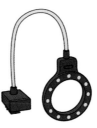

LED ring light A circular lamp that fits around the lens. Its LED lights are cool-toned and less bright than most flashes.

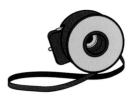

Macro ring flash For close-up shots, a flash that comes from all directions around the lens helps soften shadows.

Strobe This standard studio flash bursts on and off when triggered. It can be synced to fire when the shutter releases.

Underwater strobe A waterproof casing protects this light so it can be used in underwater photography.

Hot light Usually fit with a tungsten, fluorescent, or halogen bulb, it stays on continuously instead of flashing.

Softbox Fitted around a light, its reflective walls and diffusing material at front broaden and soften the light's beam.

Umbrella This fits in front of a light that's pointed away from a subject to bounce and diffuse the light.

Beauty dish Its bowl shape distributes light toward a focal point for an effect like a direct flash and softbox combined.

possible combinations of lights and modifiers, you can explore to your heart's content. Of course there are practical concerns, too: In the studio a big softbox may be ideal, but at parties and on location outdoors, an accessory flash is your best friend.

Grid Fitted over a light, its honeycomb pattern crisply defines light and directs it toward a subject.

Snoot This cone-shaped shield lets you focus light into a narrow beam for dramatic light and dark and contrast.

Barn doors Attached to a light source, this device's metal doors can open or close to control the spill of the light.

Baffle/Reflector This versatile tool has one reflective side and one that blocks light. Hold it or clip it to a light stand.

Light tent Place your subject inside, and external light sources will diffuse through the fabric for even distribution.

Acetate sheets Attach colored gels in front of a light source to give the light a tint in the shade of your choice.

Battery pack for studio strobe When you need full-size studio lights away from a power source, this will help.

Power pack for accessory flash Keep your flash at the ready with a pack that fits on your belt or in your bag.

13 HAVE NECESSITIES ON HAND

Whether you're in a studio or on location, getting the perfect shot is all about rigging the right setup. Aside from your camera, lenses, and lights, you'll need an array of extras for everything from protecting your gear against the elements to nailing exposure.

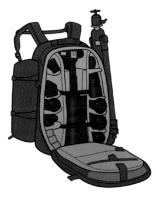

Camera bag Use a bag with specialized compartments to hold and protect your gear while you're on the go.

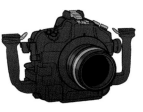

Underwater housing A waterproof casing makes it possible to take a DSLR on an underwater photo shoot.

Rain hood This soft, waterproof case secures over your rig to protect it from rain, fog, and other elements.

Blower brush Use this to gently sweep away debris such as sand or dust that could damage your equipment.

Incident light meter Use this handheld device to measure light emitted by a source in tricky or studio lighting.

Gray card This portable card is a standard midtone reference for light metering and setting white balance.

Cable release trigger It syncs with your camera, allowing you to fire the shutter from as far away as the cable stretches.

Radio-remote trigger Like a cable release trigger, but wireless, it trips your camera's shutter from a distance.

Clamps Whether securing cords out of view or attaching a reflector to a tree branch, you'll never run out of uses for these.

Rechargeable battery Keep a spare camera battery just in case. It hurts to miss a great shot because you're out of juice.

Gaffer's tape Keep easy-to-tear tape on hand for securing acetate gel sheets, fixing lenshoods, and anything else.

Memory card Your camera will likely use Compact Flash (CF) or Secure Digital (SD) cards. Always keep an extra on hand.

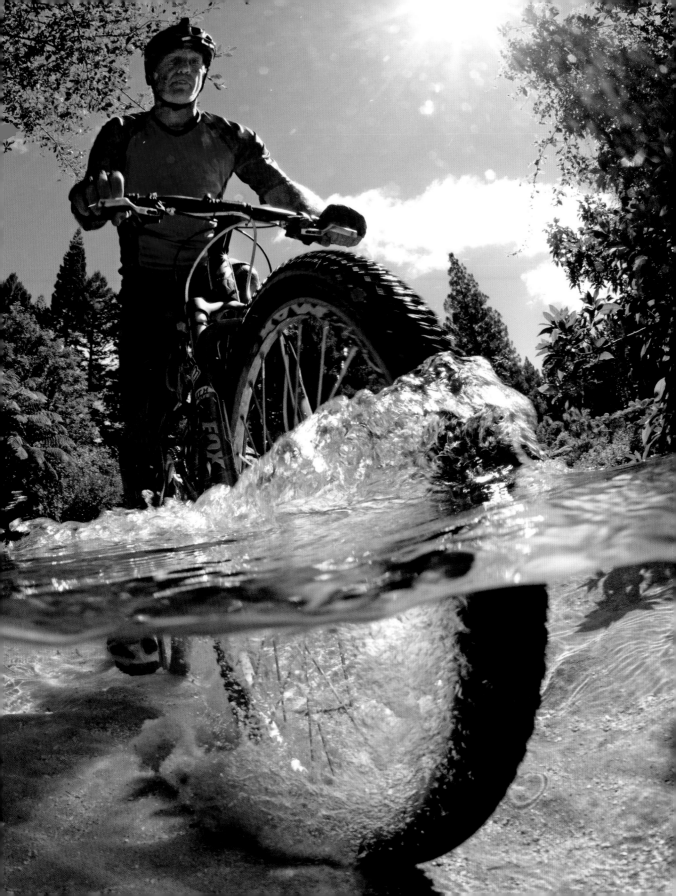

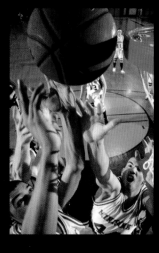

PEOPLE

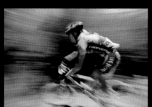

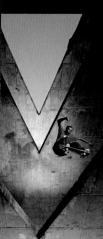

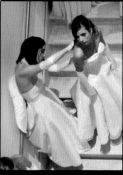

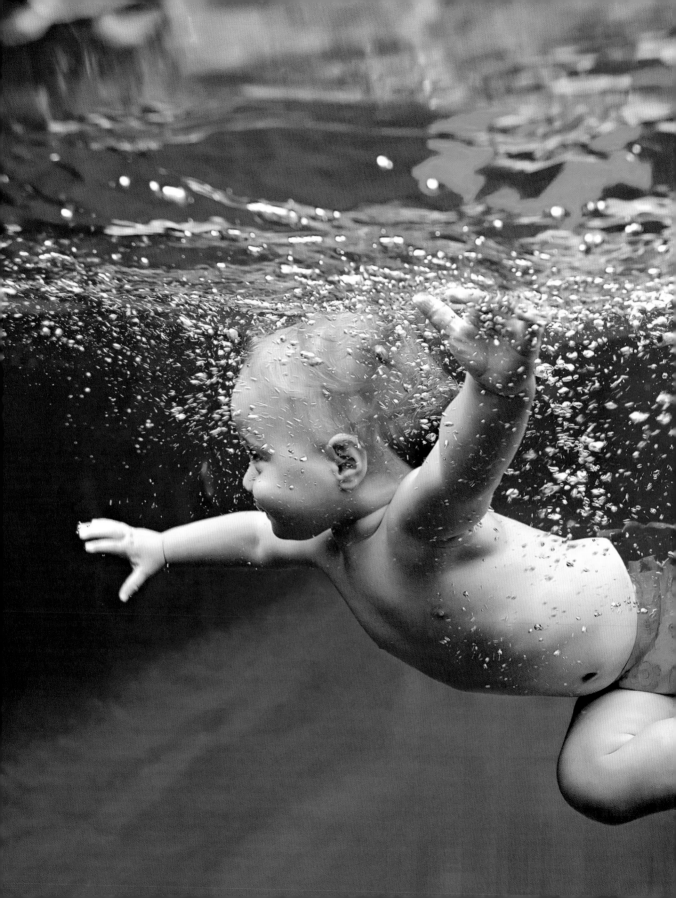

CREATE A MYSTERY

Surprising settings
and unusual poses
draw viewers in.

GRAB ATTENTION

Show your subject in a different
light with an unexpected pose
or setting. Here, underwater
photographer Tim Calver went
below the surface to capture his
friends' son Jasper as he splashed
around a pool, exploring a new
element. After lighting a few
frames with an underwater strobe
(and using an underwater housing
to protect his camera), Calver
decided in favor of natural sunlight
for a softer look. He also tried
different points of view, coming
in close to make eye contact with
the baby, but also pulling back to
include his parents in the frame.

Calver picked this image as
the session's strongest for several
reasons, including the baby's
energetic pose, the kinetic power
of the rising bubbles, and the
riveting color contrast. But the
most arresting thing about this
image is the disquiet sparked by
the utter lack of context.

Try out some unlikely scenarios
and offbeat poses yourself—for
instance, you might photograph
someone dancing in a barren
landscape or demonstrating a
seriously bendy yoga position.

15

MASTER MOTION BLUR

A CAMERA PAN HIGHLIGHTS SPEED AND ACTION.

CAPTURE MOVEMENT

Panning—using your camera to track motion—can produce captivating shots that convey action instead of freezing it dead. When done right, panning produces a sharp subject against a blurry background. But be patient: You'll get a lot of featureless smears as you develop your panning technique.

Think about your body as well as the camera. Pivoting in sync with the action in front of your lens will help you capture a moving target and keep the background streaks smooth. Hold the camera level and focus on following through with the pan (that is, track your subject with the lens until the shutter closes). Try handholding tricks to keep steady: Tuck your elbows into your body and support the lens with your left hand as you pivot. Whatever helps you brace the camera and keep up with the action is the way to do it.

Up the odds of success by getting in close with a wide-angle lens. Use a long exposure to maximize background blur while tracking the action of the subject as tightly as possible to keep it sharp. Other tricks to sharpen your subject are popping a flash and setting a slightly higher shutter speed.

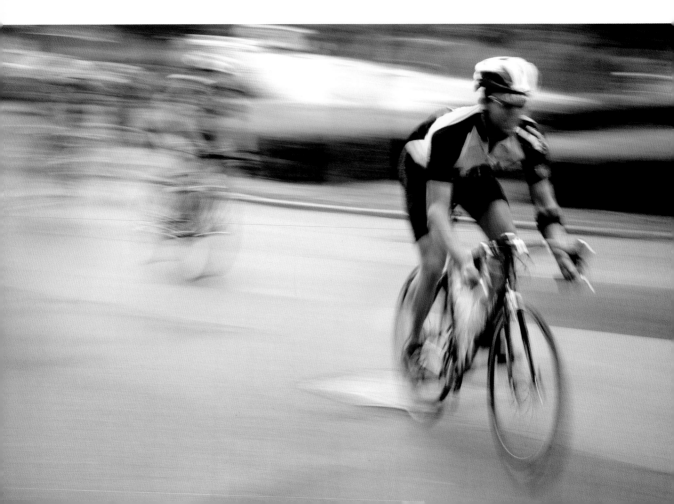

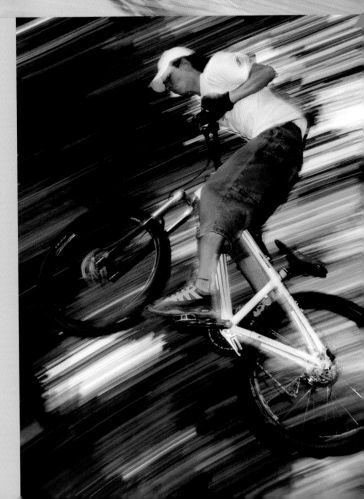

BREAKING IT DOWN

[1] Select a location. You want a fairly homogenous background, but not a solid color. Pick a position that allows the subject's line of travel to be roughly parallel to your camera's imaging plane—not one where the action is coming straight at you.

[2] Set the shutter speed. Use manual exposure control or shutter-priority mode (in which you choose the shutter speed and the camera adjusts the aperture accordingly). Try out shutter speeds from 1/125 sec down to 1/8 sec. Slower shutter speeds make for more dramatic shots, but you'll get fewer successful ones. For cycling, try 1/15 or 1/30 sec.

[3] Turn autofocus off. Your camera may get confused and home in on the background instead of the action, so it's best to focus manually.

[4] Use your whole body. Start by aiming your feet where you think the pan will end. Next, twist from your hips to point your camera toward the oncoming subject. As he or she passes by, unwind around your body's center of gravity. To help keep both you and the camera steady, hold the camera level and tight, and don't move your feet.

[5] Shoot in continuous mode. Fire off as many shots as possible while your subject passes.

TURN THE LIGHTS LOW

USE DARKNESS FOR A SERIOUS—OR PROVOCATIVE—PORTRAIT.

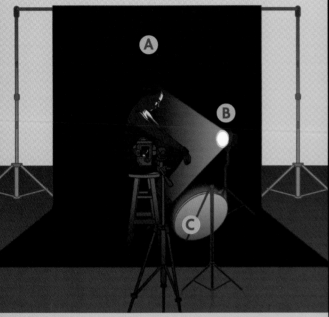

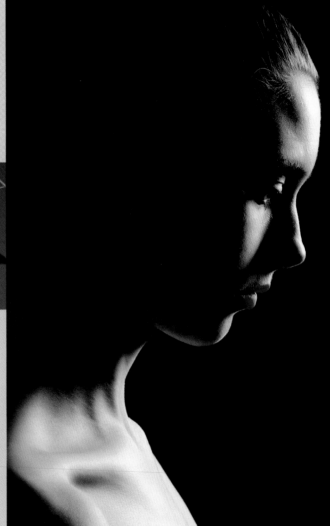

BREAKING IT DOWN

[1] Set the stage. Use a black background (A), and have your subject wear black or nothing at all.

[2] Limit the light. Use a single spot (B) directly from the side or slightly in front of or behind your subject. A reflector (C) on the opposite side will give definition, but don't let it soften the effect of the spot too much.

[3] Focus the light. Hard light adds drama.

[4] Underexpose slightly. You don't want much detail in the shadows. For this effect, the blacker, the better.

EMBRACE THE DARKNESS

When you want to make a portrait with a moody or even dangerous edge, nothing beats the atmosphere created by low-key lighting. This technique puts a dark subject against a darker background, defining the figure with highlights. For maximum drama, you can trace just a sharp, bare outline of light along the face, or use a slightly broader (though still hard) spotlight to reveal a little more of the subject. A swipe of baby oil on the skin adds spark and sheen to the highlights, emphasizing the visual contrast as well as the powerful metaphor of light emerging from darkness.

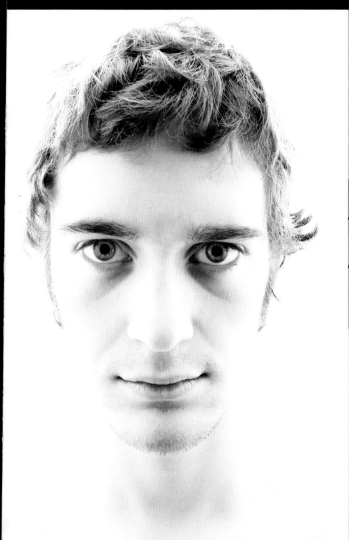

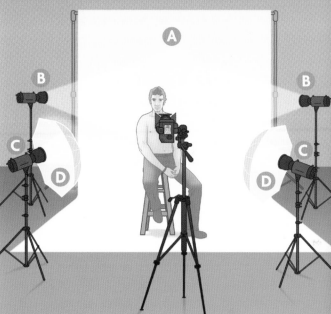

BREAKING IT DOWN

[1] Create a whiteout. Start with a white background (A). Your subject should wear white as well—or go bare.

[2] Brighten things up. The lights on the backdrop (B) should be at least as bright as the side lights (C).

[3] Keep it soft. Use diffusers (D) on your side lights to lessen shadows or wipe them out entirely.

[4] Overexpose slightly. Your histogram (the graph displaying your image's exposure reading) should be piled up at the right side, showing lots of bright light.

BLOW OUT SHADOWS

The visual and emotional opposite of low-key, high-key portraits give the impression of lightness and simplicity. They tend to portray a subject as romantic, optimistic, happy, or innocent. High-key lighting is also a great tool for emphasizing pale subjects or flattering people with uneven skin, since all that light smoothes out texture and tones. To keep your subject from being totally washed out by the light you're pouring on, consider applying defining eye makeup and a little lipstick—even on children and men—to deepen the eyes and give some color to the mouth.

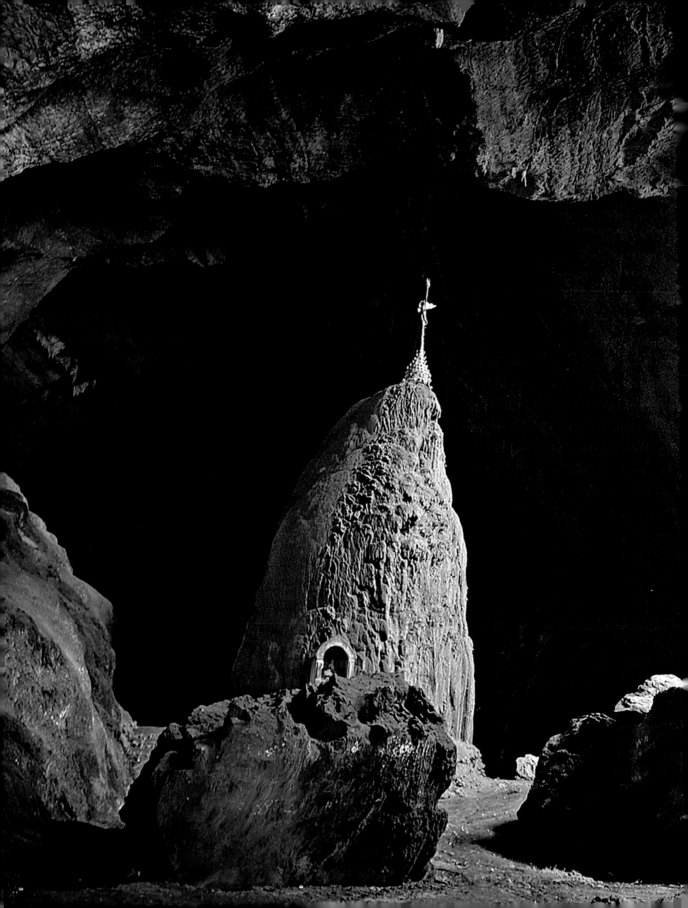

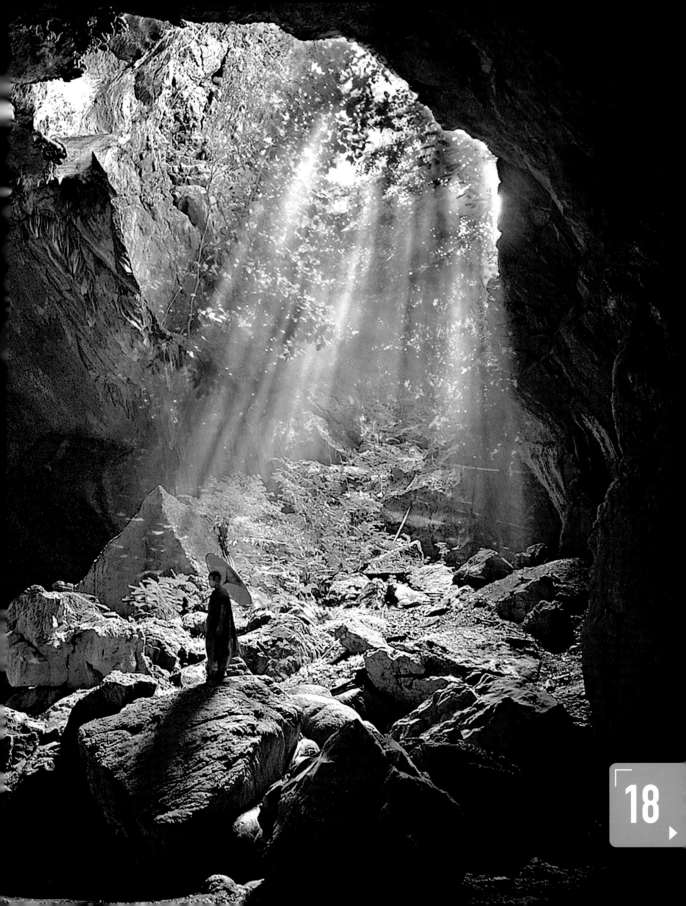

EXPLORE ENVIRONMENTAL INTERACTION

JUXTAPOSE A SUBJECT AND A TELLING SETTING.

FIND THE RIGHT PLACE AT THE RIGHT TIME

When you're planning a shot that hinges on the relationship between subject and environment, as in the striking image on the preceding pages, you often have to hang around until just the right moment. To get that shot, Koy Kyaw Winn and his guide (the Buddhist monk in the picture) took a pre-dawn trip to the historic shrine in Myanmar's Sadan Cave and awaited the perfect sun ray. The result is a photo that links the monk's stoic appearance with the radiance of his surroundings, conveying a sense of cohesion, peace, and transcendence.

Sometimes a great environmental shot is based on contrast, as in the photos shown on these two pages. They all depict real people in undirected moments set against the backdrop of highly stylized advertisements—emphasizing the divide that often exists between cultural ideals and daily reality.

Some environmental shots demand planning and patience; others simply require luck and a keen eye. So be sure to watch out for scenes that are ironic, paradoxical, or humorous—and, of course, always keep your camera at the ready.

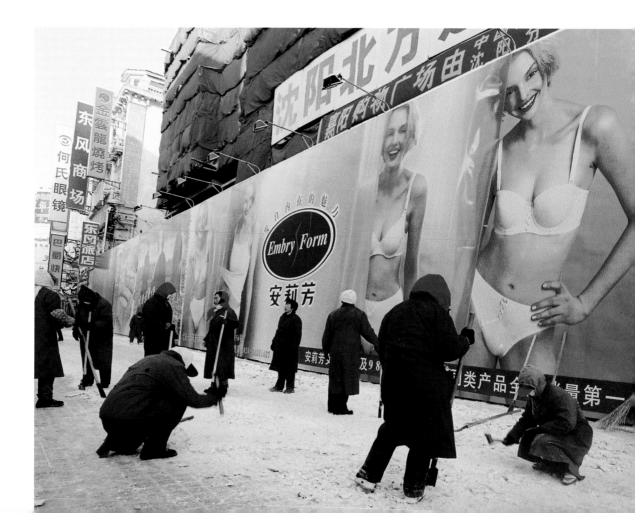

BREAKING IT DOWN

[1] **Stake out your spot.** If you're scouting a location in advance, check it out at different times of day to figure out when the light will be at its best. If you happen upon a great backdrop, experiment with angles until you land on the best way to frame the scene.

[2] **Set your exposure.** To keep people in motion sharp, you'll need a shutter speed of about 1/250 sec, and for adequate depth of field, you'll need an aperture of at least f/8. You may have to boost the ISO to get there.

[3] **Focus manually.** If your subject is already in place, autofocus may work. But if you're waiting for passersby, manually focus on an object at the distance at which you want to catch someone. That way, when the moment is right, you'll only need to raise your camera to frame and shoot—much faster and more discreet. If your camera has an LCD that you can flip up, keep your camera down by your waist and frame your shot using live-view mode—that way, most people won't realize that you're shooting.

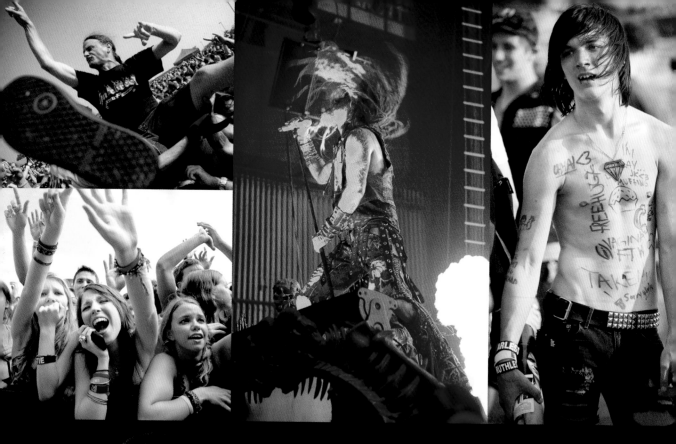

BREAKING IT DOWN

[1] **Set your ISO.** Make it a notch or two below the highest setting. Your pictures may have graininess and other visual noise in the shadows, but you'll notice it less at, say, ISO 800 than at 3200.

[2] **Hold steady.** The darker the scene, the slower your shutter speed has to be. So it may be pretty hard—or impossible—to freeze the action on stage. Embrace the blur. But to keep from adding more, turn on image stabilization and brace your elbows against your sides to handhold steadily.

[3] **Don't get distracted.** Use spot-weighted metering (which meters a specific point or area rather than the whole scene's ambient light) and single-area autofocus to keep your camera trained where you want it.

[4] **Use exposure compensation.** The lighting designer may mix up effects throughout the show, so compensate by adding or reducing exposure manually as needed.

[5] **Go high and low.** Shoot from overhead and at waist level, even if you can't see the LCD. Getting above and below the audience's eye level offers new perspectives.

[6] **Shoot a lot.** You'll be lucky to have one keeper for every 20 or 30 shots. Don't sweat it—just make sure that you're packing plenty of memory.

ROCK A LIVE SHOW

FOCUS ON THE BAND—AND THE FANS.

SHOOT TO THRILL

Established rock photographer Jeremy Harris, who took these photos, gets access that most of us only dream of: super close to (or on) the stage. You probably won't be so lucky. And you may not even be able to bring your DSLR, although most venues permit compact cameras. But whatever you're shooting with, a concert can yield awesome photos.

Shooting in continuous mode will increase your chances of snagging the perfect shot—as will familiarity with the band. The more times you see a particular group, the easier it will be to anticipate certain moves—crowd surfing, a microphone tossed in the air—and catch the action. Wrap your camera strap around your wrist to keep from dropping it, and shoot one-handed overhead when you want to cut out the dudes headbanging in front of you. But don't forget to capture the energy of the crowd. Put your back to the stage or, better yet, do some wandering.

Since stage lighting changes rapidly, your biggest challenge will be keeping up. Things are easier at outdoor shows during the day, but you may have to adjust for shifting combinations of sun and stage lighting. Whether it's out or in, start with auto white balance to cope with different color temperatures.

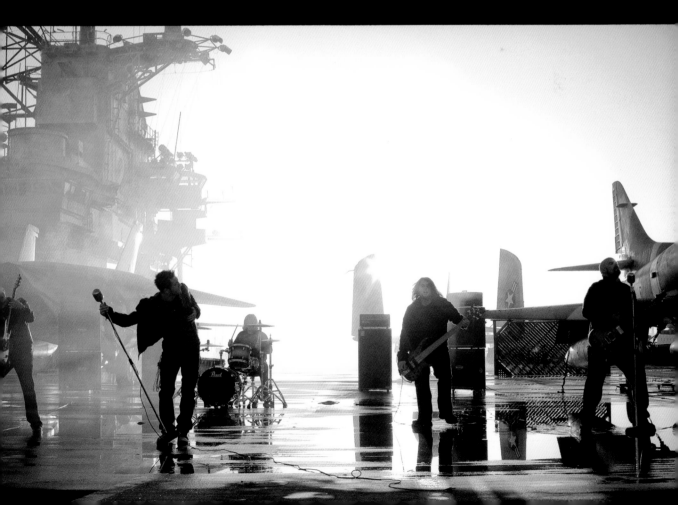

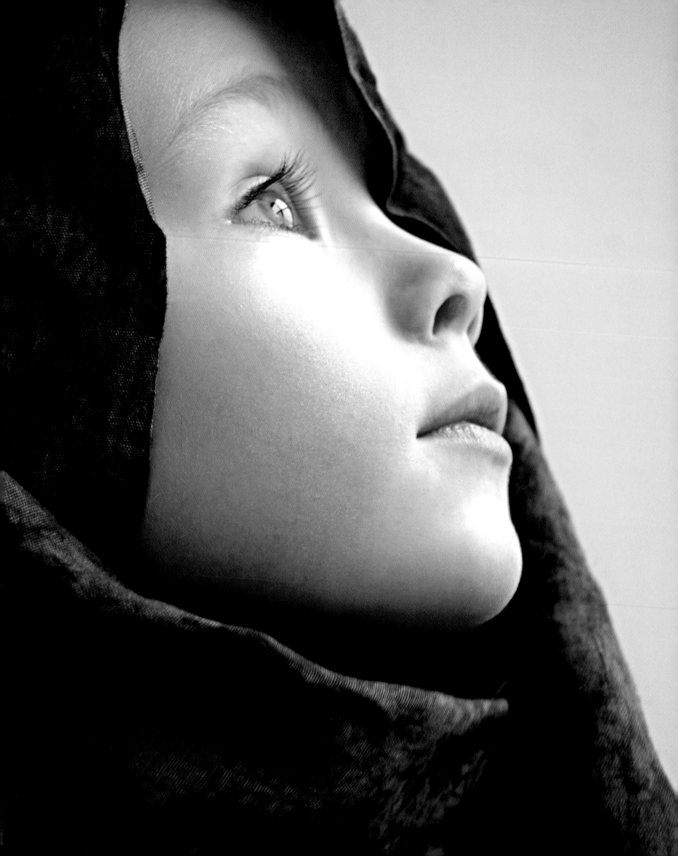

LOOK TO THE LIGHT

TRY A CLASSIC TECHNIQUE TO SHOW SOMEONE'S THOUGHTFUL SIDE.

BREAKING IT DOWN

[1] Remove clutter. Clear any distractions in the background or hang a backdrop (a bedsheet is fine) far enough behind the subject to prevent the camera from capturing its texture.

[2] Set up a tripod. You'll likely be using a long exposure in filtered light, so the extra steadiness will improve your image quality.

[3] Use a small reflector. Place it opposite the window and close to the subject to give the shadowed side of the face a bit more light. You can use a piece of white board or simply drape a white sheet over a chair for this.

[4] Build the pose. To put your subject's chest in shadow and highlight the face, place his or her back to the window with shoulders at a 45-degree angle to the glass. Then ask your model to slowly turn to face the light.

GET THE GLOW

Turn toward the sky when you want to create a portrait with a soft, even tender, mood—and have your subject do the same. Sun filtered through a window is one of the most flattering ways to light people. The soft glow minimizes any skin imperfections and adds a catch light in your subject's eyes for a bright, fresh look. The secret is indirect sunlight. A window that faces north is your best bet, but ones that face other directions can also work well—just shoot on a cloudy day, or at a time when the sun's not streaming into the room. If the sun is too bright, translucent white curtains will help soften direct sunbeams.

FIND THE SWEET SPOT

Once you've picked your window, situate your subject in it. Play around to find the right distance and angle so the light falls flatteringly on your subject's face. You want to avoid extremes, making sure that his or her features are not blown out by harsh light or obscured by too much shadow.

Sometimes the best position is with the head positioned a few inches in from the window frame. With larger windows, the light can come in from too high an angle, casting long shadows from the nose, cheek, and chin. To avoid this, move the subject deeper into the room or pull down the shade a bit.

Use a wide aperture for a slightly blurry background. That way, all the attention will be right where you want it: on your subject's gently illuminated face.

EXPLORE MOODS AND ANGLES

As your model starts to get comfortable, ask him or her to try out new postures and expressions. Subtle shifts in expression—a shadow of wistfulness, an enigmatic smile—capture your subject's essence and make for a compelling portrait.

Start off with some three-quarter views of your model's face, then move toward a profile by having him or her gradually turn to look directly out the window.

COMPOSE IN MIDAIR

WHEN THEY NAIL THE MOVE, BE READY TO NAIL THE SHOT.

STOP THE CLOCK

How many times have you seen a friend do something that made you think, "If only I'd caught that on camera!" Photography lets us stop and study things that happen too fast for the eye to take in at the time. But capturing a particularly smooth move (or anything that happens fast) is no accident. To nail the shot, you'll have to plan for it, find the perfect location, use the right gear—and do it over and over again.

Take this bold, graphic photo by Ben Bergh. It's a great example of an action shot that packs plenty of visual impact, because Bergh did more than just freeze movement—he carefully crafted an arresting composition of gesture and architecture.

SET UP THE SCENE

Bergh and his skateboarder friend scouted out an abandoned, unfinished office building in Johannesburg, South Africa, that would set a dramatic stage. Bergh positioned himself one story below the action. Rather than rely solely on the sunlight coming from the open roof, he lit the scene with four small remote-triggered flash units. The two men agreed not to give up until the skater landed the trick and Bergh had the perfect shot—and on the 60th attempt, they got it.

What makes this image successful as a picture, and not just a record of a dangerous jump? First, the strong lines of the V-shaped ceilings and the symmetry of the framing draw the eye deep into the image. the skater's body also forms a rough V shape as he jumps across the gap, perpendicular to the building's Vs. That adds visual tension by simultaneously echoing and countering the dominant geometric motif.

Then there's the lighting: Ben placed his flashes at different distances so they'd light each cutaway ceiling layer at a range of intensities, giving depth to the scene. Also, the burst of light on the skater separates him from the background and allows an exposure quick enough to freeze him in midair. The colors and textures work to the photo's advantage, too—the pattern and roughness of the cement contrast with the blank sky, but they're subtle enough not to steal attention from the figure, whose red shirt makes him pop.

Whether you're photographing an extreme athlete, a jockey on a galloping horse, or a friend doing a cannonball off the high dive, look for locations with strong leading lines to serve as a backdrop that contrasts dynamically with your subject's body or clothing. Then use lighting to freeze your subject and draw the focus of the image to that millisecond of amazing action. You'll have both a jaw-dropping photograph and an amazing feat captured.

THE GEAR

A full-featured DSLR You'll need good focus tracking and the ability to capture a lot of frames in continuous mode. As for exposure settings, your shutter must be at least 1/250 sec to stop action, and aperture f/8 to f/11 for enough depth of field.

Off-camera flash Combining sun and flash creates an electric look that amps up the energy in an action shot. How much flash you need depends on the location and ambient light. Don't forget stands, clamps, or other supports.

Remote flash control If your camera and flash don't have this capability built in, you'll need a remote trigger. Infrared control works when your gear is arrayed in a line of sight, but if you want to position your lights behind an object or around a corner, you can use mirrors or radio control.

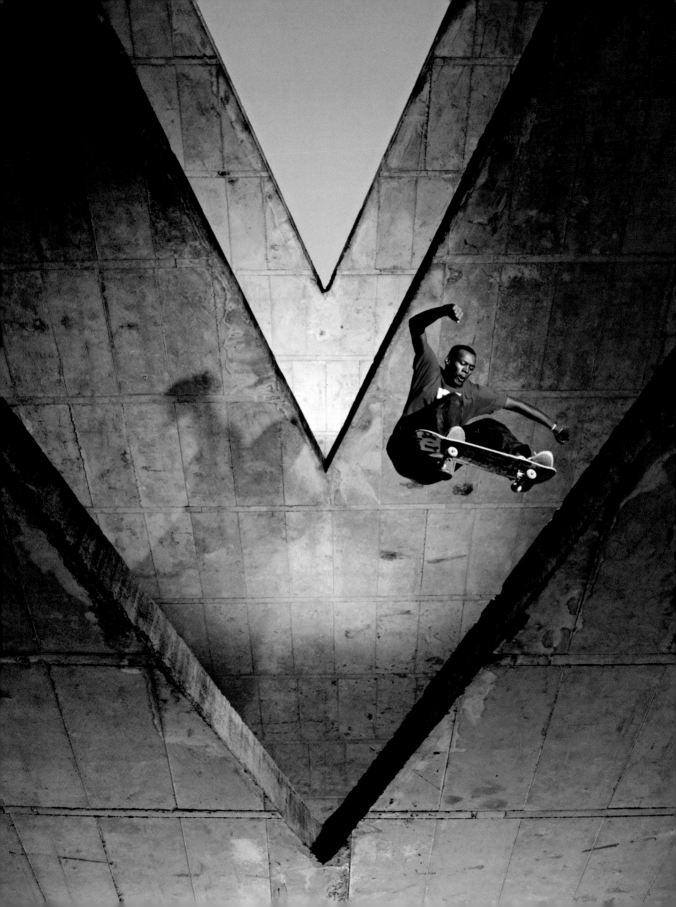

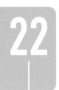

22 DOCUMENT THE BIG DAY

CAPTURE THE HIGHLIGHTS OF A WEDDING.

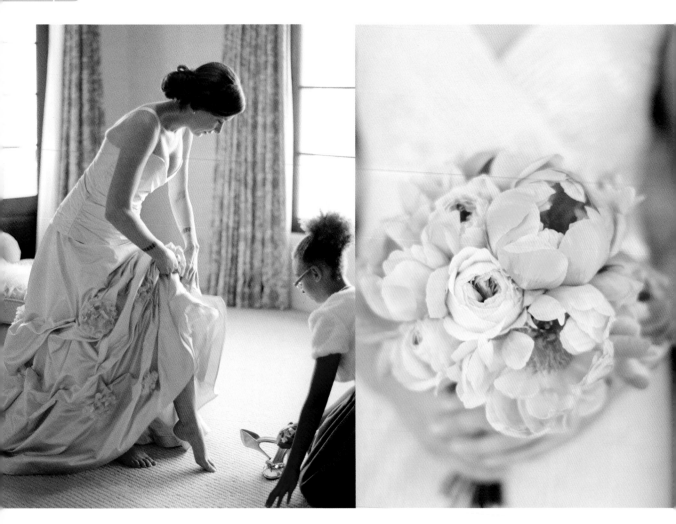

GO BEHIND THE SCENES

Weddings are as much about the preparations as the "I do" moment. So to tell the full story, you'll need to follow the key players through the day. Try to capture the excitement in moments of preparation. You can approach this like a photojournalist by staying unobtrusive and handholding the camera. Or use a more cinematic style, as Thayer Gowdy did here, evoking Cinderella to underscore the idea of a fairy-tale wedding.

SPOTLIGHT THE DETAILS

So much thought goes into the flowers, cake, and wedding rings—you should put just as much effort into capturing them. Take inspiration from still-life paintings and isolate these details using shallow depth of field and focusing manually. Position a colorful bouquet against a neutral background. As Gia Canali's photo above shows, the bride's dress is perfect choice. A white bouquet? Shoot it against a soft but rich color such as sapphire or raspberry.

Whether you're shooting casually for friends or taking on a professional assignment, think of photographing a wedding as telling a tale—one that a couple will want to revisit over and over. Show the narrative of the day, along with all the rich details.

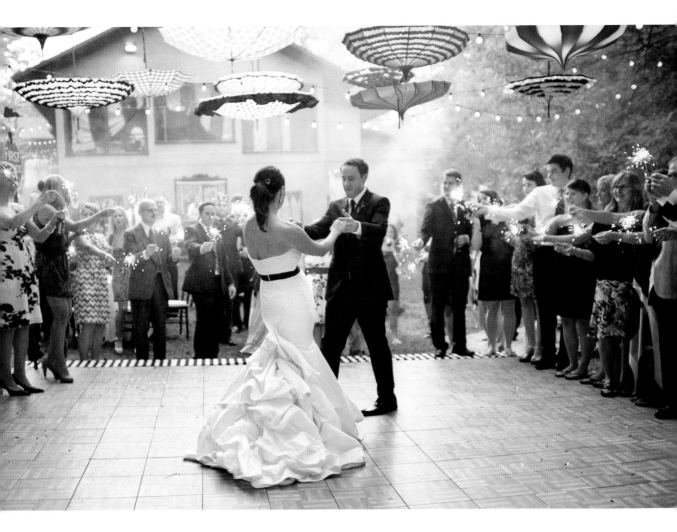

SHOWCASE THE FIRST DANCE

You'll rarely have enough ambient light to freeze the newlyweds as they dance. As in this photo by Gabriel Ryan, you'll almost certainly need an off-camera flash. Position it away from your camera, whether on an L-bracket or simply in your hand, and use as little power as you can get away with in order to preserve the atmosphere of the scene. Try shooting from above the dance floor for a fresh perspective—from a balcony or a ladder, or even standing on a chair.

Before or after the dancing, take the bride and groom aside for a few portraits. A couple of tips: Avoid putting the bride closest to the camera—in a white dress against a black tux, she'll appear larger. To further flatter, instead of lighting her face directly, position your flash so that the light falls diagonally across her, creating shadows in the gown and under the bust. And give the couple a break from formal poses. Take a cue from fashion shots with unusual angles and lots of movement.

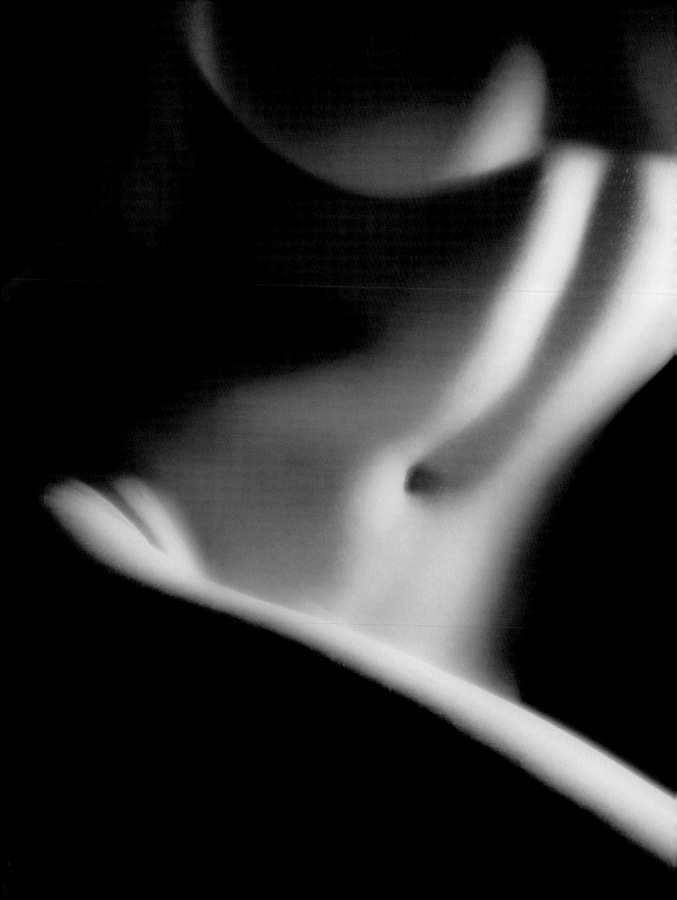

FLATTER THE FORM

REVEAL NATURAL BEAUTY WITH A CLASSIC NUDE.

EXPLORE BODY CONTOURS

When viewed through a camera lens, the human body can be a mesmerizing landscape, or an art form—one that owes more to classical sculpture than to *Playboy*. Whether you photograph a professional model, your partner, or even yourself, you'll have an opportunity to explore a range of photographic possiblities. Play with shadow, explore shapes and contours, and experiment with abstraction. Don't be afraid of eroticizing your image, but you shouldn't feel you have to, either.

If you don't have friends or significant others willing to pose, you'll have to hire a model. Start your search by asking local drawing instructors to recommend figure models. No matter who your model is, it's important to discuss your intentions honestly and clearly. And be sure to get proof of legal age and a signed model release before you start to shoot.

Be mindful of your model's comfort. Set up in a warm room and keep a robe on hand. Consider having another person present as an assistant—adding someone else to the shoot can dispel tension. Use a moderate telephoto lens so you can stay at a respectful distance. If your subject seems intimidated, start with tight close-ups of less intimate parts of the body: the nape of the neck, a hand across the thigh, or the curve of the back. Reassure your model with acknowledgements that you're getting great shots.

Ask your model to turn in tiny increments to change the way the light hits the body. Your goal is to highlight lines you want to emphasize, and hide those you don't in shadow. Avoid noise by staying below ISO 400, and keep the aperture wide for shallow depth of field. For black-and-white, shoot in RAW and convert later.

BREAKING IT DOWN

[1] **Put your model in place.** Have your model pose on the floor in front of a dark, seamless backdrop (A) while you handhold the camera at a low angle. Ask your subject to lift and twist upward and to change positions slowly.

[2] **Set up your lights.** Put the main light (B) at about a ten o'clock position. If you're using a back light (C), try setting it up at two o'clock. Start with the lights at a low angle, then change the height to see what happens.

[3] **Temper your lighting.** Use barn doors or cardboard baffles (D) to focus the beams on your model. Make sure that no light shines into your lens and that the background stays dark.

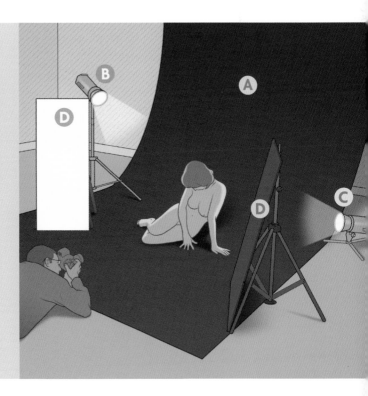

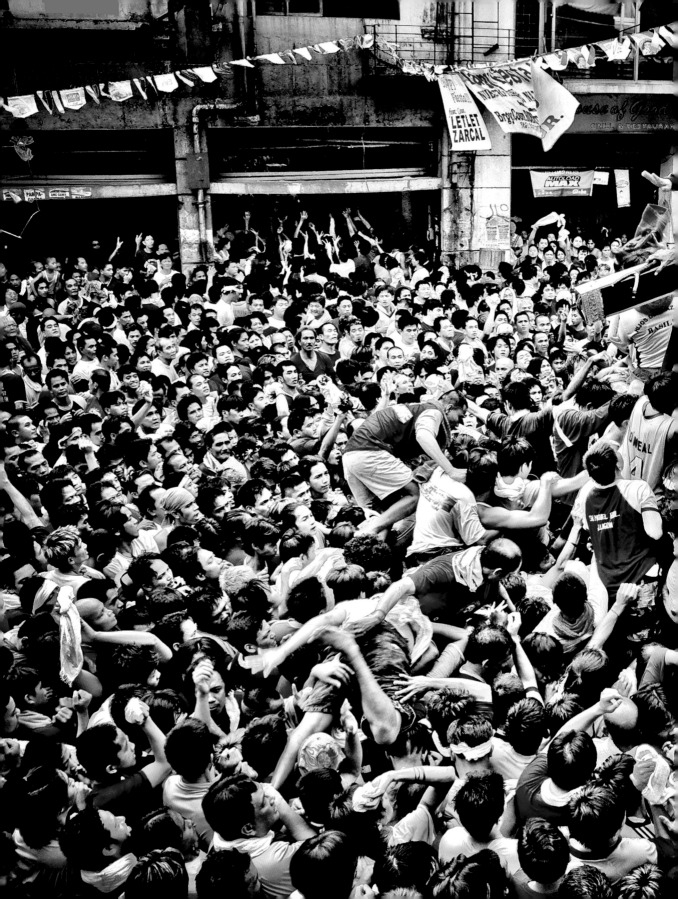

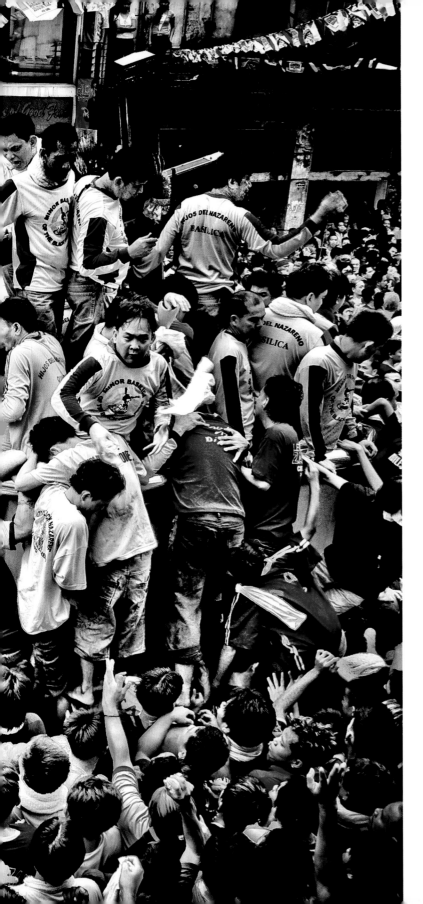

ENCOMPASS A CROWD

When a throng forms, take notice. And turn an unruly group into a well-structured shot.

SHOW COLORFUL FERVOR

When Arnel Garcia decided to photograph the annual Black Nazarene religious procession in Manila, he was worried about getting trampled by the fervent crowd. A neat solution—and one that gave him a commanding view of the unfolding drama—was hanging from a second-story fire escape and extending his DSLR (equipped with a wide-angle lens) as far over the throng as he could.

But bravado wasn't enough: Garcia needed to deploy artistry, as well. For starters, he emphasized the surging force of the mob by framing the shot so it builds toward the human pyramid in the top-right corner. And he conveyed a sense of unity by adjusting color saturation and contrast with software until he achieved a near-monotone punctuated by vivid spots of red.

Composition and color are key to taking standout shots of large groups. So is changing your angle of view: Zoom in to catch gestures, and use wide shots to take in the crowd's raw energy.

SHOOT EXTREME ACTION

CATCH AN UNEXPECTED ANGLE ON SPORTS.

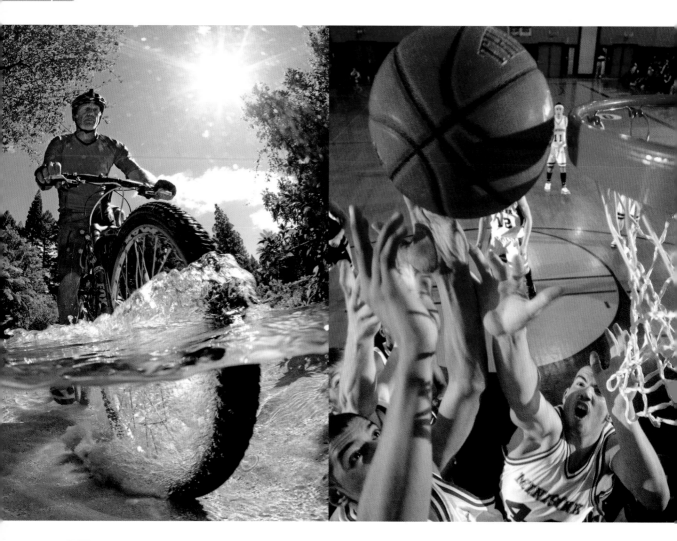

SEE FROM BELOW

Chris McLennan used an underwater housing for his camera and his fisheye lens, which was wide enough to get close to the wheel while still capturing the background. The sand bounced light up at the cyclist, cutting shadows that would ordinarily be inevitable in a backlit scene. To minimize distortion, McLennan kept the horizon centered. The rider, meanwhile, had to find the right speed—avoiding too much splash yet still conveying motion.

GET THE HOOP'S-EYE VIEW

Getting a shot like this takes planning, precision, and permission. Newspaper photographer Chet Gordon clamped and secured his camera behind the backboard, focused manually on where he expected the peak action to happen, and used gaffer's tape to hold the focus ring still. This kind of stop-action shot requires a lot of light, so he mounted four strobes high in the bleachers, and used a radio-remote flash and a camera trigger to orchestrate the whole shebang.

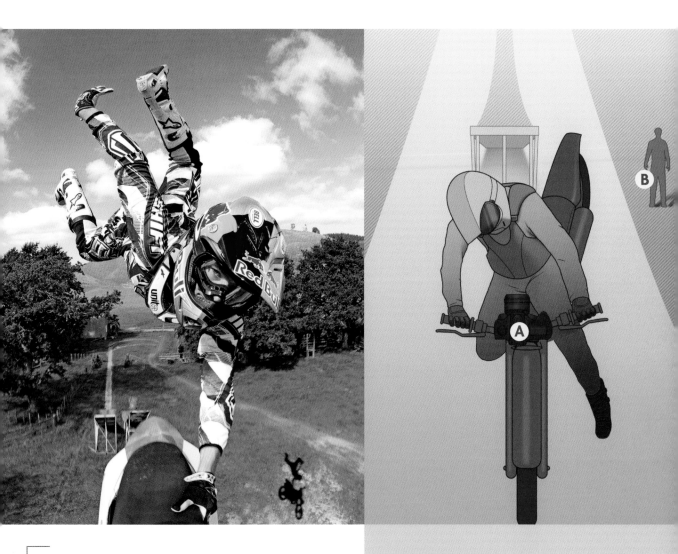

SHOOT CRAZY BIKE TRICKS

When Chris McLennan shot X Games freestyle champion Levi Sherwood, he wanted the photo to be, well, extreme. He made the look of the image even more effective by using a fisheye lens to separate Sherwood from the background, and fired a radio-remote trigger from 50 feet (15 m) below. As Sherwood flew up and off the ramp, he had to move to the very back of his bike to keep his whole body in the image frame—any closer to the lens and he would have been cropped out.

BREAKING IT DOWN

[1] **Put the camera where the action is.** To catch a bike rider from the crazy angle shown at left, clamp your DSLR (A) to the bike's handlebars.

[2] **Keep your finger off the trigger.** For any of the shots on this page, a radio-remote trigger is key.

[3] **Step out of the way.** You have to stand out of the path of action, but where you have a good vantage point (B). That way, you can fire the remote trigger at exactly the right moment.

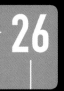

26 GET IN CLOSE

To isolate expressive features and form a bond between subject and viewer, crop close.

FOCUS DEEP

If the eyes are the windows to the soul, Faisal Almalki's portrait of his mother throws open the shades and climbs right through. It's not merely the tight close-up, or the way her hijab isolates and frames her eyes, or even the powerful stare that makes this photograph

so exquisite. It's that all those things contribute to the almost uncomfortable intimacy of her gaze—and the sensation of being able to stare right back.

Technique plays a major role in the success of such a close portrait. For one thing, few people let anyone (especially anyone with a camera) get this near—and Almalki didn't have to. He used a telephoto macro lens to get a tight view of his subject, which also prevented distortion. A shallow depth of field softened the skin at her temples, making her eyes stand out even more sharply. And by shooting the portrait in sunlight, Almalki caught his own distorted and silhouetted reflection in those eyes—a subtle detail that contributes to this photograph's intensely striking blend of intrigue and familiarity.

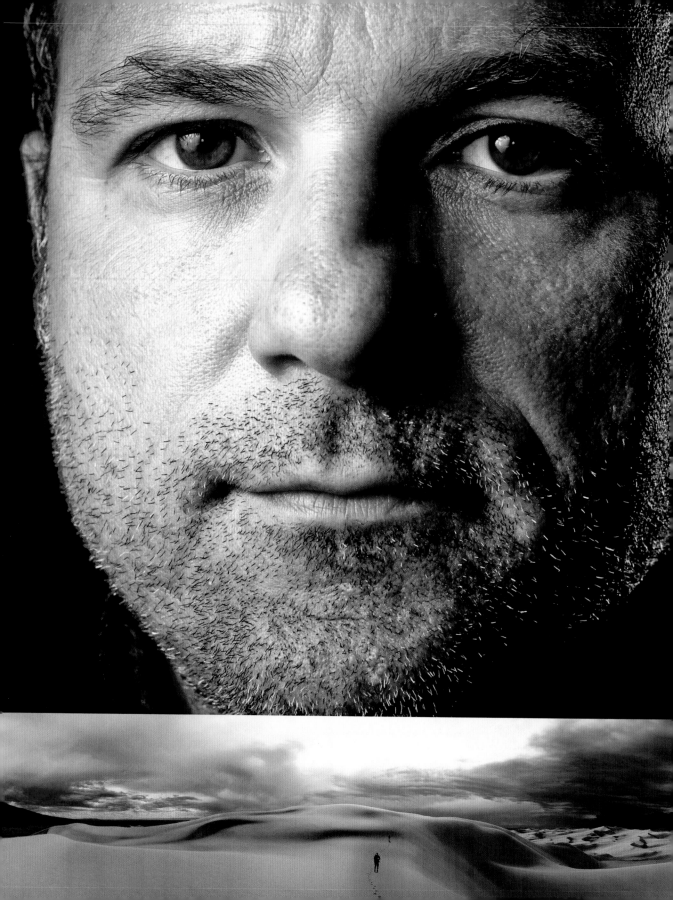

STEP INTO THE PICTURE

GET OUT FROM BEHIND THE CAMERA AND BECOME YOUR OWN BEST MODEL.

CHOOSE A CONCEPT

Maybe it's because we spend so much time criticizing photographs, but photographers are notoriously camera-shy. Then again, the only way to ensure that portraits of you meet your exacting standards is to take them yourself. Acting as your own model also allows you to deeply explore the portrait as a means of depicting an inner landscape, since no one knows yours the way you do. Perhaps best of all, when you're shooting self-portraits, you never have to apologize for tinkering with the lighting or doing a reshoot.

First, decide what kind of image you want to make. Do you want a traditional head shot, or something more conceptual? Consider making a dreamscape that reflects emotions or fantasies, like the desert scene at left. Zach Dischner created it by setting his camera on a tripod and firing the shutter several times as he walked away with a wireless remote trigger in his hand. He combined exposures later to craft an image featuring two ghostly figures.

GO HEAD ON

If your goal is a straight-on head shot, you may be after the trickiest type of self-portrait to pull off, because you have so little leeway in focus and composition. As you set up the lights and adjust the frame and exposure controls, use a friend or an object that's about the size of your face as a stand-in positioned at the spot you'll occupy in the frame. If you're using an object, find one that has a high-contrast detail at eye level to help you get the focus right, like a big stuffed animal or a piece of cardboard marked with tape.

Using available light or a continuous source instead of a strobe will let you see how you're lit while you set up. (Emmanuel Rigaut used precisely placed lights for his head shot at left—broad and soft on one side, hard on the other.) Put your camera on a tripod or other support, compose your shot, meter the exposure, then choose your settings accordingly. Use a remote trigger (a cable release or wireless remote) to fire the shutter; most allow autofocus, and won't require you to go back to the camera after each shot, which you'll have to do if you use the camera's self-timer.

CHECK YOURSELF OUT

Want to see how you look in front of the lens? Simply set up a mirror at the camera position. This won't let you frame precisely, but it will help you play around with pose and expression.

But if your camera has a swing-out LCD monitor, you're golden: Flip it out next to the lens and turn on the live-view mode to see what the camera sees. If you don't have an articulated LCD, turn your computer monitor into a live-view screen by connecting it to your camera using a cable and photo software. It will be easier to see from a distance than a tiny LCD screen.

THE GEAR

Tripod You'll need to steady your camera. Use a flexible support in tight spaces.

Stand-in object Use a substitute while you compose your shot and set exposure.

Remote trigger A cable release or wireless remote saves you from having to get up between each shot.

Mirror Set up a mirror beside the camera so you can see yourself as you shoot.

Camera with articulated LCD You'll be able to twist the screen around to face the front of the camera so you see what it sees.

Tethered monitor This will be easier to see from a distance than your LCD because it's bigger. Position it so you can see it when you are faced in the direction of your photo—at camera position for a straight-on view, or to the side for a profile.

LET KIDS BE KIDS

CHILDREN'S PORTRAITS SHOULD BE AS PLAYFUL AS THEY ARE.

WORK WITH MINI MODELS

If you can get them to reveal the essence of their personalities in unselfconscious, happy moments, kids make ideal portrait subjects. To help children be themselves in front of the camera, read their moods and engage them by asking silly questions and talking about their interests. And give them as much freedom to move around as your space and setup allow. If they want to lie down or jump around, go ahead and let them—it may lead to a great shot.

With babies, schedule your portrait session for right after nap time, use your most soothing voice, and keep toys—especially ones that move and make sounds—on hand to grab their attention. Jiggle a noise-making toy right next to your camera lens so that they'll look toward it. Pose them on their bellies (on a soft cushion or blanket) with their arms out in front, then lie down to photograph them at eye level.

What not to do? Don't confine kids with stuffy settings, a lot of artificial lighting, and unnatural poses. Never direct or correct them—instead, make suggestions that sound fun. Don't fuss around with your gear; have everything set up in advance so kids don't have time to get distracted. Don't keep shooting when your subjects look bored or cranky. And don't make kids say "cheese!" In fact, don't make anyone say "cheese," ever.

LIGHT LITTLE ONES

One way to maintain a relaxed atmosphere—and soften the look of your photos as well—is to shoot in diffuse natural light, as photographer Amy Perl did for the portraits you see at right. The huge windows in her studio admit lots of indirect light, and she can set up wherever that light is best by using rolling walls—one for hanging patterned fabrics and one painted white—which do double duty as backdrops and reflectors.

You can mimic this effect by using fabrics or wallpapers you'd like to use as backdrops and mounting them on large pieces of lightweight foamboard. Or keep things even simpler by tacking your backdrop of choice to a wall behind your subject. If you're feeling ambitious, use a rolling coat rack to create a movable backdrop, or get a backdrop stand.

TINKER WITH THE DETAILS

If there's just not enough window light where you're shooting, use continuous (hot) lights or flicker-free fluorescents. In either case, always add bounce with an umbrella or diffuse the light through a softbox.

When you're ready to shoot, limit depth of field by keeping your lens open to a fairly wide aperture. Get in close, positioning your subject nearer to your camera than to the background. Using a slightly telephoto lens will help throw the backdrop out of focus, drawing attention to bright eyes, natural smiles, and the tough-to-resist exuberance of your youthful models.

BREAKING IT DOWN

[1] **Set up the backdrop.** Use cheerful hues and patterns that complement children's coloring and clothes. But a baby going au naturel will probably look best against a simple backdrop.

[2] **Determine the exposure.** A wide aperture (an f-stop of f/4 or below) limits depth of field, which will keep your focus on the child's eyes. It also affords a faster shutter speed to help you capture fleeting expressions.

[3] **Skip the tripod.** A handheld camera gives you lots of freedom to follow squirmy kids, and is much easier to use when you're down at baby level. But some kids do better when they have the reassurance of eye contact, so in that case, frame your shot using live view (especially if you have a flip-up LCD screen) instead of the viewfinder. And shoot in continuous mode so you don't miss a single moment.

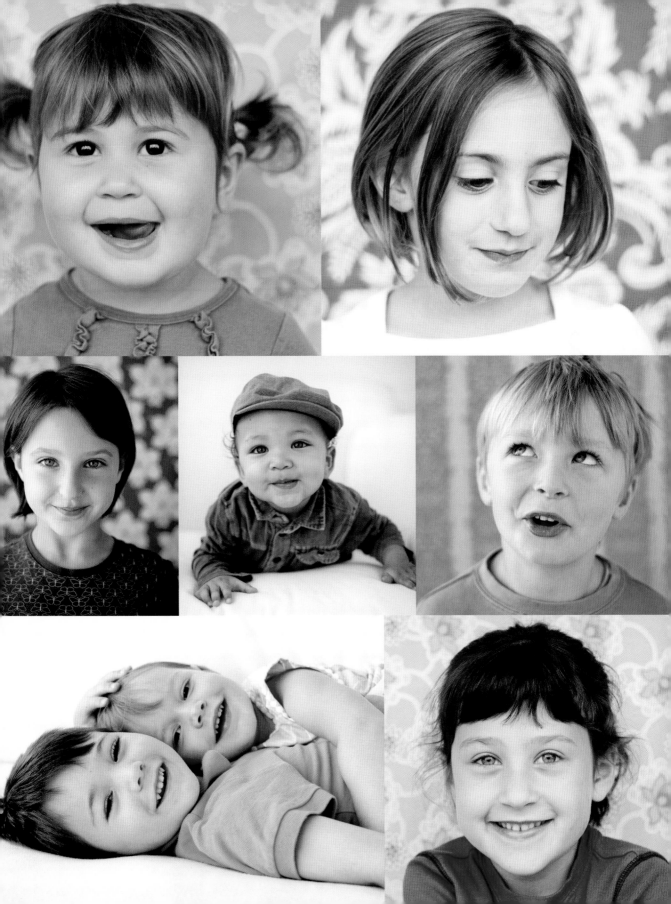

TAKE AN ANGLE ON ANIMALS

OFFBEAT FRAMING BRINGS OUT CRITTERS' SILLY SIDES.

GO TO EXTREMES

Photographer Chris Petrick could have just exaggerated this pet donkey's nose or tilted the horizon. But he did both—to the max. Running diagonally across the frame, the grass tilts like a fun house's floor. Placing a wide-angle lens close to the donkey magnified its muzzle while reducing its neck to a spindly stalk. And by cropping with software so the disembodied face peers down from the side, he made the animal look utterly goofy.

You don't need to stuff your pet into a costume to get a giggle-inducing portrait. Creative camera angles and ultrawide-angle lenses can show your best friend from a wacky new perspective.

MANUFACTURE MENACE

This amusing photograph owes its wry tone to the snug crop, the looming angle, and the pet bunny's serious expression. All those elements contribute to making the rabbit—an animal normally portrayed as the picture of sweet innocence—seem like a paradoxically ominous character. To get a shot like this, you need a close-focusing wide-angle lens and a willingness to get belly-down in the grass for a perspective that will exaggerate the animal's size.

GET BOTTOMS UP

For this shot, Darwin Wiggett got underneath a sturdy glass-topped coffee table he'd set up in his backyard. Then all he needed was a wide-angle lens and a dog willing to hold still for a few seconds in return for a treat. Manual focus ensured that the dog's face (especially those crucial whiskers) stayed sharp. Wiggett only had time to capture a couple of frames, but still managed to snap the pooch in a dynamic, frame-filling X-shaped pose.

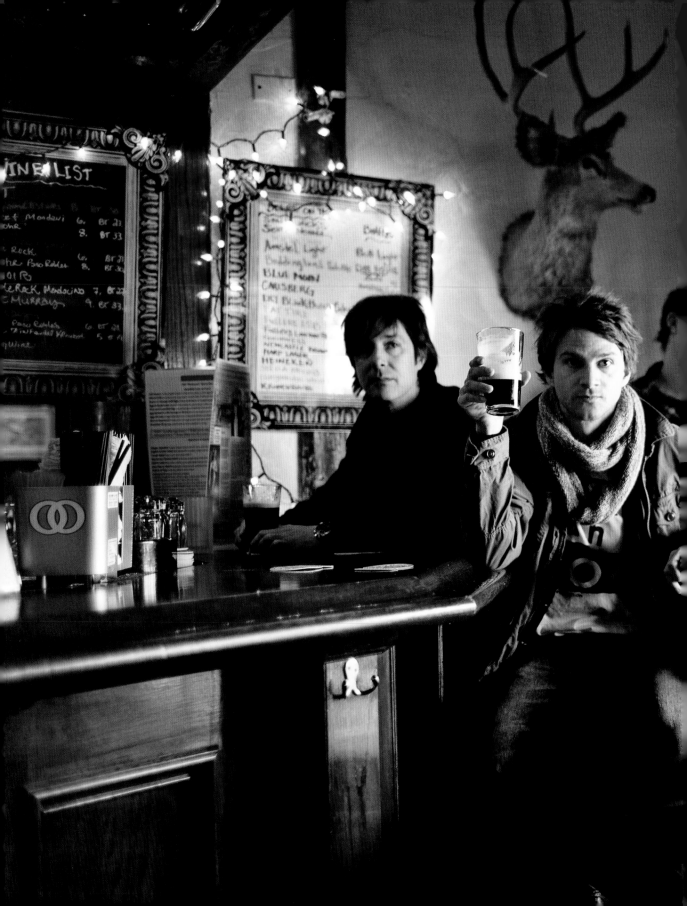

30 FOLLOW THE BAND OFFSTAGE

GET AN ALL-ACCESS PASS TO GREAT IMAGES.

AIM FOR THE ESSENCE

A great photo can define a rock band's image. To shoot an iconic offstage portrait, you've got to set the tone by taking control of everything from the location and the lighting to the props and the clothes. Knowing the look you want, right down to body posture, will let you create a compelling expression of a group's persona.

For the photo below, Adam Elmakias captured the scrubbed yet grungy feel of Christian heavy-metal band The Devil Wears Prada by finding the perfect location: an almost-empty warehouse in Dayton, Ohio, with high ceilings, lots of room, and natural light. He made the band look commanding by having them square their shoulders and feet, while the waist-high camera makes the subjects subtly tower. Completing the imposing effect are sharp shadows, which Elmakias achieved by positioning one light coming from back left, and another aimed downward from back right.

That edgy look won't be right for every group, so adjust the details to suit the band's image and your vision. And if you decide you want to make one member stand out, do as Elmakias did on the previous page: Use lighting and composition to single out the band's main member—or place him or her closest to the lens and in clearest focus, as in the photo at right.

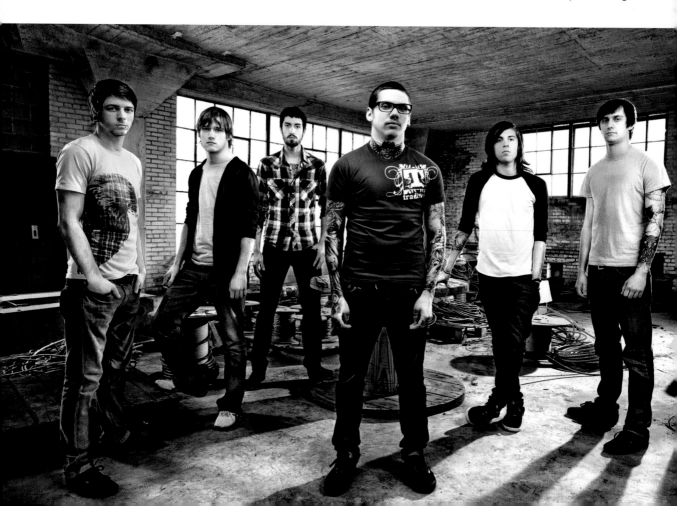

BREAKING IT DOWN

[1] Come at it from angles. Back lights and side lights (A) help separate figures from darker backgrounds and create interesting foreground shadows. Use bare bulbs or grids for crisp shadows, or use diffusers for a gentler effect.

[2] Heighten definition. Pose each subject in the photo (B). If one musician casts a shadow on another, move the lights or the people.

[3] Soften front light. Use umbrellas and softboxes (C) on the lights that shine down on the band to lighten the shadows on their faces and clothes.

[4] Stop spillage. A flag made of black foam core (D) will help shape the light and sharpen the shadows.

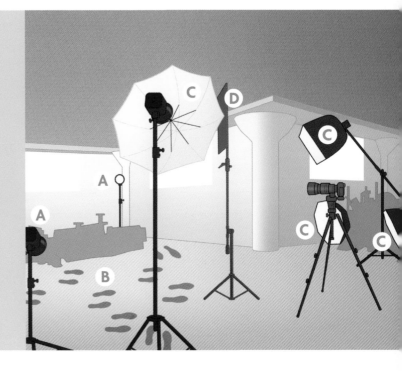

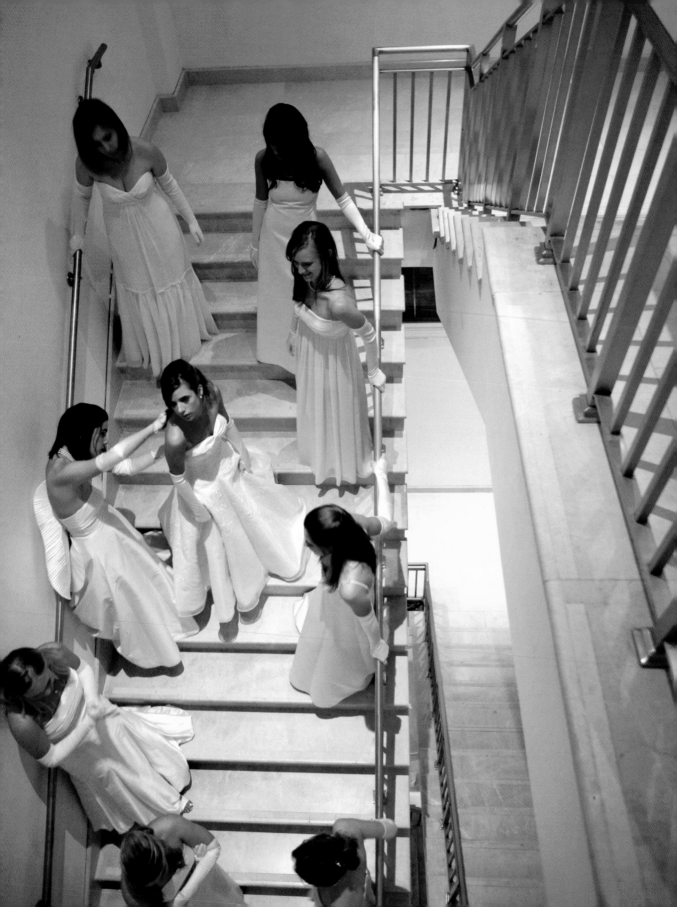

PICTURE PARTY PEOPLE

GO BEYOND THE SNAPSHOT.

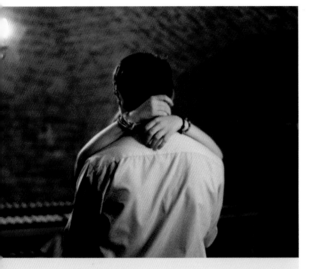

GET SOME DISTANCE

Anyone can take snaps at a party, but it requires extra effort to get a picture that offers insight into the scene. For starters, you'll have to switch your perspective from participant to observer. Fade into the woodwork by photographing until people grow less aware of your camera. That way, you're more likely to catch telling moments like partygoers sharing a laugh or an embrace. To shake things up, skip the straight-on shots of people smiling and consider alternate perspectives—like shooting from overhead. Scope out balconies and stairways, or mount your camera on a monopod and extend it above the crowd, using a remote release or a self-timer to fire the shutter.

TAME YOUR FLASH

When you can, shoot without a flash—especially the one on your camera, which can blast out the faces closest to you and make the background go black. Brace your camera against a wall or a piece of furniture to steady it, since forgoing the flash may mean you need a slightly longer exposure.

On occasion, though, a flash can give you light when you need it and direct your viewer's eye to the essential spot in a crowded scene. Use an accessory flash with a swiveling head that will let you bounce light at a 60-degree angle off the ceiling or wall. And a sync cord will keep your flash in tune with the camera so you can separate them and aim flash from the side.

Dial down the flash output to keep the strobe from overwhelming the ambient light. To keep shadows from looming behind people (unless you want that), avoid shooting partygoers when they're close to a wall.

Want to show people dancing or talking animatedly? Retain a sense of the movement by setting your flash to slow sync—even compact cameras have this setting. This gives you a longer shutter speed for some motion blur, plus a brief burst of light to capture your subjects sharply. A shutter setting called *trailing*, or second-curtain sync, puts the blur behind the flashed subject.

BREAKING IT DOWN

[1] Pick your ISO. Set the highest sensitivity your camera affords (to help with low light) before the image becomes too noisy.

[2] Shoot in continuous mode. Because your subjects will be moving around, talking, and laughing, it may be hard to catch them without mouths agape and blinking eyes. Using burst will up your chances of capturing someone wearing a flattering facial expression.

[3] Don't be afraid to zoom in. Zooming in on interactions from across a room rather than lingering conspicuously close to people can help you catch them in natural, candid moments.

[5] Know the schedule. If you're photographing an event featuring speakers, dances, or other events you want to document, make sure you're aware of the schedule. That way you can be prepared and waiting at a good vantage point so you won't miss significant moments.

GO FOR GLAMOUR

USE A STUDIO CLOSE-UP TO MOVE FROM GOOD-LOOKING TO OUTRIGHT GORGEOUS.

MAKE PRETTY PICTURES

Flattering studio portraits highlight natural radiance and sculpt your model's face with soft shadow—and, of course, minimize any flaws. To accomplish all those things in this image, photographer August Bradley used a rather complicated lighting setup to ensure maximum control of the highlights and shadows that shape and define his model's face.

Soft light from a beauty dish set close to and slightly above the model is the secret to the image's balance between shimmering highlights and the gently feathered shadows under her eyebrows and chin. (The closer you place the beauty dish to your subject, the larger the highlights will be and the more abruptly they'll fall off into shadow.) Bradley also layered in accent and background lighting to create a full, smooth, and softly illuminated effect.

Even if you've developed a detailed lighting plan, you'll have to adjust lights and angles during the shoot, since even tiny movement can bring out or de-emphasize certain parts of the face. And you may want to pull back a bit, since not everyone has the bone structure and flawless skin that shines in a close-up as tight as the one here. Remember, even with the most gorgeous models, pros use software to retouch images after shooting to fix flyaway hair and other distractions; you may want to, too.

BREAKING IT DOWN

[1] **Set up an overhead light.** Start by putting a strobe equipped with a beauty dish (A) directly in front of and somewhat above your subject's face to simultaneously focus and soften light.

[2] **Don't skimp on side lights.** Add side accent and fill lights (B). Bradley used grid attachments and a softbox on these lights, adding gentle highlights along the model's cheeks and preventing spillover light that would have eradicated the shadows and flattened her face.

[3] **Finish with backlighting.** For the background light (C), use a grid to create a gradation from highlight to shadow on the white backdrop.

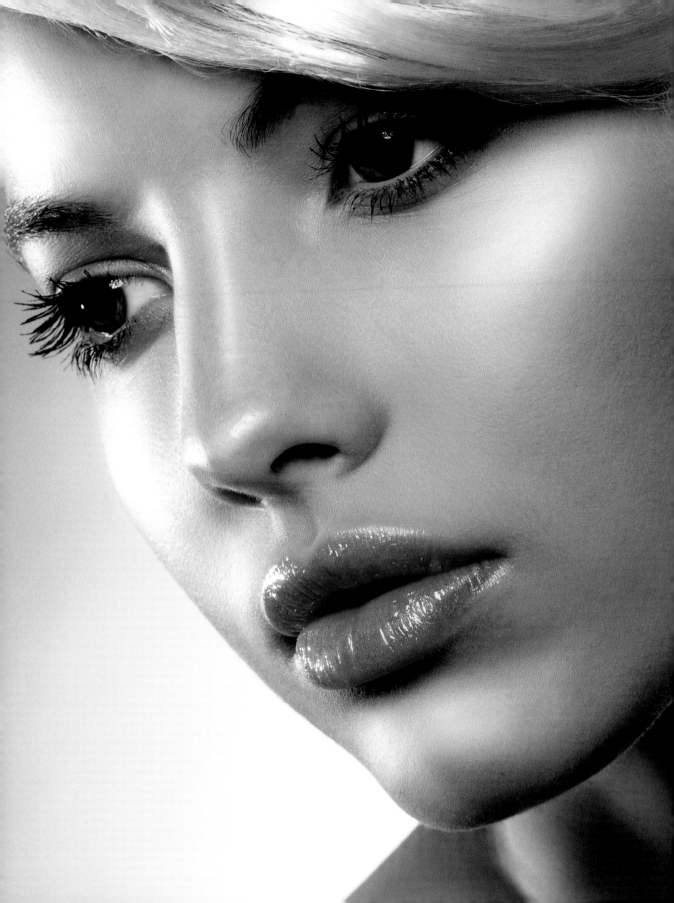

FOCUS ON FELINES

CRAFT A FORMAL PET PORTRAIT.

CAPTIVATE THE CAT

Pet photographers know why the phrase "it's like herding cats" signifies a nearly impossible task. Felines don't take direction and rarely make eye contact. But once you have a setup that allows you to use either natural light or studio strobes, you can make a perfect portrait in just a couple of minutes—until kitty decides to leap off the set and hide under the sofa.

Ideally, you'll have an assistant on hand to help hold the cat's attention. Your helper (or you) should dangle an irresistibly wiggly object, such as a feather on a string, from a long pole. Keep it at the camera position, or just above it, to draw the cat's gaze toward your lens. To capture a playful kitty with outstretched paws, dangle the toy over your subject's head, high enough that it won't be visible in your photo.

CONTROL THE LIGHTING

Whether you use strobes or natural, reflected sunlight in a bright room, you'll need plenty of illumination. If you don't have enough natural light, use a spotlight on the background and one at each side (or just on one side with a reflector on the other). Any frontlighting should be soft and at a high angle—never use a direct flash straight from the front. The idea is to keep the light gentle to preserve detail in both the texture and color of kitty's fur.

Except when they're in lounge mode, cats tend to move a lot, so you'll likely need a shutter speed of at least 1/250 sec to keep your image sharp.

CHOOSE THE RIGHT BACKGROUND

For your backdrop, the simplest option is to hang or drape a cloth or other backdrop in a color that contrasts with or complements the color of the cat's coat. For a more formal portrait, consider using a deep neutral gray like the one professional cat photographer Helmi Flick chose for the photos here.

BREAKING IT DOWN

[1] **Create a set.** Place a table at least a foot (30 cm) in front of your backdrop. The table should be tall enough to let you shoot comfortably at the cat's eye level. That's important, since it will give you the best chance of capturing kitty's true self.

[2] **Get a stand-in.** Use a stuffed animal or other cat-sized object for test shots.

[3] **Set exposure.** Use an incident light meter, which measures the output from each light source in your setup. That's different from your camera's meter, which measures the light reflected off your subject. An incident meter lets you make sure you've got the right exposure before your model even arrives on the set.

[4] **Keep shooting.** Set your camera to continuous shooting mode. Cats may not be the most cooperative models, but if you take enough photos, you're bound to nab some sweet shots.

34

CATCH KIDS IN MOTION

TO SHOW CHILDREN AS THEY REALLY ARE, PHOTOGRAPH THEM WHEN THEY'RE ACTIVE AND ENGAGED.

GO FOR SPEED

Motion is a kid's natural element, but snapping the desired moment without blur can be tough. If you need an excuse to get a fast-focusing DSLR, children are definitely it.

A few camera tricks will help you keep up. Besides shooting in continuous mode to catch action and fleeting facial expressions, use a lens that lets in a lot of light (designated f/2.8 or lower) so you can set a fast shutter speed and rely on ambient light, without flash.

In some ways, photographing kids is similar to photographing wildlife. You want to capture behavior in the field (or in a sports arena, on a playground, or on an auditorium stage), but you may be far away and unable to control your subjects' actions. Use a telephoto lens to reach close in and also visually separate kids from the background. When you're shooting a group, wait to snap your shutter until they're all concentrating on the same thing—say, a ball or another performer.

Once kids become aware of the camera, it can be hard to avoid getting big fake grins and goofy monster faces—if they don't utterly refuse to have their picture taken. For natural, unselfconscious photos of kids, get them moving.

SWING INTO ACTION

A great tactic with toddlers is to get them busy with an activity, then engage their attention briefly as you grab your shot. A swing set is a great way to catch the bright-eyed smile of a little one having fun. And its steady speed and predictable path gives your DSLR's autofocus system a decent chance. Aim for the spot where the swing's arc crests and it comes to a brief halt. Pan the camera slightly to let a cluttered background smear into blur—and zoom in on that blissful expression.

COAX A JUMP

Catching an older child or a teenager in an unguarded moment may be tough. Try encouraging him or her to move around to get those spontaneous moments. As with younger children, stick with natural light whenever possible, because flash can add hardness or contrivance to your photo. Want to give a picture of an older kid a sense of lingering childhood? Take a high angle and shoot downward, thus emphasizing the subject's face and making the body seem smaller.

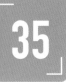

35

POSE A FAMILY PORTRAIT

BRING GENERATIONS TOGETHER IN A PICTURE.

SHOW SOME COMPASSION

Some of the worst family photos result from a flurry of snapshots at the dining table. Everyone's crowded uncomfortably at one end, grinning for the camera and hoping the ordeal will be over soon so they can eat. The usual on-camera flash flattens out faces (except when it emphasizes under-eye bags) and often blasts out the features of those closest to the camera.

Don't torture your family—or yourself, since you'll have more luck creating a group portrait that everyone loves if you photograph your relatives relaxing in comfortable positions. Coax them into a setting that allows them to interact in a genuine way. And instead of the dreaded flash, let natural light soften their features and build a warm, intimate mood. Look for ways to emphasize their cohesiveness as a group through positioning, mood, and even wardrobe, while at the same time showcasing differences in age, gender, or personality.

DIRECT YOUR SHOOT

Think of the story you're trying to tell, and let your choices flow from that. For instance, in the image at right, photographer Amy Perl wanted to emphasize generational differences, so she put the oldest and youngest next to each other. And offering a glimpse of the living room beyond the subjects supported the secondary theme of home.

As Perl did here, scope out which part of the house or yard enjoys the best light, and gather everyone there. Remove distracting clutter and make the location count by including visual elements, like a fireplace or Christmas tree, that say something particular about the family or the event. Use enough depth of field to capture the ambience, but if it draws too much attention, defocus the background slightly to keep the emphasis on your subjects' eyes. Don't dictate individual poses, but group your subjects loosely and allow them time for real interaction.

Put taller people in the center, and heavier people farther from the camera. (Try to keep any wildly patterned clothing toward the back, too.) Although most portraits work better when the subjects look directly at the viewer, having people look at each other can also be very effective—try it both ways.

CONSIDER MONOCHROME

Shoot in color—but when you process your images with software later, consider converting your family portraits into black-and-white. This conversion can bring clashing clothes into harmony for a more unified group portrait, and also infuses photographs with a timeless, classic feeling that will be right at home on your walls for years to come.

BREAKING IT DOWN

[1] **Use ambient light.** Shoot in diffuse (never direct) sunlight, either through windows or outside in light shade. When there's no sun, use ordinary household lamps to add a soft glow to the scene. Avoid on-camera flash at all costs. Instead, bounce an accessory flash off white walls or a ceiling.

[2] **Build a family circle.** Put the oldest member of the group in the center, with everyone else huddled close, not lined up straight.

[3] **Mix things up.** Don't stop at one or two shots. Move people around, encourage them to interact, and see what happens. Try lots of different angles.

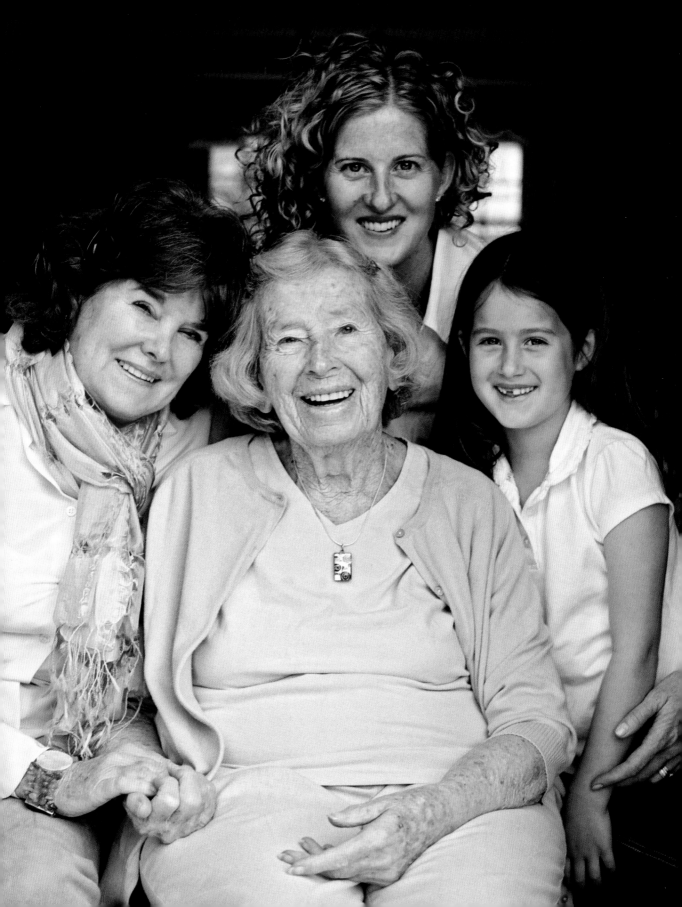

GO TO THE DOGS

TAKE YOUR TWO BEST FRIENDS—YOUR PUP AND YOUR CAMERA—OUT FOR A WALK.

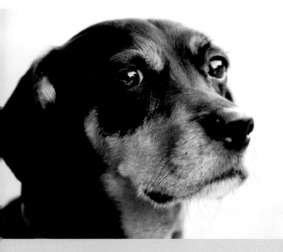

BREAKING IT DOWN

[1] Pick your day. The best conditions? Bright and overcast. Shadows soften, the color of the fur deepens, and you'll avoid glare. But to stop action without a flash, you need plenty of ambient light.

[2] Shoot at eye level. Whether you're taking action shots or portraits, your picture will be much more effective if you photograph from the dog's height.

[3] Limit depth of field. This helps eliminate distractions and hold the viewer's attention on your subject. You don't have to erase the background entirely, though—a sense of context can really help your shot.

[4] Focus carefully. The shallower your depth of field, the harder this becomes. Always focus on the eyes—if they're not on the same plane, pick the one that's closest to the camera. When you're going for action shots, use focus tracking; when you want close-ups, focus manually.

ENTER A DOG'S WORLD

The world of pet owners seems about evenly split between cat connoisseurs and dog devotees. But there's one arena in which the dogs definitely take it: They're much easier to photograph because they're more obedient and focus more readily—especially if you have tasty treats on hand.

CAPTURE SOME ACTION

Anna Kuperberg's frolicsome beach shot nailed a dog's playful agility as he looked back at his owner while trotting along the shore. As effortless as that image of canine joy and freedom feels, it took some preparation on the part of the photographer. She went for limited depth of field, which rendered the dog sharply against an out-of-focus beach.

If you want to catch your own dog in action, set a fast shutter speed of at least 1/500 sec. A long telephoto lens affords a sense of close-up intimacy without your having to be right in the middle of the action. And you can improve your chances of getting a sharp shot by using a camera with great focus-tracking capability (it can keep a moving subject in focus) and a fast continuous mode.

SHOW THE LOOK OF LOVE

To keep a dog looking into the lens, try pet-portraitist tricks—squeaky toys, treats, odd sounds that make ears go up and heads cock into adorable "what the heck?" positions. For the ultimate attention-grabber, hold a favorite treat by your lens to capture the pooch's full attention.

For the portrait of my dog Lilli on this page, I (your author and pet lover) set the camera and framed the shot as Lilli watched passersby in the park, then made only enough of a noise to get her to glance over without turning her head. A short telephoto macro lens, set to f/2.8, blurred out the background. And with a depth of field that shallow, shooting Lilli's snout at an angle kept it reasonably sharp.

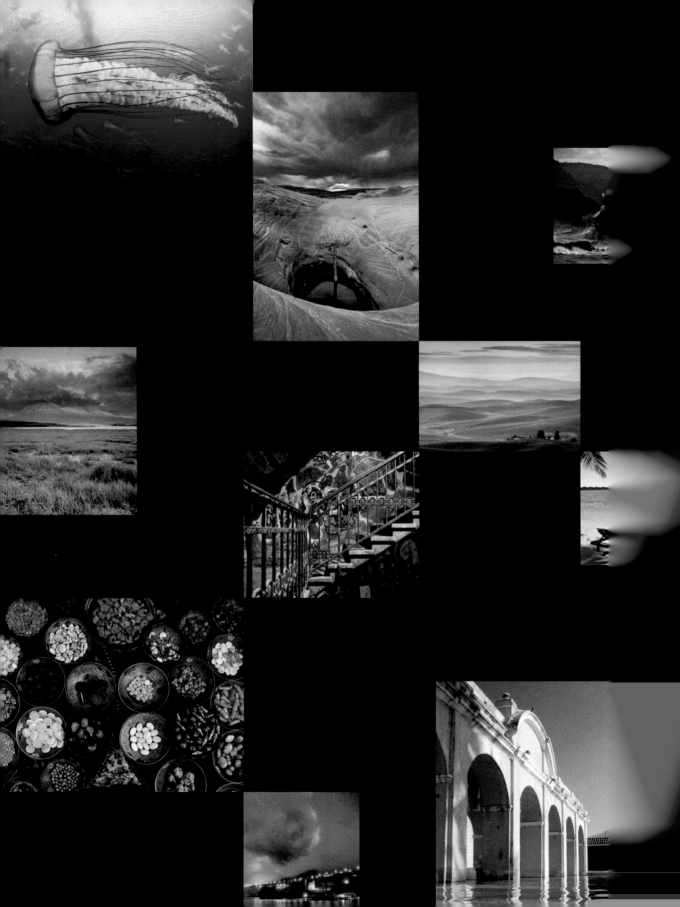

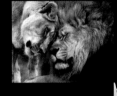
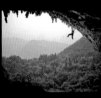

PLACES

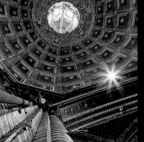

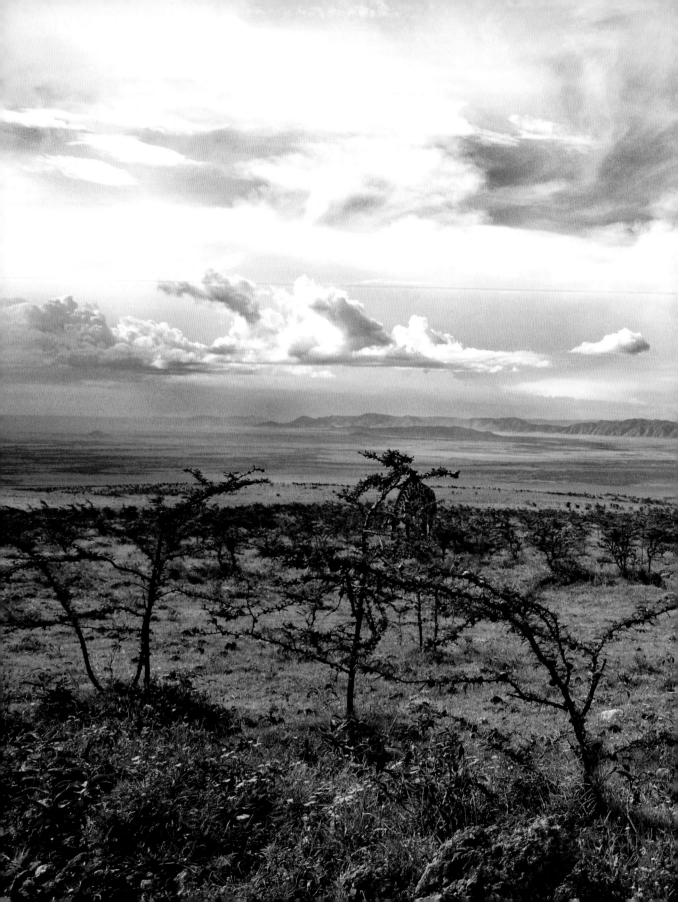

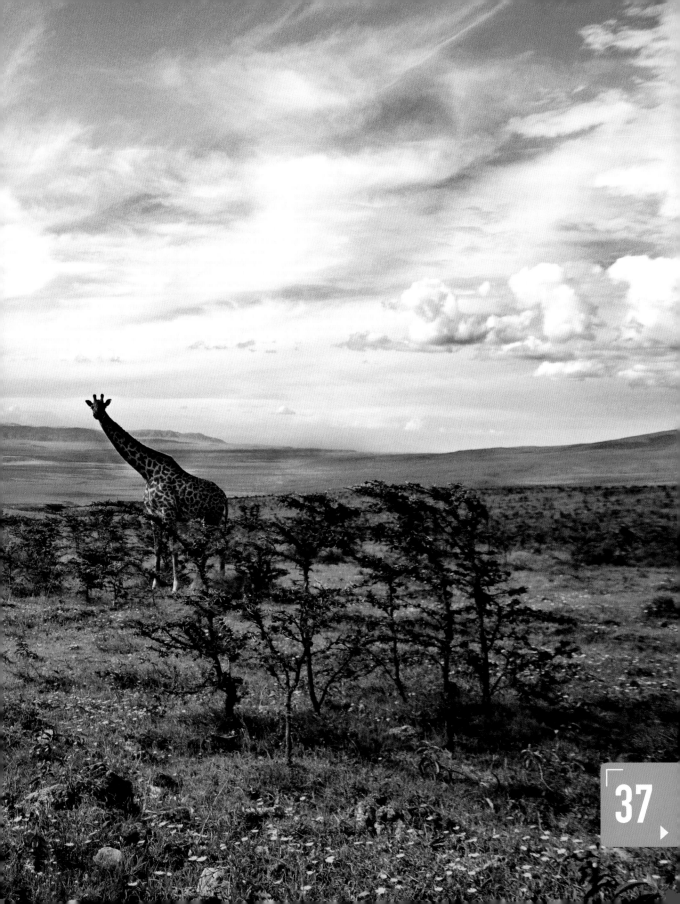

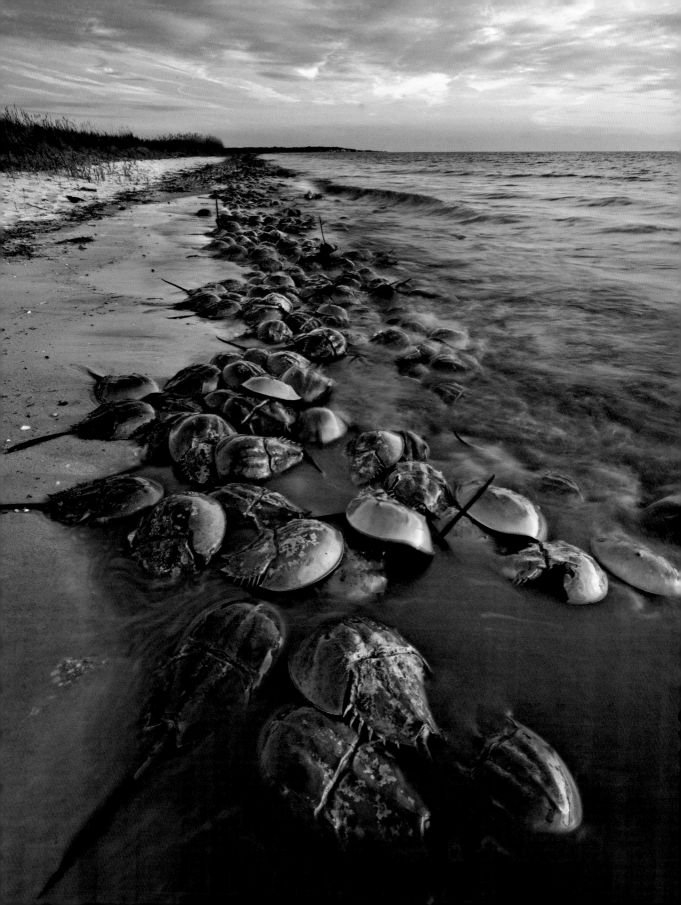

ENCOUNTER ANIMALS IN THE WILD

LET THE WILDLIFE AND THE LANDSCAPE WORK TOGETHER.

TELL A FULLER STORY

To convey the bigger picture of how animals live, step back and take a wider view of them grazing, hunting, or playing in their natural habitat. To get effective shots of wild creatures in the places they live, you'll need to blend elements of portraiture with principles of landscape photography.

Although some wildlife photographers prefer to have the sun overhead for close-up portraits of animals, with environmental portraits you're also shooting a landscape—and landscapes are better captured when the light's coming down at an angle. The magic hours around sunrise and sunset will give you the soft, slanted light that you need to separate the scenic elements with gentle shadows. This kind of light also brings out textures in the setting and your furred or feathered subjects.

How much of an animal's habitat you'll want to show depends in part on the story you want to tell. Is the animal engaging in interesting behavior that somehow depends on or even alters its environment, such as when a beaver is building a dam? How important to the picture is the time of day or the season?

Sometimes the season is everything, as in Ian Plant's photo at left, which shows horseshoe crabs spawning on Delaware Bay's New Jersey shore. He knew that those prehistoric creatures visited the same beach at the same time each year, so that's when he arrived on the scene with his camera. The very subtle motion blur of that long procession of animals, set against the sharp detail on the shoreline, gives the viewer enough clues to get a sense of just what those crabs are up to.

Planning is an essential part of many environmental shots of animals, but stay alert for happy accidents, too. Kyle Jerichow thought he had finished a shoot in Tanzania's Ngorongoro Crater when the driver stopped the Jeep to take a last look at the view. Standing up, Jerichow saw a pair of giraffes—and grabbed his camera to capture the scene on the previous page.

THE GEAR

Wide-to-normal zoom This lens will bring in all the surroundings when you need to show not just animals, but the places they live. But unless you can get close, the animal won't be all that prominent in the scene. And remember that with a wide-angle lens, you may not be able to get close enough to reveal wildlife in the foreground.

Telezoom lens Yes, you need a second lens, because when you're shooting wildlife, chances are you're going to want to get much closer than caution allows. And that's where a telezoom lens comes in—it has the length of a telephoto lens combined with a zoom's adjustable focal length.

Tripod When you break out the big lenses, steady support is a must. And tripods make things much easier if you have to wait a long time for a creature to creep into the sweet spot of your picture.

CONSIDER COMPOSITION

When shooting, keep the rules of composition in mind. Layer elements to preserve a sense of depth; look for leading lines, curves, and diagonals that will keep the eye moving through the frame; and keep your chief points of interest off-center. Rather than thinking of the wildlife as the subject of the photo, try treating it as one picture element that needs to work with the others in your scene. But, unlike a tree or a rock, an animal has a face, so you'll almost always have a better picture when that face is visible—preferably looking into the scene or at the camera.

ZOOM WAY, WAY OUT

For out-of-this-world perspective, grab a window seat the next time you fly.

SHOOT FROM A PLANE

Because they can hover, balloons and helicopters are ideal vehicles for aerial photography—but you can get great shots from a commercial airliner, too.

Although the image won't be as pristine or the view as clear as it would be if you were suspended without a window between you and the sky, you can still convey the soaring emotion of flying and show the peaceful beauty of the earth as captured from above. Shooting through the acrylic window can actually be a plus at times, since the slightly grainy or distorted quality may make your images more dreamlike.

Once you reach cruising altitude, set your camera to a fast 1/500 sec (1/1000 sec or faster on ascent or descent) to help compensate for the vibration of the plane, and focus manually. But you'll also have to deal with the light: If you have a rubber lenshood, press it against the window to block glare and reflections from inside the plane. A UV filter on your lens may also help temper the glare and haze at high altitude.

CAPTURE SOME CULTURE

DEPICT THE RICHES IN A MUSEUM, LIBRARY, OR OTHER EXHIBITION HALL.

MAKE ART OUT OF ART

Some people may think shooting artwork is "too easy." But it can make for compelling photographs—as can capturing the way people intersect with a visually dramatic environment.

Art museums aren't the only quasi-public places where you can play with this motif. Libraries, churches, and aquariums all offer a variety of photographic subjects. Look at the photos here, as well as the magnificent study of the New York Public Library's Main Reading Room by Peter Kolonia on the previous page. But before you shoot, make sure you know the rules, as many cultural centers restrict photography.

TAME THE LIGHT

Sun pouring through windows or a glass ceiling may overwhelm the exposure. Use a split neutral-density filter to tame the brightness up top and reveal dimension in the art, as Alexander Viduetsky did below.

For a mix of sun and ambient light, set a custom white balance using the most neutral tone in the scene (a white wall, for instance). Exposing for the highlights helped reveal the detail in my photo of the sculpture (opposite). A polarizing filter will cut glare for a clear view of things behind glass, as in this aquarium view by Mike Saemisch. If using flash, keep it away from the camera so it won't bounce back into your lens.

BREAKING IT DOWN

[1] Pack a few lenses. You'll need an ultrawide-angle to capture the whole room and a telephoto for distant details. If you don't have one zoom that will do it all, you'll have to bring two. Stow your gear in a small bag, belt case, or jacket pocket, because many public buildings prohibit backpacks and large bags.

[2] Find your position. Museum entryways are often designed to offer broad vistas of a grand hall. Take advantage and set up your camera there. And look for angles that let you comment on the scene by showing visitors interacting with—or ignoring—what's on display.

[3] Hold steady. Chances are you won't be allowed to use a tripod, though you may be able to get away with a monopod. So if the light is dim and you need to crank up the ISO, look for a chair, donation box, or other support to help you keep your camera steady. Nothing nearby? Become a human tripod as you handhold. Turn on the image stabilization in your camera or lens; lean against a doorframe or wall; tuck in your elbows; and hold your breath as you slowly press the shutter button.

ITALIA

SHOOT FROM ON HIGH

FOR A STARTLING PERSPECTIVE ON A SCENE, SCALE SOMETHING TALL—AND LOOK DOWN.

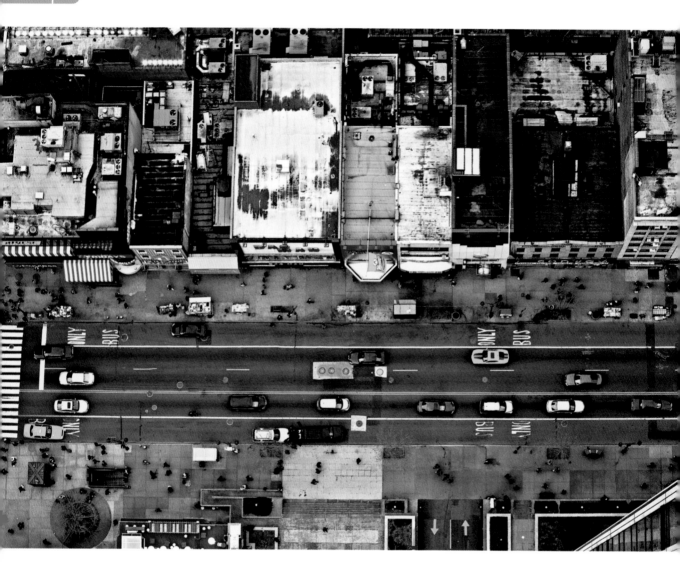

CLIMB UP ON THE ROOF

When it comes to extreme overhead views, it helps to have friends in high places. Thanks to a friend in the building's management company, *Popular Photography*'s Dan Bracaglia gained access to the roof of a Manhattan skyscraper (more than 60 stories up) to capture this shot straight down onto West 34th Street using a telephoto lens. The resulting grid of muted red rectangles and stripes, punctuated by surprisingly vivid pink, is vertigo-inspiring.

For a photo with a startling perspective like this, wrap your camera strap securely around your wrist and carefully hold the camera out over the edge or railing, pointed straight down. If the roofline allows, lie down for a more stable position, and always bring a friend to spot you. An articulated LCD screen that you can position to see while you're framing the shot will help. And turn on your image stabilization system to counteract your trembling hands.

Shooting from above flattens the scene below, making pattern, shape, and color pop in an otherwise collapsed space. It can offer a refreshing view that shines new light on the everyday, and even lend a sense of order to a chaotic or randomly arranged space.

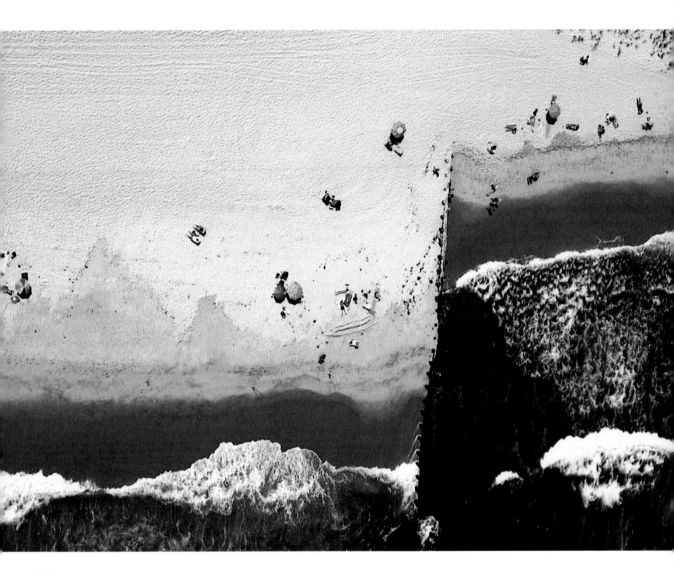

GO TO GREAT HEIGHTS

The farther above a scene you get, the more its elements melt into abstraction, making your photo a study in shape and color. Whether you're looking down from a cliff or a helicopter, you'll need a fast shutter speed to keep your picture sharp—and an artistic eye for framing. Look for echoing shapes, intriguing patterns, and contrasting hues.

Photographer Melissa Molyneux spotted this view of surf and turf while flying over the Jersey Shore. She framed her shot to keep the composition off-balance, snapping the moment the barrier fence broke the shoreline about one-third of the way in from the edge of her picture. She played by the rule of thirds on the opposite axis, too: The shoreline is about one-third up from the bottom on the left side, and one-third down from the top on the right. Diagonals and snaking curves in the waves and wet sand keep your eye moving through the scene.

SHOOT A THRILL RIDE

For high-energy images, capture the crazy curvatures and intense action at a theme park.

FREEZE THE FUN

A rollercoaster's dizzying gyrations. The stately grace of a carousel horse. The whirl of lights in the summer dusk. Where people, vibrant colors, and lights converge, you'll find plenty of fodder for fascinating photos.

To fill the frame with action, you'll need a wide-angle lens like the one Kevin Cantor used for this view at Busch Gardens in Tampa, Florida. With a shutter speed fast enough to stop the speeding ride (at least 1/500 sec), Cantor made time stand still. And the close crop of the spiraling tracks brings the foreground in so tight, it looks like the coaster is about to burst out of the picture.

To get amusement park photos this arresting, choose a ride and watch it run its course from different viewpoints. Note the climactic moments you'll want to capture, choose a perspective, and get your camera poised.

As the sun starts to sink and longer exposures are needed, let motion blur convey a sense of speed. You may not be able to set up a tripod in a crowded park, so bring a monopod or a flexible camera support or clamp.

DEPICT THE DESERT

FIND BEAUTY IN ROCK, SAND, SCRUB, AND SKY.

DISCOVER THE DRY

For a photographer, the desert is anything but empty. Even the most austere landscape yields rich opportunities for great pictures that draw on textures, shapes, colors, and patterns. Look carefully and you may even find wildlife to capture in dramatic close-up. Shoot on days when clouds ruffle the sky and seasons when desert wildflowers bloom, and you'll be rewarded with even more visual variety, as evidenced by Guy Tal's photos shown here. For your sake and the sake of your photos, avoid midday's strong overhead sun. The more angled light of early morning and late afternoon rakes the scene, bringing out the tones and texture of the dry land.

The key to successful landscape photos, especially when the land is flat and nearly featureless, is to pay attention to basic compositional rules—which are illustrated beautifully by Ian Shive's picture (on the previous page) of Monument Valley on the Utah-Arizona border. The slanted rock makes for a compelling foreground element, the buttes command attention at the center, and the cloudy sky adds drama to the top third of the picture: a classic example of the rule of thirds. The snaking curve of the road draws the viewer's eye into the heart of the frame.

The desert offers so much opportunity for a wide variety of photographs that you'll want to have as many different kinds of lenses with you as you can carry. Start with a telephoto for views of faraway formations. A macro lens will let you get detail shots of flowers and other surprising landscape details, as in the photo at near right. And an ultrawide-angle lens lets you take it all in.

Besides plenty of water, there are a couple of other practical things you'll want to take along on a desert photo safari. Bring a brimmed hat or an extra shirt for shielding the LCD or viewfinder so it's easier to see in bright light. And for cleaning sand off your lenses, a blower brush is better than a microfiber cloth, since it helps you avoid rubbing sand into the glass.

THE GEAR

Lenses Tote the biggest range of lenses that you can, from ultrawide to telephoto to macro.

Tripod A tripod will let you use the LCD for composition and ensure a straight horizon.

Filters Use a polarizer to cut glare, deepen the blue of the sky, and bring out cloud formations. And you'll definitely need split neutral-density filters to balance exposure of sky and land.

SHOOT A SKY SHOW

GO TO THE ENDS OF THE EARTH TO PHOTOGRAPH A HEAVENLY DISPLAY.

LOOK TO THE SKIES

A psychedelic concert spectacle put on by the Norse gods? Not exactly. But the aurora borealis (or the southern version of this polar phenomenon, the aurora australis) puts on an amazing show that lights up the night with swirls of colors caused by geomagnetic storms in the atmosphere. You're likeliest to see the lights by getting as close as you can to either of the poles during the colder months of the year. And if you can catch the lights, you can shoot them.

The primary photo gear you'll need is a wide-angle lens, a tripod, and extra batteries, because they drain fast in the cold. A cable or other remote release is also a good idea, since it will help you avoid jostling your camera with chilled fingers.

The lights are your glorious subject, but the surrounding environment is important, too. Framing your shot with some stationary element—a cabin, a stand of trees—in the foreground will anchor the composition and lend human scale to the eerie display. Or set up near water to capture the lights' reflection.

Set your camera's white balance to auto or daylight, and shoot in RAW so you can correct color later. Start with ISO 400, your aperture wide open (say, f/4), and a shutter speed of 30 sec. Play around, bracket your shots, and bear in mind that a shorter exposure will yield crisp shots that capture the structure of the lights, while a longer exposure will blur the lights into a glow and capture more foreground.

BREAKING IT DOWN

Check the almanac. The aurora borealis is linked to an 11-year solar cycle. During years of peak activity, you can expect more drama in the sky and visibility much farther from the poles than usual. For shorter-term predictions—as little as three days in advance—consult the National Oceanic and Atmospheric Administration at www.swpc.noaa.gov.

Consult a map. The phenomenon occurs along the earth's magnetic poles. Some good places to see the northern lights are Alaska, Canada, Sweden, and Norway. And if you're headed toward Antarctica to see the southern lights, head as far south as possible in places like Australia, New Zealand, and South Africa.

Get out of town. Avoid light pollution by getting as far from cities as you can. The farther you are from terrestrial lights, the brighter the celestial ones will shine.

LOOK UP AT INTERIORS

For inspiration, visit
a church, a capitol,
and other places with
elaborate architecture.

FIND THE DIVINE INSIDE

The classic way to shoot a building
with a domed roof is to position
your camera directly under the
center so that the dome fills the
frame. But other angles can also
yield dramatic results, as in Kah
Kit Yoon's photo of the cathedral
in Siena, Italy. Its energy comes
from the richness of the detail and
the column that thrusts up in the
foreground, its alternating green
and white stripes emphasizing the
deep perspective. It's so deep,
it almost gives you vertigo.

For a similar effect, look for
converging lines, interesting angles,
and inspiring natural light. Set the
white balance to daylight to keep
the sun coming in through the
windows neutral. A small aperture
will create a starburst effect
around lights and maximize depth
of field to pick up more detail.

The small aperture, dim
lighting, and noise-minimizing
ISO (80) required a long 5-sec
exposure—but tripods are banned
in some public spaces. So Yoon
put the camera on a chair and
set its self-timer to avoid jostling
it by pressing the shutter button.

45

SHOOT THE SHORE

GET A WIDE ANGLE ON COMPELLING SEASCAPES.

TIME YOUR TRIP

Before you head for the beach, check the weather report. Sunny and clear may be good for your tan, but not necessarily for your photos. For rich texture and color, shoot when there are at least some scattered clouds and avoid the middle of the day. That way, you can catch the golden light of late afternoon, the blue calm of early morning and twilight, and the red- and purple-tinged drama of sunrise and sunset.

As for equipment, a wide-angle lens is your best bet for capturing a compelling seascape. And use a polarizing filter to reduce reflections and glare.

COMPOSE A WATERY LANDSCAPE

Choose a focal point that anchors the scene—such as the beach chairs on the previous page—and compose around it. Make use of a curving shore and diagonal lines. Keep your horizon straight. And when it comes to framing key elements, follow the rule of thirds.

Consider how you'll want to depict the water. You may want to dramatize its power by capturing the spray of impact, or emphasize its soothing nature by smoothing out waves and ripples (below right). Use a fast shutter speed for the former, or a minutes-long one for the latter.

BREAKING IT DOWN

[1] Use a tripod. As with all landscape photography, a tripod comes in handy as you frame your image and strive to keep the horizon perfectly level. (Be sure to clean the tripod thoroughly when you get home.)

[2] Set your exposure. At sunrise and sunset, expose for the sky and bracket like crazy, from way overexposed to way under. You'll want plenty of options so you can get the most brilliant color.

[3] Balance the sky and shore. To preserve detail in the foreground, use a split neutral-density filter, since it will tame the brightness in the sky while allowing full exposure in darker rocks and sand.

[4] Get the bluest blue. For a rich sky and colorful waves, as in the photo at left, use a polarizing filter and shoot early or late in the day—but not when the sun is too low on the horizon, or the water will look dark, not blue. If you're using an ultrawide-angle lens, beware: A polarizer can produce odd dark banding in the sky.

DWELL ON DETAILS

Let your eye be enticed by abundance—then reduce your image to the evocative essentials.

CLOSE IN ON COLOR

Most shots travelers take of markets and other commercial spaces—middle-distance views of piles of goods—are underwhelming in their similarity. To transcend the trite and capture a market's exotic essence, drill down to the details.

What takes Dina Goldstein's shot of a Jerusalem market to the next level? The high-contrast hues and variety of textures are a great start. But what really holds it together is its balance of pattern and randomness, which creates a dynamic visual tension. Shooting from above turned the picture into a nearly abstract study in color, shape, and texture. The angle and tight focus strip away extraneous environmental information—while retaining a feeling of exoticism and excitement.

You can get this kind of shot whether you're in the souk in Marrakech or the supermarket across town. Scan the setting for details that create a compelling display or express the mood of the spot. Capture them from an interesting vantage point and you'll have a photo that goes way beyond a standard snapshot.

SHOOT A WATERY REFLECTION

FOR MORE POWER IN YOUR PICTURE, MIRROR A SCENE—OR DISTORT IT.

PSYCH OUT SYMMETRY

You may be tempted to build a centered composition that's neatly bisected where solid meets water. Resist! Instead, explore unexpected ways of framing, as in this photo by Matea Michelangeli. The vanishing point where the arches end is placed two-thirds of the way into the frame. And cutting off the building's reflection at the bottom of the image takes it from static to dynamic. Use a polarizer to enhance reflections.

FOCUS ON THE WATER

As a flamingo in a zoo bent in to take a drink, Miguel Angel de Arriba framed his shot to capture a swirl of reflected color and distorted shapes reminiscent of a Pucci-print fabric. He left just enough of the bird's head at the top of the picture to act as a visual punctuation mark and make the image easily comprehensible, but the rest of the photo is given over to near-abstraction. He popped a flash to intensify the flamingo's reflection.

There's a reason the reflecting pool was invented: It doubles the impact of a strong image. Whether perfectly still or ruffled by a breeze or a bird, broken by boulders or caught in a puddle, a watery reflection adds visual impact to a scene.

DOUBLE DOWN ON A SUNSET

The realization of Partha Pal's photo above, taken during monsoon season in West Bengal, India, was an exercise in planning and patience. It uses an undisturbed reflection to savor twice as much sunset. He arrived at the scene ahead of time, metered the light and set his focus to the distance, and then knelt down low for a water-level perspective. After spotting a cyclist down the road, he waited to click the shutter until the two-wheeled silhouette arrived just where he wanted to freeze it. To capture the reflection of a sunset or sunrise at the perfect moment, you'll have to know exactly where and when the sun will rise or set—information that's usually available. Arrive several minutes in advance to survey your scene, choose the perspective you find most compelling, and frame the shot. For a silhouette like this one, don't rely on chance—bring a friend to model.

DELVE INTO DESERTION

FIND INSPIRATION WHERE OTHERS FEAR TO TREAD.

VENTURE OFF THE BEATEN PATH

You arrive by bike so there won't be a car parked on the side of the road to signal your presence. A few hundred paces through the woods, you spot the fence that you'll jump over. You stash your bike in the shrubs and advance on foot with a backpack filled with camera gear, a cell phone, a powerful flashlight, and a first-aid kit (you never know!). Then you enter the neglected ruins of a long-shuttered building—yours to explore and photograph. This is how photographer Phillip Buehler approached the Greystone Park Psychiatric Hospital and the old Alcoa aluminum plant in New Jersey shown here.

The melancholy allure of abandoned structures is undeniable. Photographers help preserve and document these places—from celebrated ancient ruins like the Roman Forum, to the Salton Sea relic on the previous spread (captured by Steve Bingham), to the contemporary decay of deserted urban buildings.

Trespassing can heighten the excitement of such expeditions, but you don't necessarily have to scale fences. Try incorporating a barricade into your shot. If you decide you want to de-emphasize or obliterate an obstruction, try manually adjusting the focus far beyond the fence. If there's a caretaker or guard on site, ask for permission to photograph. And remember, many historic ruins are open to the public for at least a few days a year.

When you're shooting a touristy site, be it the Acropolis or Alcatraz, you'll have to do some planning to keep people out of the frame so they don't undermine the atmosphere of moody emptiness. Arrive early, stay late, and visit on days when the weather is bad. Scope out angles that cut others out of the scene. On a bright day, use a neutral-density filter to reduce the amount of light that comes through your lens so that you can shoot longer exposures, because if you keep your shutter open for ten seconds or more, passersby will blur into ghosts or disappear from the scene altogether.

BREAKING IT DOWN

[1] **Steady your shot.** In an abandoned hospital or factory, you may need a long exposure to capture the rich details of peeling paint and crumbling walls in dim natural light. Used with a level, a tripod will help keep building lines straight. And by slowing you down a little, it may spur you to consider compositions more carefully, instead of snapping everything you see.

[2] **Shoot with a wide-angle lens.** To give your images a sense of context and draw viewers into the scene, you'll have to fit as much of the space as you can into the frame. Watch out for distortion, though, especially at the edges—you don't want the walls to lean in (unless they actually lean in). Keeping your camera level instead of tilting it up or down will help keep buildings squared off.

[3] **Leave the site undisturbed.** To respect the space and future visitors, your photos should be all you take home with you.

PHOTOGRAPH A CASCADE

SHOOT THE LIGHT, MOVEMENT, AND MAGIC OF A WATERFALL.

FOLLOW FALLING WATER

Whether you're shooting Niagara Falls or a slender cascade you happen on during a hike, waterfalls can be one of the most captivating and romantic photographic subjects in the natural world. Go early or late in the day to avoid glare—because when sunlight falls at an oblique angle, it's far more likely to create rainbows in the mist.

Let the shape of the falls determine whether you frame horizontally or vertically, accentuating width or height, respectively. If you can get there safely, sometimes the best perspective is from a distance at midstream. But since many waterfalls are in narrow gorges or places where it's hard to stand back far enough to take in the whole scene, a wide-angle lens will allow you to include everything you want in the frame—even if you can't put a lot of distance between yourself and the cascade. As you frame your shot, scout out angles and look for a vantage point that will give you foreground elements such as flowers or ferns, as well as middle ground features like rocks or trees to lend a sense of depth.

SHOW THE FLOW

As you start shooting your images of falling water, you can alter the effect by choosing to isolate and reveal the powerful spray of droplets or letting individual rivulets melt into flowing, misty ribbons.

To get a kinetic shot that captures every droplet splashing off the rocks, set your shutter to 1/500 sec or faster. Alternatively, to make the flowing water seem to blend into a taffy-smooth flow, as in these photos by Mark Adamus (and as many photographers tend to prefer), mount your camera on a tripod, and set a shutter speed of between ½ sec and 5 sec or even longer, depending on the velocity of the flow.

Especially on bright days, neutral-density filters may help slow the flood of light into your lens, compensating for the slow shutter speeds you'll have to use for such a shot. Keep experimenting until you manage to catch your ideal of cascading perfection.

THE GEAR

Tripod This is crucial for the slow shutter speed you'll need to create smooth ribbons of water.

Wide-angle lens You'll capture the entire scene (including the foreground elements vital for depth) even if you can't pull back far from the falls.

Polarizing filter As in other watery situations, these filters reduce glare.

Neutral-density filter You'll reduce the amount of light that is let in through your lens, allowing you to keep the shutter open longer.

Rain gear Protect your camera from spray and mist by covering it with a rain hood—and consider bringing a poncho for yourself.

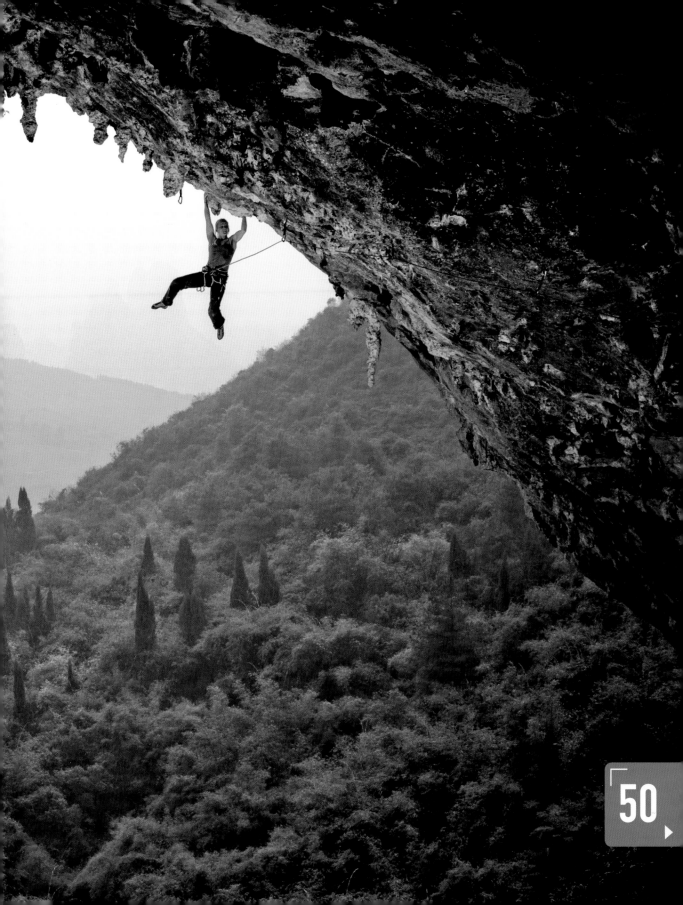

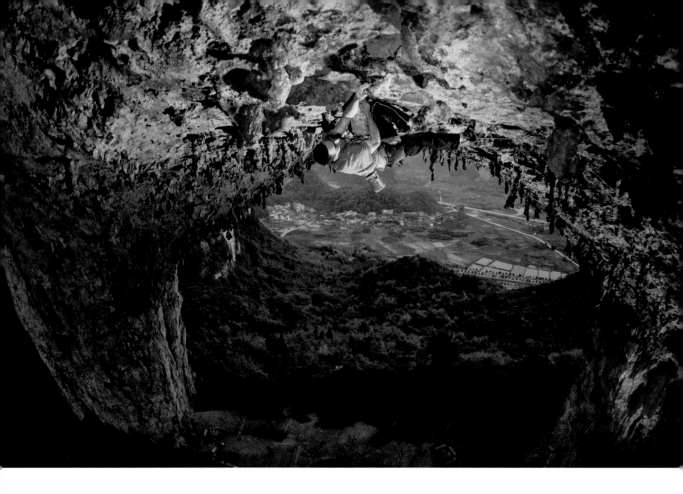

50

CAPTURE OUTDOOR DRAMA

HIGHLIGHT SUBJECTS GRAPPLING WITH THE GREAT OUTDOORS.

LET THERE BE LIGHT

When you shoot people dangling from rocks and cliffs, their athletic postures are just as important as the daunting topography. If you want to catch both, you'll need to use accessory lighting—as Tim Kemple did in these photos of climbers, including the riveting shot (previous page) of Emily Harrington at Moon Hill in China. Off-camera flash will also come in handy when you want to illuminate foreground objects such as flowers and boulders—or put a twinkle in an animal's eye. Another bonus of adding light is that it lets you set a faster shutter speed to keep your subject sharp.

Use a subtle hand, though, to highlight key elements without overwhelming ambient light and making nature look like a stage set. Set your flash low—when you meter it, the output shouldn't be more than one stop above the natural light. If your flash throws a shadow, direct a less-intense light into the shadow (a fill light) to erase it. Headed deep into backcountry? Instead of strobes and heavy battery packs, bring along small accessory flash units, light stands, and remote triggers. Reflectors will also amp up the light without weighing you down too much.

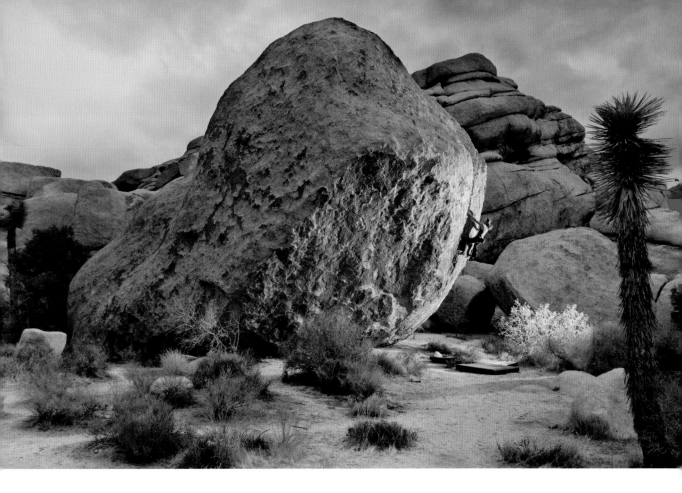

BREAKING IT DOWN

[1] Find the right site. To give a photo depth, don't forget to look for intriguing shapes in the background as well as the foreground.

[2] Place your main lights. Put them in a spot that will accent the action, as Kemple did by placing two flashes on a single stand (A) low and to the right of the camera, just out of the frame.

[3] Place the fill lighting. Kemple put two more flash units, again on one stand (B), down low and to the left, aimed at the cliff walls. These he set to half power and zoomed out to their widest.

[4] Work with ambient light. Meter your background and set your lights to work with the natural light. Use manual mode to gain more control over the exposure—and make sure not to exceed your camera's flash sync speed, which can throw part of your frame into darkness.

REIMAGINE A MONUMENT

Photograph an iconic scene in an unexpected way to capture more than just a cliché.

GO BEYOND GOLDEN

Anyone can get a great picture of a classic building, monument, or landscape—they're icons because they're so visually striking. But how do you work something as familiar as the Golden Gate Bridge into a composition that communicates your unique perspective?

Take these images as inspiration to come up with your own twists on monument shots. Show it from an unusual angle or in dramatic weather. Or add a new element to the scene, such as passing planes or crashing waves.

Plan ahead to capture a monument during a special event or phenomenon. Follow the lead of Ed Callaert, who wanted to show the full moon rising at sunset in precise alignment with the bridge and the Transamerica Pyramid, as shown in the top right photo. The moon hits this mark just once a year. On that evening, he set up his tripod in the right place to catch it (the ferry provided an unexpected bonus). Challenging? Of course. But you're not just a tourist—you're a traveling photographer.

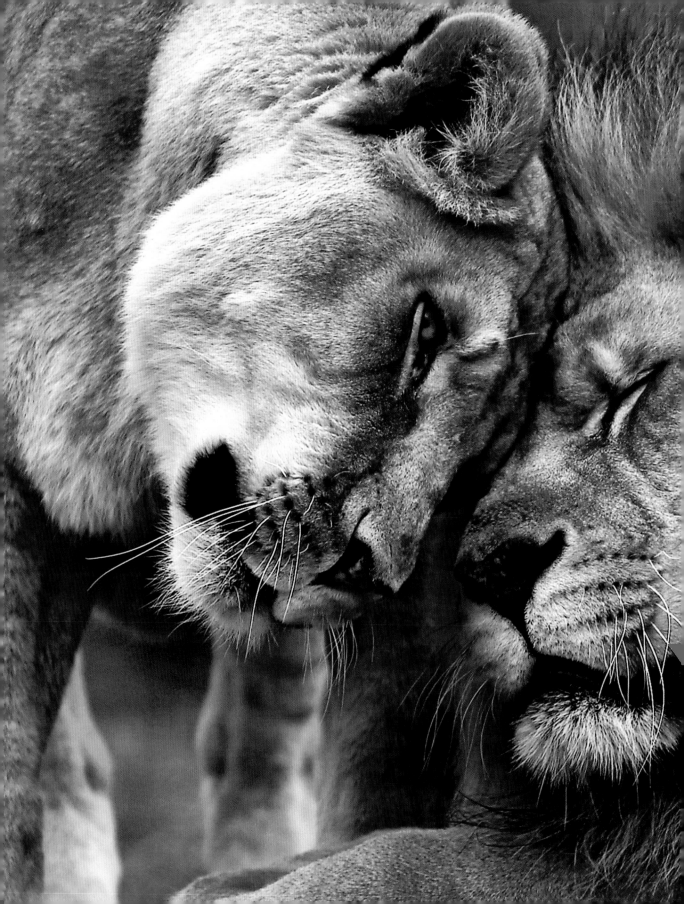

ZOOM IN ON A ZOO

MAKE PORTRAITS OF WILDLIFE—WHILE SKIPPING THE SAFARI.

TAKE IT FROM THE PROS

Wildlife photographers don't always take pictures of animals in their natural habitats. For close-up portraits and shots that capture the poignance of captivity, many pros head to the zoo. To get pictures as effective as these, you'll need to follow their most important rules: Plan carefully and leave your family at home.

Timing's important. Try to avoid vacation crowds and field trips. Remember that animals tend to be most active first thing in the morning—and everyone perks up at feeding time. Photograph creatures during mating season for dramatic behavior, big antlers, or vivid plumage. Then return after the young are born, to shoot affectionate family portraits.

Choose just a few exhibits or animals that you want to photograph and spend a few hours at each. Many zoo animals walk the same paths repeatedly, which will give you an opportunity to plan your shots and consider the light. Avoid animals that seem bored and listless, or catch their attention by jangling keys. If you want to make your photos look as though they were taken in the wild, zoom in close or choose exhibits with good natural light and authentic-looking habitats.

BREAKING IT DOWN

[1] **Pack for the day.** Bring your DSLR and a spare battery, a long telephoto lens (at least 300 mm), a midrange zoom, and a wide-angle lens—though that's the one you'll use the least. Also pack a tripod, a rubber lenshood (and glass wipes) so you can press your lens up to glass walls, teleconverters for extra lens reach, and an accessory flash.

[2] **Set your camera.** Use continuous shooting mode and the highest possible frame rate to catch fleeting facial expressions and body language. Unless the light is very bright, stick with ISO 400 to allow faster shutter speeds. And use a fairly wide aperture to help blur out telltale zoo details with shallow depth of field.

[3] **Focus on the eyes.** As in any portrait, the eyes are your subject's most important feature. A flash can help retain a sense of animation by adding a gleam to the eye, as long as it's subtle and does not disturb the animal.

GET TUNNEL VISION

Venture through a tunnel and find more to shoot than the light at its end.

ENTER THE VORTEX

Whether in a photograph or on film, concentric semicircles and streaks of light draw you deep into a scene, giving a sense of motion and gaining momentum as the lines converge. And tunnels are the perfect place to capture that potent effect.

Lowell Grageda harnessed that power with this shot from inside a Shanghai commuter train. He used a wide-angle lens to fit the full width of the tunnel into his frame, while a long exposure (1/3 sec) turned the arched rows of lights into stripes as the train hurtled by. The image's lack of symmetry adds to the impact.

You don't need to shoot from a moving vehicle in a dark tunnel to get this effect. If you're on foot, mount your camera on a tripod, keep the shutter open for a minute or more, and trace arcs along the tunnel's walls and ceiling with a flashlight. In fact, you don't even need a tunnel. Explore the compositional possibilities of long, arched spaces wherever you go: an airport's jetway, a mall's escalator, even a park's tree-sheltered path.

54

CATCH SOME NIGHT MOVES

TO KEEP A NIGHTSPOT SCENE AUTHENTIC, STICK WITH AVAILABLE LIGHT.

GO FOR THE GLOW

What do we love most about our favorite places to hang out? Chances are, it's the atmosphere. Whether it's classy or kitschy, that ambience is a result of a carefully considered (or charmingly chaotic) combination of elements such as colors and textures. And because the most important element is the lighting, when you're trying to photograph the vibe of a place, you'll want to work with the light that's there.

MAKE THE MOST OF LOW LIGHT

To shoot photos that reflect the true atmosphere of a bar or restaurant, look for unusual points of view, experiment with every shot, and turn off your flash. Shooting with only ambient light means that you'll have to shoot at a slow shutter speed, open your camera's aperture wide, or boost its sensitivity with a high ISO. If it's a really dark dive, you may even want to do all three at once.

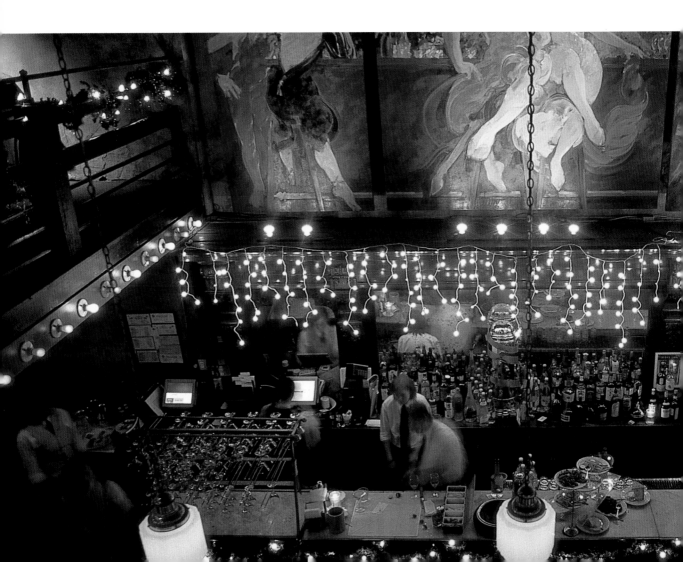

Consider not just the light, but also the elements you want to highlight in your photographs. If you aim to capture people's faces, you'll need a reasonably fast shutter (at least 1/60 sec). But bear in mind that you'll lose depth of field, and the high ISO you'll need may give you graininess or other noise in the shadows.

If you want deeper focus, the shutter will have to stay open long enough to blur motion. The effect can be kinetic, as in the shot below, or ominous, like at right, where the figure looks like a passing ghost.

Mixed lighting, especially with both sun and lamps, can be tricky. Start with your camera's white balance on auto. If the resulting pictures seem too yellow, change the setting to tungsten; if it's too cold or blue, go with cloudy or even sunny for a little warmth.

BREAKING IT DOWN

[1] **Balance light with dark.** To keep some atmospheric darkness in a scene, underexpose slightly, either through your manual settings or by using exposure compensation.

[2] **Support the camera.** Use a flexible or tabletop tripod. No tripod? Steady your camera on a chair or bartop, and if you're handholding your camera, brace your arms against a railing or the edge of a table.

[3] **Master the art of noise.** Up your camera's sensitivity, but set it below the point where image noise becomes a problem. Every camera model reaches this level at a different ISO, so know your gear—as well as your own tolerance for noise.

[4] **Match exposure to your subject.** To capture more of the scene and render people as ghosts, use a small aperture (f/8 or f/11) with a long shutter speed (as much as 5 sec). For a portrait or a close-up of food or drink, use a faster shutter and a wider aperture. Shooting in aperture- or shutter-priority mode will let your camera's light meter make the trade-off. If you want to refine the look, use exposure compensation.

[5] **Focus manually.** In dim light, your camera's autofocus may be unable to lock on focus. When that happens, switch your lens to manual mode and do it by eye. You can do this more easily if you use your LCD's live-view feature, which lets you zoom in on a detail in the scene to focus.

SEE THE FOREST AND THE TREES

GET LOST IN A CLASSIC SUBJECT.

EXPLORE NATURAL ENCHANTMENT

Why do so many fairy tales unfold deep in the woods? Maybe for the same reason that forests make great photos. There's mystery in the dappled light and shadows, startling beauty in silvery spring and vivid autumn leaves, and poignancy in bare branches and gnarled roots. If you zoom in with your camera, you'll discover that each tree has its own details that create character. And if you pull back, you'll see the forest's enticing patterns and swaths of color. Once you start photographing trees, you may never get enough.

Not that taking photos in the woods is easy. Sure, the photographic possibilities seem endless, but you'll often find yourself limited by tight spaces and challenged by the light—or lack of it. Plus, backlighting can cause color fringing (distorted bands of color along borders where bright and dark areas contrast) and other imaging oddities in areas of fine detail. But there are ways to avoid those issues so you can capture a forest's quiet magic.

THE GEAR

Tripod You must keep your camera steady for long exposures and bracketing shots. And a tripod will come in handy for capturing flowing water if you happen upon a waterfall or stream.

A full range of lenses Use a wide angle to snag the big picture (but beware distortion at the edges, which is much more noticeable with vertical subjects like trees). A long telephoto lens can isolate patterns, shapes, and colors in the forest. And bring a macro lens for close-ups of bark, lichen, wildflowers, and other small subjects.

Polarizing filter Never go to the woods without one—it will cut the glare from green leaves and deepen blue skies on bright days.

First, consider your available natural light carefully. Every forest has times of the day when the light is best, and that varies with the density of the trees and foliage. Sometimes, as in the photo at left, bright, slanted sunshine is what makes a shot, highlighting the contrast in texture between tree and rock and illuminating the leaves' delicate hues. To avoid the flare produced when sun strikes the lens, you might want to set up your tripod in a shady spot, and always use a lenshood.

Factor in—and take advantage of—weather. The even light of cloudy days lets you shoot at any time. It also makes it easier to explore the details of bark and mosses, and colors both soften and stand out against the gray background of clouds or fog. On windy days, use a long exposure to let the motion of swaying trees smear into impressionistic daubs of color.

Pay attention to the direction of shadows and consider incorporating them into your composition, as David Clapp did in the springtime scene on the previous page. The picture is immeasurably strengthened by the strong diagonals of shade.

WARM UP THE SCENE

A canopy of green leaves can emphasize the cool colors in a scene and lend a blue tint. If you want to counteract this effect, switch your camera's white balance to cloudy. And when setting your exposure, lean toward the bright side, opening up the shadows and letting highlights blow out if you must. To keep your ISO and aperture low, you're likely to need a slow shutter speed—say, 1/15 sec or more.

To increase the odds of success in challenging lighting situations, bracket your shots—that is, take the same picture at various exposures. You can also try using high-dynamic-range (HDR) imaging (which combines multiple exposures to achieve a photo in which each element is properly exposed) either through in-camera settings or by combining bracketed images using software. HDR gives you a much broader range of tones in your picture—just use a subtle hand.

TAKE IT ALL IN

A FISHEYE LENS IS ALL YOU NEED TO CREATE BOLD DISTORTIONS.

BEND REALITY

The singularly wide—and convex—images on this spread were all taken with a fisheye lens. These special optics give you a ridiculously wide 180-degree angle of view, along with a healthy dose of barrel distortion for intriguingly bowed lines at the edges of the frame.

The extremely wide view that a fisheye lens affords makes it a natural choice for capturing huge spaces. And the fisheye's distortion will add a new twist to architectural shots, as shown in the photos here. But if you want the wide view without that distortion, get far away from your subject, ensure that you have no vertical lines in the foreground, and place the horizon line dead-center in the frame. You'll have a perfectly straight—and very sweeping—landscape.

Moving from the landscape to the tabletop, a fisheye lens creates cool close-ups because it exaggerates the size of objects as they get closer to the lens. And you can come in very close indeed—some fisheyes render sharp images of things just millimeters away. Photograph a cathedral gargoyle from that close range, and it will seem to be all nose and teeth—an effect with obvious comic possibilities.

BREAKING IT DOWN

[1] Choose the right lens. For a round image, use a circular fisheye lens. But make sure you factor in the size of your DSLR's sensor. If your camera has a smaller APS-C–sized sensor, a circular fisheye made for a full-frame camera will have its image cropped into a rectangle. If you're after a rectangular image, use a so-called full-field (or diagonal) fisheye, which will work on any DSLR.

[2] Get down low. By exaggerating the foreground, you'll make a towering subject loom even larger and the earth seem disconcertingly concave.

[3] Hold the center square. The closer elements in the scene are to the center of the frame, the less distorted they'll be. Use this space to give your viewer's eye a break or to show crucial elements clearly.

[4] Stay away from people. Human subjects will look fine in the distance, but fisheyes aren't flattering for up-close shots of people.

[5] Lean forward. Check the bottom of the frame each time you take a shot, because the angle of view is so wide you risk catching your own feet!

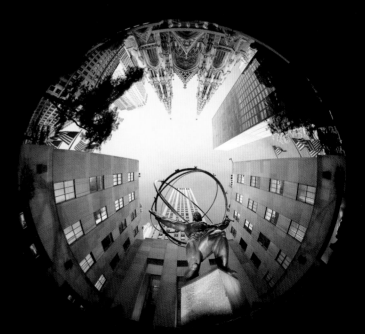

RIDE THE WAVES

CAPTURE AN ICONIC SURF SHOT—WITH OR WITHOUT THE BOARD.

MAKE MAGNIFICENT WAVES

To capture crashing surf against a rocky coast, your best—and safest—vantage point is from the beach. If there's a rock or jetty jutting into the water, get out on it so you can capture the full shape of the wave by shooting perpendicular to the break.

Use a telephoto lens to bring you closer to the action. The long focal length will also compress the apparent distance between far-off elements in the background and reduce depth of field, creating a defocused backdrop against which the breaking wave will stand out in sharp, luminous relief.

Some more wave-enhancing tips: Exaggerate a breaker's height by setting your tripod low to the ground. Use the strong sidelighting of early morning or late afternoon to make the water glow with the sunlight pouring through. To freeze the wave at its peak, shoot at a shutter speed of at least 1/250 sec. A polarizing filter will help cut the glare off the water. Guard your gear against corrosive salt spray and sand by using a protective UV filter on your lens and a rain hood over your entire camera. And finally, clean your tripod thoroughly before putting it away.

You don't have to get wet for a photo that captures the ocean's mythic power. But to bring your viewers into the barrel of a wave, you'll have to take the plunge— and you'll have to bring your camera with you.

GO INTO THE TUBE

For killer shots straight into the barrel of a wave, you and your camera will have to take to the sea, so you'll need a waterproof compact camera or an underwater housing for your DSLR and lens. Before you wade in, attach your gear to your body with the same type of wrist straps that surfers use to tether their boards, because if you get socked by a wave, you'll almost definitely drop your camera.

When you're shooting, fill the frame with rushing water by using an ultrawide-angle lens—or even a fisheye—and holding your camera close to the waterline. Not only does this technique allow you to capture the full body language of a surfer riding a wave, but it can also be a great way to make a tube that's too small to surf on look powerful, magnifying its visual impact.

As with any complicated shot, the best teacher is experience. The more you pick up about surfing and the way the water breaks on the particular stretch of shore you're shooting, and the more you practice, the easier it will be to catch both waves and surfers at their peak.

SHOOT THE CITY

CREATE DRAMATIC CITYSCAPES BY DAY AND NIGHT.

WALK THE METRO BEAT

Cities offer photographers a dizzying range of modern landscapes: from uplifting to gritty to bizarre. As you pick your subjects and frame your shots, focus on the things that compel your eye, whether you're drawn to urban beauty, as were Alex Fradkin (who shot the building disappearing into fog on the previous page) and Jay Fine (who shot the figures silhouetted against the window, also on the previous page), or to the seamier side of city life. Whatever your particular vision, there are some tips to keep in mind as you set out to shoot the classic elements of cityscape photography: striking architecture, bright lights, and the way big buildings dwarf the human form.

PICK THE PLACE AND TIME

As with landscape photography, avoid shooting at midday, when colors will be washed out and patterns muted. The slanted sunlight of early morning and late afternoon will enhance the textures of structures, bringing out sculpted and painted details and the building's materials themselves. Experiment with training your camera on details like the mica sparkling in a concrete sidewalk, or the shadows running along a windowsill. If you're more interested in sweeping views than vivid details, shoot from bridges, rooftops, or the observation decks of tall buildings.

GO VERTICAL

Since we spend most of our time focused on what's happening at street level and we forget to look up, a photograph that captures a vertical perspective can be surprisingly effective. Turning your camera 90 degrees will let you emphasize a skyscraper's height and depict the upward progression from the gutter below to the penthouse high above.

COME BACK AT NIGHT

Try shooting at dusk, especially after a rain: Wet streets will reflect colorful lights and add more vibrancy to your shots. And when the sun dips below the horizon, the city lights up in all its electric glory.

When you're shooting shady or dark spaces or blurring city lights, you'll have to find a way to steady your camera for low lights and long exposures. If you can't set up a tripod because of spatial restrictions, try clamping your camera to a railing, setting it on a ledge, or mounting it to a flexible tripod and wrapping that around a lamppost or a flagpole—which is how Fradkin got his fog shot.

When you can't do any of those things, engage the image stabilization system in your camera or lens. That's what allowed Philip Ryan to get the handheld shot of a Berlin stairwell on the previous two pages with a 1/15-sec exposure, despite the meager sunlight coming in.

BREAKING IT DOWN

[1] **Choose a direction.** For white streaks, look toward the cars' headlights; for red, their taillights. Place yourself above the action to keep the lights from shining right into your lens.

[2] **Support the camera.** Use a tripod or very steady flexible support (which you may be able to attach to a railing).

[3] **Set a small aperture.** Keeping your f-stop near the smallest your lens offers will create starbursts from city lights and allow long shutter speeds.

[4] **Experiment with speed.** How many seconds to leave your shutter open depends on how fast traffic is moving, how long you want the car trails to be, and how much ambient light there is. You may need anywhere from 4 to 30 sec.

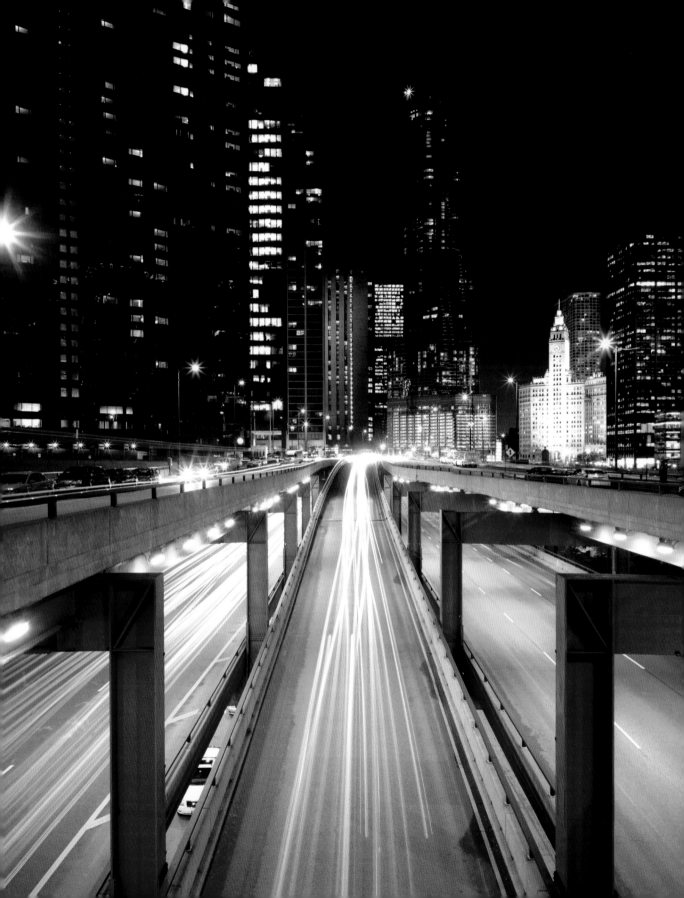

FRAME A PERFECT SHOT

Use some old-school composition to capture landscapes bathed in magic-hour light.

FOLLOW THE RULES

No rule is sacred—especially a photographic one. But sometimes following them yields spectacular results, as in this perfect dawn landscape taken by Chip Phillips at Steptoe Butte in the Palouse region of Washington state.

The undulating beauty of this photograph demonstrates the power of the rule of thirds. The top one-third of the frame belongs to the sky, the pastel midground occupies the central third, and the deep green foreground anchors the bottom third. The farm buildings—the central point of interest—are framed about one-third of the way up and about one-third of the way in from the right side of the photo.

A trick to making a landscape dynamic is to include a snaking line of road or ridge to lead the eye through the image. You'll increase your luck by using the same tools that Phillips did here: a tripod, a wide-angle lens, and a split neutral-density filter to balance the bright sky and considerably darker foreground.

CATCH THE MAGIC HOURS

PHOTOGRAPH GLITTERING SKYLINES AT DUSK AND DAWN.

SHOWCASE CITY SHIMMER

Most of the time, we experience the lights of a city in stark contrast to the black of the night sky. Yet midnight is not the best time to take a photograph of city lights, since a completely black sky can flatten a photo and rob it of nuance. Instead, skylines often come off best when they're set against the hues of dawn and twilight. Even scenes as colorful as Times Square or the Las Vegas Strip shine brighter against a backdrop of streaky pastels or deep velvety blue, since subtle colors add a sense of depth to your picture.

BREAKING IT DOWN

[1] **Scout your spot 24 hours before.** Visit the scene at the same time as your planned shoot. Make sure that you can set up a tripod and that the sunset or sunrise and moon are in good places for your composition.

[2] **Set up before the main event.** Mount your camera on the tripod, choose your focal length, and set your focus manually—before the sky starts changing color.

[3] **Use aperture-priority exposure mode.** Start by setting the lowest ISO on your camera and an aperture that will give you enough depth of field. For a starburst effect, narrow the aperture to f/11 or smaller; get cleaner lights at f/5.6 or wider.

[4] **Expose for the colorful sky.** Aim your camera at the sky while you meter. Setting your shutter speed according to this reading will prioritize exposure of the sky, making the most of its vibrant colors.

[5] **Shoot remotely.** Use a cable release or self-timer. You'll have as little as 10 minutes with lots of color in the sky, so make every minute count.

For evidence, take a look at Frank Melchior's dazzling shot of Seattle's Space Needle. It shows how a little light and an unexpected composition take a photo into new territory—but you need a plan.

First, don't settle for a static skyline marching straight across your frame—you'll get a much different photo if you frame the skyline behind a distinctive foreground element. Try to pick one that adds both visual interest and a layer of meaning specific to the place in your picture—a string of red paper lanterns above Hong Kong, or a tower of the Golden Gate Bridge framing a San Francisco moonrise. Knowing a city's topography well will help you find that perfect vantage point. To get his unique perspective on the Space Needle, Melchior drove to Queen Anne Hill in Seattle at 5 a.m. to capture the view through a public sculpture by Doris Chase—a composition he'd been pondering for some time.

GET PICTURE-PERFECT TIMING

To catch a colorful sky with just a tiny bit of light, aim for the ten minutes before and after sunrise and sunset. For the rich blue of twilight, that means just before dawn or just after the sun dips below the horizon. Since you have such a brief window, stake out your spot, mount your camera on a tripod or other secure support, set your focus and baseline exposure in advance, and turn on your camera's bracketing function so you get a wealth of shots to choose from.

Now think about the details. Do you want to capture starburst-shaped highlights? Then shoot at a smaller aperture, such as f/16. If you prefer softer, larger lights, then go with the biggest aperture you can.

Make these decisions early to avoid wasting precious moments. Or get some help from your camera by shooting in aperture-priority or shutter-priority mode: As you change your f-stop or shutter speed, the camera will adjust the other settings.

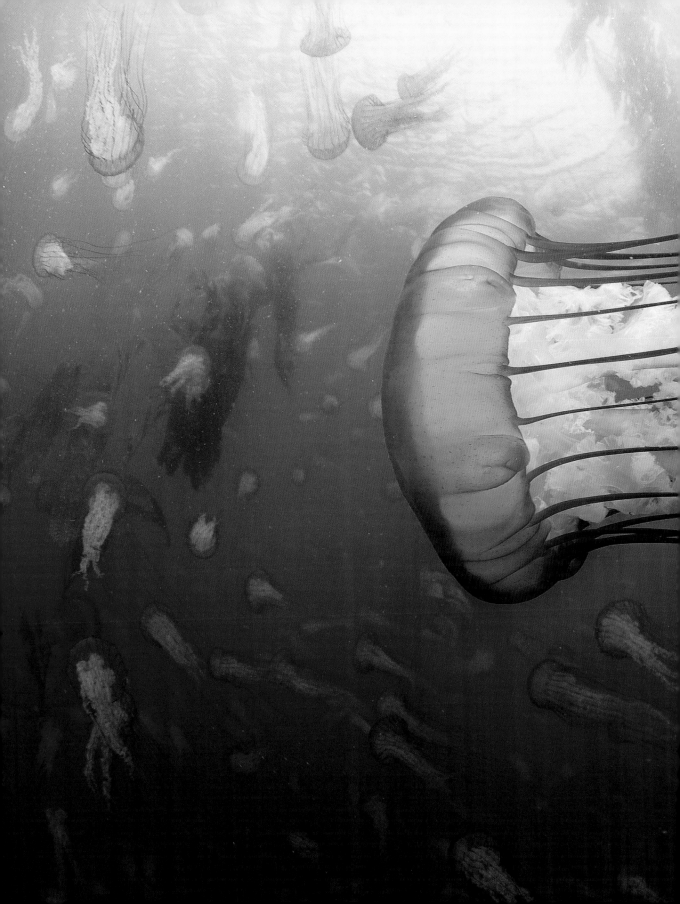

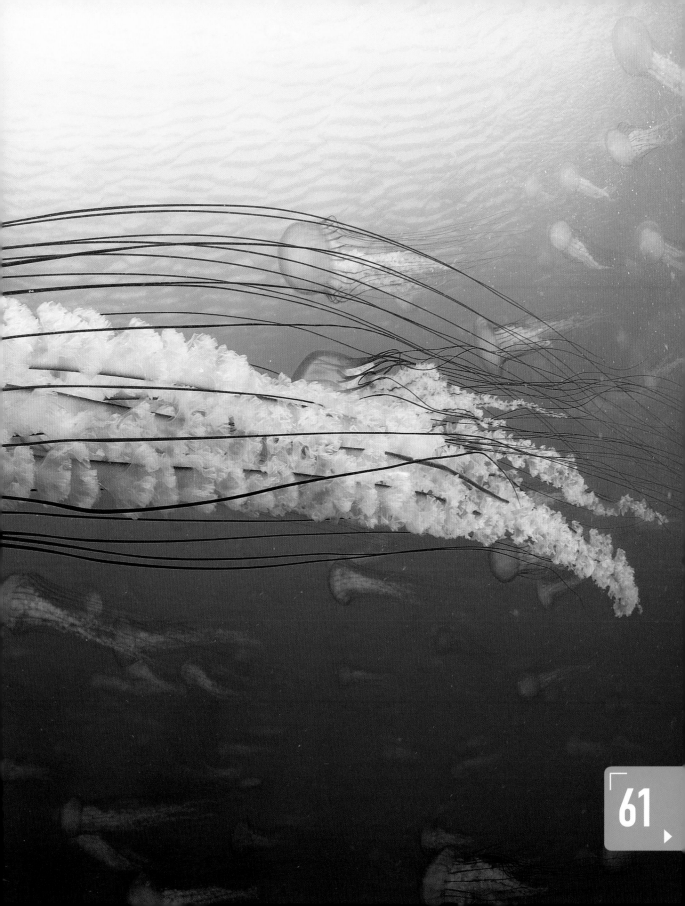

EXPLORE WATERY WORLDS

DIVE IN AND DISCOVER THE WONDER THAT LIES BELOW THE SURFACE.

SEE UNDER THE SEA

Underwater photography requires special gear; how much you need depends on how deep you're going. For splashing around in a pool or at the beach—and for snorkeling and relatively shallow dives—you may be able to get away with an underwater compact camera. But if you want to go deeper, you'll need to deal with rapid falloff in visibility and increased pressure—which can be as dangerous to cameras as water is.

That means more gear, starting with a waterproof, pressure-proof housing for your camera and lens. The housings and other equipment needed for underwater endeavors were once available only to committed shooters due to their prohibitive cost. But with an array of more affordable (or rentable) gear on the market today, there's no reason not to photograph the abundance of mysterious curiosities in the ocean.

A DSLR will give you far more control to sharpen picture quality, deal with lighting challenges, and catch fast-moving fish. As for lenses, stick with wide-angle and macro ones for close-up work and use prime (single focal length) lenses, because you may not have access to the zoom ring through the underwater housing. The farther from the surface you go, the more monochromatic the scene will appear. One reason: There's less natural light to illuminate the colors. Counter that effect with a pair of underwater strobes on either side of the camera, as sidelighting helps define your subject's shape and bring out colors and details, and adds a sense of dimensionality. Another bonus from underwater sidelighting is that it lets you avoid backscatter, the sparkly interference caused by front light bouncing off tiny particles in the water.

You can take better control of your exposure and colors if you shoot in RAW mode and finesse your images in processing later. But if you're shooting JPEGs, turn to your white balance setting. Some cameras have an underwater mode you can set. If yours doesn't, try using the cloudy setting to warm up the the predominantly cool tones in the image by enhancing reds and yellows.

SEEK A SUBJECT

Another must for underwater photography: patience. Instead of rushing from one reef to the next looking for an elusive eel, stay as still as you can and wait for the denizens of the deep to get used to your presence. Dive with an experienced guide who can lead you to the most compelling creatures and reefs. And remember: Even if you don't get exactly the undersea shot you're after, you're in for an amazing experience.

THE GEAR

Waterproof camera You can find compacts built to withstand pressure down to 33 feet (10 m), but most only go down to about 10 feet (3 m). Choose one with full manual controls, but know that even these will have limitations such as relatively slow autofocus, smaller sensors, and less sensitivity than most DSLRs and ILCs.

Underwater housing If you want to step up to the next level, protect your camera and lens with an underwater housing. Made of polycarbonate or aluminum alloys, the housing seals your regular camera in a water- and pressure-proof chamber while giving you access to most controls. Look for one designed for your camera model, and rent if you can't afford to buy.

Lens port Protect your optics with a lens port: a clear, pressurized bubble that fits into the camera housing to accommodate different-sized lenses.

Underwater strobes To illuminate your subjects in the gloom of the lower depths, you'll need two strobes, set on articulated arms and connected to your camera via sync cords. They can sharpen subjects in shallow, clear water, as well.

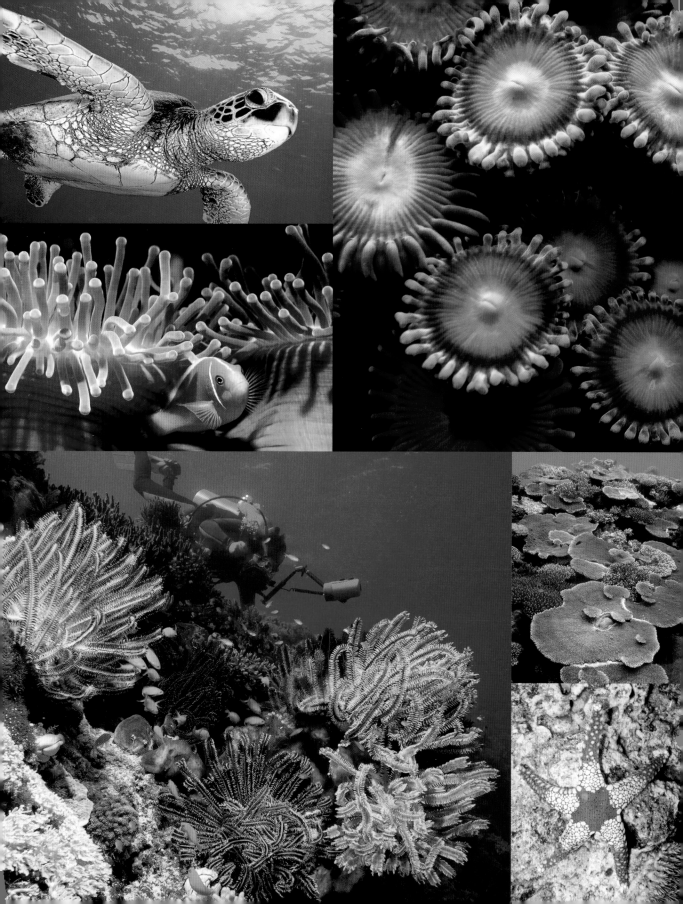

WITNESS THE WEATHER

WHEN STORMS BREW, GET OUT AND SHOOT.

GO FOR A SOFT SCENE

As you can see in this photo, fog acts like nature's softbox, smoothing out contrast and muting colors. Backgrounds disappear, stripping your picture down to the simplest elements. When shooting in the gloom, use a tripod, because the dim light requires shutter speeds as slow as 1/4 sec. Your meter will tend to underexpose the scene, so add 2/3 to 1 stop using exposure compensation or a spot meter aimed at a gray rock. The mist will wreak havoc with autofocus, so adjust manually.

SHOOT THE SNOW

Think bare trees etched against a field of white, or dark clouds over a brightly blanketed field. When capturing scenes like the one here, the tough part is keeping snow white, because your camera's light meter will want to render it a midtone gray. Use exposure compensation and bracket your shots to make sure you get one that shows snow's true color. When flakes are falling, shoot at 1/250 or 1/500 sec to capture them as dots; 1 sec or longer will blur them into streaks or make them disappear.

Don't let rain, snow, fog, or thunderstorms keep you and your camera indoors. Use a zoom lens so you don't have to change lenses in soggy conditions, and a rugged, weather-sealed DSLR (some are made to resist the elements) or a rain hood.

REVEAL THE WIND

When the wind picks up, dramatize its effect by setting up your tripod in a spot where you can capture nature in full sway: Record treetops tossing, leaves swirling, or, as in this shot by Darwin Wiggett, prairie grasses waving.

To reveal the movement caused by wind and smooth out the details, use a very long exposure (up to 10 sec, depending on the wind speed). If it's sunny, you'll need a neutral-density filter to shoot with a long shutter speed without overexposing.

You may also want to use a split neutral-density filter to capture deeper color in the sky and bring it into better balance with the darker hues in the foreground.

While wind can strike at any hour, the best time to capture the drama is before or after a storm, when the sky is dark but sunlight still strikes the scene. The startling contrast of bright foreground against a threatening sky will add a sense of mystery and tension to your image.

MAKE MOUNTAINS MAJESTIC

EXPLORE THE CONTRAST BETWEEN SKY AND RIDGE.

INSPIRE SOME AWE

When the first landscape photographers set out to capture dramatic mountain shots, they had to lug enormous view cameras, filters, glass-plate negatives, and all their darkroom chemicals and equipment with them. While you no longer have to buy a horse and wagon to carry all your gear, you'll get the most impressive results if you photograph mountains with the same careful attention to composition, exposure, focus, and detail as those photographic pioneers.

The photo by Saul Santos Diaz on the previous page has it all: It follows the rule of thirds, draws the viewer's eye in with the bridge's strong diagonal, makes excellent use of both cloud and water, and offers a striking juxtaposition between cozy domesticity and craggy ruggedness.

In mountainous terrain, you'll find tremendous contrast between the brightest and darkest areas of the scene, so split neutral-density filters are essential. They'll let you darken the sky and peaks while allowing more light in the foreground to illuminate wildflowers, boulders, or grass. With the uneven horizons mountains create, graduated rather than hard-edged filters work better. But beware creating too even a balance—a range of dark and light gives depth to a scene.

A wide-angle lens is a classic tool for mountain photography, and most photographers orient the camera horizontally for an expansive view. (And most use a tripod to keep that horizon straight.) But for a different effect, try turning your camera vertically to emphasize a mountain's height.

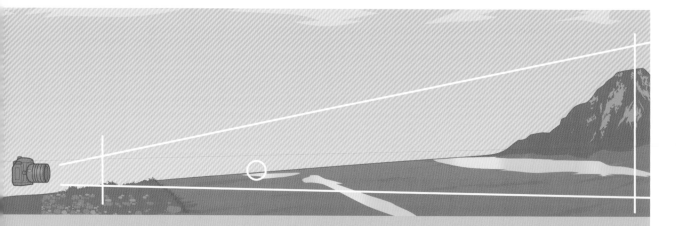

HYPERFOCAL DISTANCE

To keep both the foreground and distant elements sharp, you'll need to focus at the hyperfocal distance of your lens (the point of focus that gives you the greatest depth of field possible). Find this point by first setting your aperture a notch below the smallest on your lens (e.g., f/16) and focusing to infinity. Then look through your camera's viewfinder or at its LCD to note by eye the leading edge of the area that's now in focus. Focus manually on that point, and you'll have the largest area of focus possible for your lens and your subject, for a sharp image from the blades of grass at your feet to the mountains on the horizon. With live view, you can magnify the image in your LCD to make sure you've reached perfect focus; if your camera offers depth-of-field preview, brighten the LCD to see it, too.

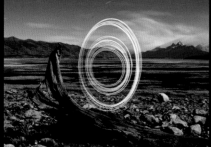

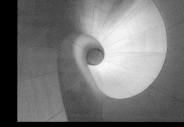

THINGS

SNAP INTO ACTION

CAPTURE DRAMATIC—AND NOISY—MOMENTS WITH A STROBE AND A SOUND TRIGGER.

64

TAKE SOUND ADVICE

Photographers usually draw their inspiration from the visual realm, but a sound sparked this photo by Mark Watson. When he accidentally broke the point of his pencil, he was surprised by how loud the noise was: loud enough to fire an audio flash trigger.

That's the device that will help you capture fast but noisy moments, like the instant a glass breaks, a paintball hits a wall, or a pencil snaps. Your reflexes aren't quick enough so that you can press the shutter

button in time, but a shutter release that's triggered by the action's sound gets the job done. You'll also need a high-speed strobe to create an intense but very brief burst of light that freezes extremely fast action. And for an intense close-up like this one, you'll need a macro lens with high magnification.

Despite the specialized gear it takes to freeze motion sharply, Watson didn't have to spend a lot to do it here —and if you're keen on creating a similar shot, neither

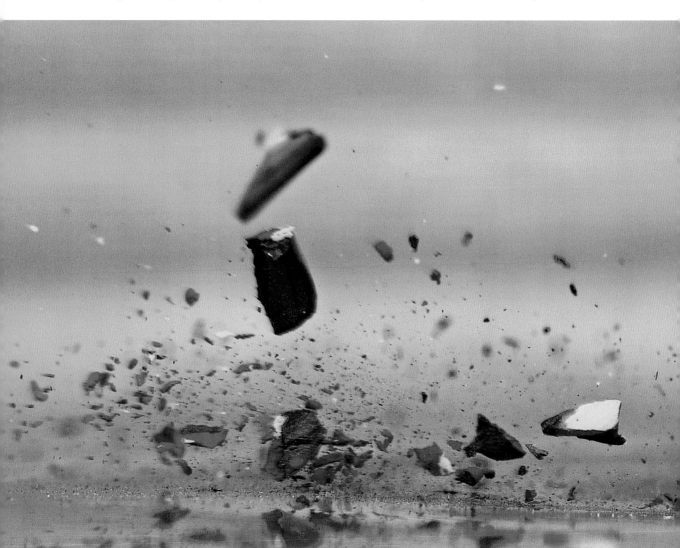

willl you. Sound-activated flash triggers aren't all that expensive. The strobe light Watson used to get this shot was especially cheap, since he picked up the same kind that DJs use to light up a dance floor. And instead of using a dedicated macro lens, he popped a filter-like macro magnifier onto his regular lens.

The resulting image is a picture with tremendous energy and vibrancy. The intense metallic crimson of the pencil's casing, the brightly colored pencil shards flying through the air, and the rough texture of the wood speak for themselves visually, adding up to an extraordinary view of a very ordinary event. One last thing you'll need? Patience. Because you'll have to break—and sharpen—a lot of pencils to get this shot.

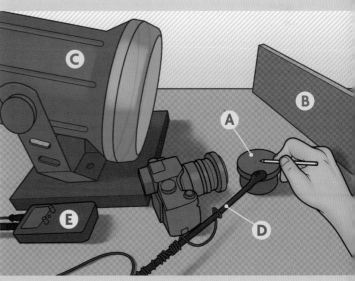

BREAKING IT DOWN

[1] Select an environment. Choose a room you can darken, with a table or desk at a comfortable working height. Protect the table by snapping the pencil against another hard surface—a plastic jar, for example (A)—in a contrasting color. A neutral background (B) keeps the viewer's focus on the action.

[2] Set up your gear. Put the strobe (C) and a camera with a macro lens or magnifier on the table. Place the mic (D) as close to the pencil tip as possible without showing up in the frame. Turn the audio trigger (E) and the other devices on, with the strobe set for its dimmest output.

[3] Prepare your camera. Start with your camera's lowest ISO, a midrange aperture of f/8 or f/11, and a shutter speed of 2 sec. Focus manually. Once your pencil has marked up the platform, focus on those marks.

[4] Tinker with your settings. It will take several tries as you figure out the optimal time to catch the pencil shards flying into the air. First, snap the pencil tip to test the audio trigger: If the flash doesn't fire, turn up the mic sensitivity. Turn off the lights, but keep the door open so you can work in the faint light from the next room. Set the trigger delay for 90 milliseconds, click the shutter, then snap the pencil to fire the flash. Check the image: If you didn't catch the shards in midair, adjust the delay until your timing is right.

[5] Fine-tune exposure. Since your exposure settings must be so precise for this shot, move the flash slightly closer or farther away to get the best exposure instead of changing your camera settings repeatedly.

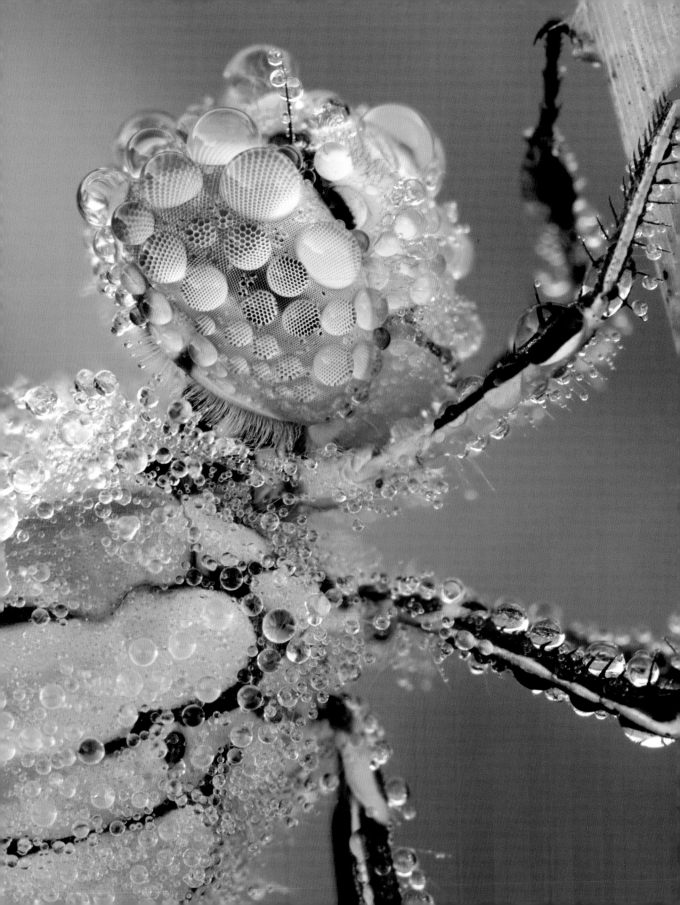

BEAUTIFY BUGS

DEFY EXPECTATIONS BY MAKING CREEPY-CRAWLIES APPEALING.

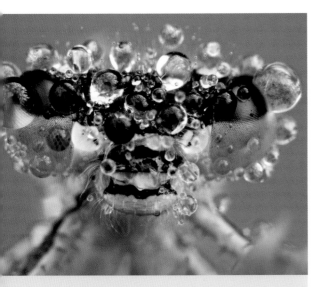

LOOK AT CRITTERS UP CLOSE

It's hard not to be completely mesmerized by close-ups of insects. Their vibrant colors and gasp-worthy strangeness make for fascinating detail shots. And bug portraits aren't that hard to capture: All you need is curiosity about (and a willingness to get close to) spiders, caterpillars, and their kin—and gear that will magnify them for the camera.

HUNT THE PERFECT SPECIMEN

Photographer Martin Amm found the dew-covered insects you see on this page near his home in Germany, and used his lens to transform them into glistening, crystal-studded creatures. The morning he encountered the multicolored dragonfly (at far left) and the green grasshopper (in the smaller photo on this page) was cold, still, and foggy—but soon to be bathed in diffuse light from the rising sun.

Everything was covered by fine dewdrops, making it tough for winged insects to walk, let alone fly. So Amm had about an hour to shoot before the scene warmed and his subjects took off.

GET THE RIGHT GEAR

You can't get extreme close-ups like these without the right equipment. Besides a DSLR and a tripod to steady it, you'll need a macro lens that offers 1:1 (also known as life-sized) magnification. Adding an enlarging lens or macro bellows will give you even more magnifying power, as will an extension tube (which increases the size of the image that hits your camera's sensor) and a teleconverter (which increases the effective focal length of your lens), though these reduce the amount of light that enters, so you'll need a longer exposure.

If there's enough of it, shoot in natural light. If you can't, use a diffuser on your flash. Or try a macro ring flash, which fits around your lens. Either will banish shadows on your tiny subjects, allowing every otherworldly feature to be revealed.

BREAKING IT DOWN

[1] Get up early. Set out on your photo mission long before dawn, when three factors are likely to benefit you: high relative humidity, still air, and cold but above-freezing temperatures.

[2] Lie in wait. Search in the grass surrounding lakes and ponds for your sleeping subjects. When you've found one, set up and wait for dawn—and enough ambient light to take your photo. If you must use flash, be sure to use a diffuser or a macro ring flash for a shadow-free, natural look.

[3] Use the right equipment. Your setup should include a 1:1 macro lens or a macro bellows (an inexpensive option that increases magnification by bringing the lens closer to the subject).

[4] Stay steady. To prevent camera vibration, use a tripod and a camera that permits mirror lockup (which keeps the mirror raised until you release it, to prevent the vibrations it causes when it moves), plus a remote shutter release or a self-timer.

ZOOM IN ON ARCHITECTURE

TRANSFORM BUILDINGS INTO MEDITATIONS ON FORM.

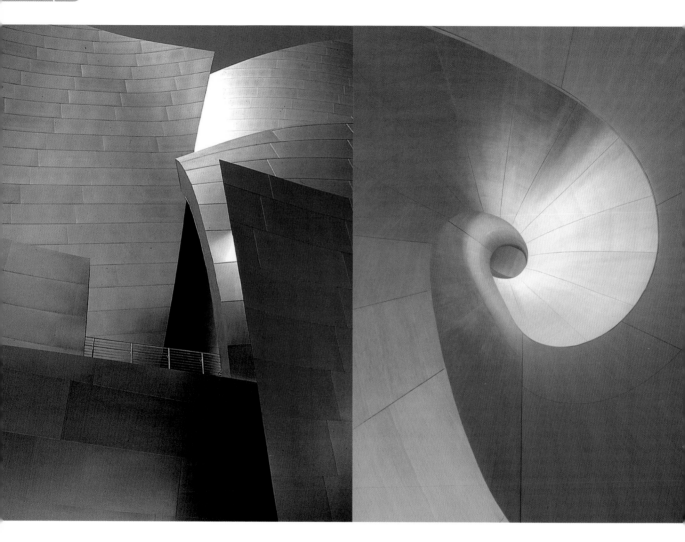

PLAY IT STRAIGHT

A building with solid surfaces unbroken by windows has the visual effect of a giant sculpture. You can reveal its smooth expanses by stepping back and getting a straight perspective, as Harrison Scott did with his photo of Gehry's Disney Hall in Los Angeles. The clear blue sky cast a cool glow over the building's metallic surface, and the sun's angle threw alternating highlights and shadows that add depth to the overlapping, curved walls.

WORK THE SCENE

It took George Hatzipantelis several trips up and down Gehry's spiral staircase in the Art Gallery of Toronto before he found a perspective that would let him flatten this complex three-dimensional form into a swirl of undulating lines and shades. Near the bottom, he bent backward over the banister and shot straight up. To capture detail all the way to the end of the image's perspective, he used a wide-angle lens and a small aperture.

Groundbreaking architects like Frank Gehry conjure mystery from complex lines, irregular quasi-organic shapes, and gleaming high-tech surfaces. A camera lets you transform the beauty of dramatic structures into magic of your own.

MASTER REFLECTIONS

Glass-clad architecture like Gehry's IAC Building in Manhattan offers photographers a choice: minimize or capture reflections. If you want your photograph to emphasize the building's structure, use a polarizing filter to cut glare and enhance the remaining reflections that your camera records in the glass.

But sometimes keeping reflections in a photo adds layers of visual complexity, as demonstrated by this shot from Philip Ryan, *Popular Photography's*

technical editor. Having shot the IAC building many times, Ryan had a good sense of its angles and the best vantage points from which to capture them. To get this shot, he added the reflection of the geometrically patterned building next door.

Scout different perspectives for compelling reflections. And wait for a cloudy sky, or until just before or after sunrise or sunset—reflections are best revealed under soft light.

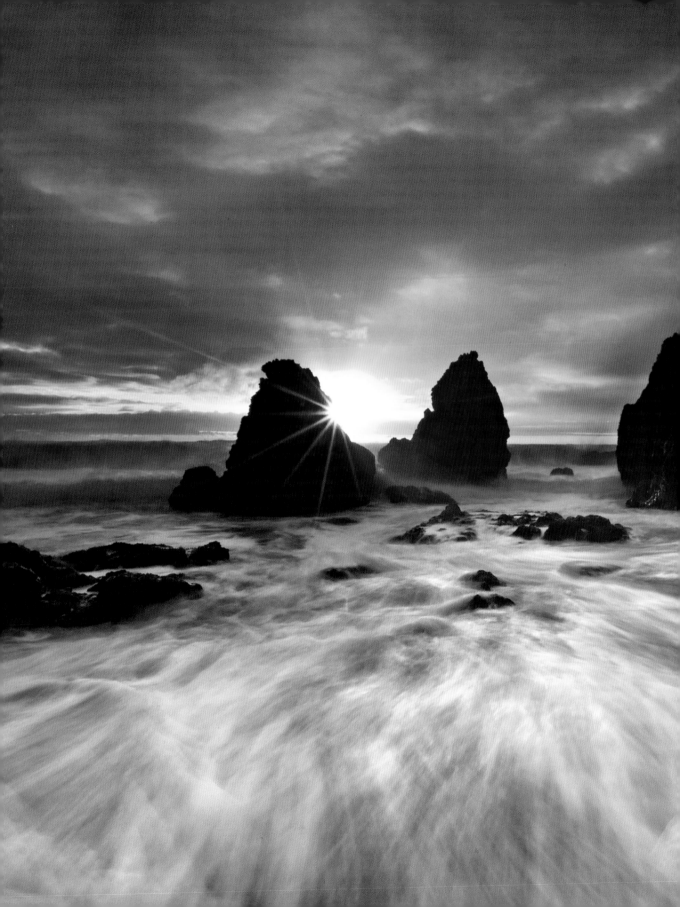

PERFECT A SUNSET

When photographing a cliché, be sure to get it devastatingly right. Or subvert it entirely.

SURPASS EXPECTATIONS

Who doesn't love a sunset, especially from the beach? Everybody tries to take that particular shot—but very few get an image that's powerful and unique enough to wow viewers jaded by similar images.

This picture by Jim Patterson is a standout because it nails every element. First, he framed the sun between rocks by wading into the surf and burying the legs of his tripod in sand. Clouds added texture and color. A wide-angle lens took in the full scene, a small aperture created the starburst effect, and a split neutral density— filter helped balance the exposure. Finally, a long exposure turned the waves into cottony streams.

Or try thwarting expectations. Shoot just the sky, or only the watery foreground. Make your image black-and-white. Or turn your back on the sunset, capturing its glimmer on the sand or its reflection in someone's sunglasses. Offbeat perspectives, creative cropping, and using software to tweak color are great ways to get a fresh take on an old subject.

CLOSE IN ON ABSTRACTIONS

TURN ORDINARY OBJECTS INTO ART.

THINK LARGER THAN LIFE

Close-up macro photography lets you magnify tiny things. It can be used in a straightforward way to depict details, or deployed artfully for uncanny effects. In the latter case, extreme close-ups can transform something that's usually overlooked into something that's really worth looking at.

Consider Villi Vilhjálmsson's photo of soap bubbles. It fills the frame with complex, irregular blobs that challenge the viewer to make sense of them. You may see animal shapes, or perhaps human forms. Focus falls off from sharp to soft as you peer through the top layer to the bubbles underneath. To further enhance the abstract, unreal quality, Vilhjálmsson converted the image to black-and-white after the photo shoot.

GET THE TECHNICALITIES DOWN

The closer you get to a subject, the shallower your depth of field, so you'll need to shoot with a very small aperture (try one step up from your camera's smallest). You and your camera may block the available light, so use a reflector or strobe for more illumination—or a tripod and long shutter speed to compensate for dim lighting. And because you're getting in so close, you'll need to make fine manual adjustments to your focus.

Macro work requires some special gear. A macro lens is your best bet, but if you're on a budget, try a reversing ring: It lets you mount your regular lens backwards for powerful magnification, though you'll lose autofocus, and your photographs may not be as sharply detailed.

BREAKING IT DOWN

[1] Stage your scene. Set a clear bowl of bubbly water on top of small supports—Vilhjálmsson used tea-light holders (A)—on a white table. Place a battery-powered LED (B) under the bowl.

[2] Place the camera. Mount your camera, outfitted with a macro lens (C), on a tripod and tilt it so that it looks down onto the bowl.

[3] Set focus, f-stop, and ISO. Focus manually and set the aperture to f/16. A low ISO will give you a cleaner image.

[4] Turn off the room lights. Your bowl will be lit only by the LED. Use aperture-priority or manual mode to determine the shutter speed, and then fire away.

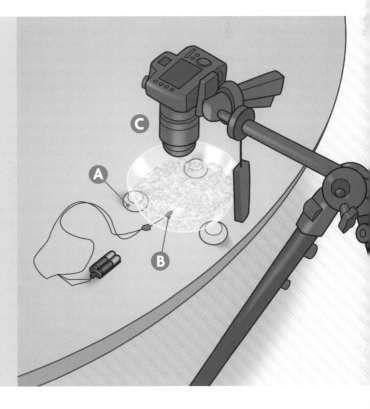

WARM UP COLD-BLOODED CRITTERS

SHOW A NEW SIDE TO SLIMY SUBJECTS BY GETTING CLOSE—OR SHOOTING THEM IN ACTION.

CATCH LEAPING CREATURES

Some people are put off by the scaly and slithery, but reptiles, amphibians, and fish make for unexpected and colorful models. In fact, if you shoot them right, your subjects will practically jump out of the frame.

Start by finding critters that can cope with being handled and that routinely exhibit photogenic behavior such as eating, jumping, and running. The staff at a specialty pet store will be able to help; consider shooting in the store as an alternative to taking critters home. Get to know your subjects' habits, so you can predict their actions for better photos. If you find you have a passion for these animals, you may be able to work with the herpetology department at a local zoo.

When you're shooting, use a macro lens, since the magnification will help you capture the beauty in scales, spots, and other fine details. To help the viewer connect with your exotic subjects, hold your camera at their eye level. Focus carefully to keep attention on the eyes and blur out backgrounds.

Chances are you'll need to use a flash—or a few of them—to delineate your subjects' shape, reveal details, and separate them from the background (especially if they're in camouflage mode). But keep the output low and natural-looking. Diffuse the light on the background and keep the main light direct. A macro flash will help by circling your subject with light.

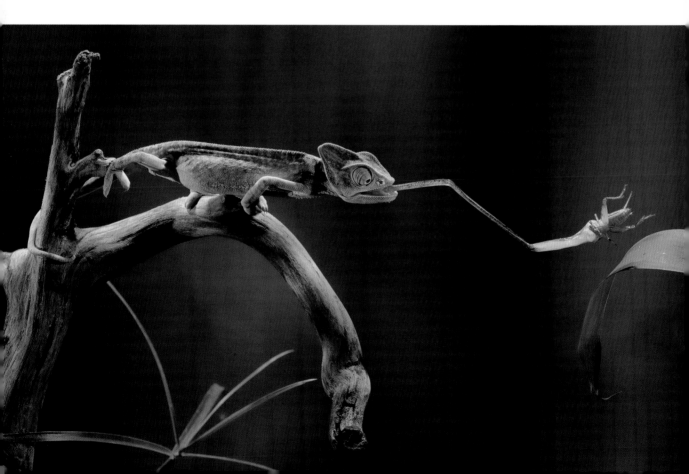

BREAKING IT DOWN

[1] Decide on a backdrop. Use anything from a simple cloth to out-of-focus vegetation, adding appropriate plants or rocks for visual interest. Make sure the room has ambient light that you can dim—and is warm enough so your models stay both comfortable and active.

[2] Arrange the gear. If your subject is in a tank, don't flash straight onto the glass. Place synced flash units above, to the side of, or at an angle to the front pane.

[3] Work out exposure. Aim for 1/250 sec at about f/8 and ISO 400 or less. To catch quick, darting motions, you'll need a very fast flash duration (about 1/8000 sec), which means lower flash output (1/16 power or less). Experiment and check results in your camera's LCD.

[4] Calm your subject. Cover the creature's container with a towel for a few minutes. (Most of these animals find darkness relaxing.) After you uncover it, your now-mellow subject might briefly hold still for a portrait.

[5] Try a trip wire. Catch a frog in midleap or a chameleon nabbing its prey by firing the camera and flash units remotely with an infrared trip wire. This throws an invisible beam of light across your subject's expected path. When the animal crosses it, your photo is snapped.

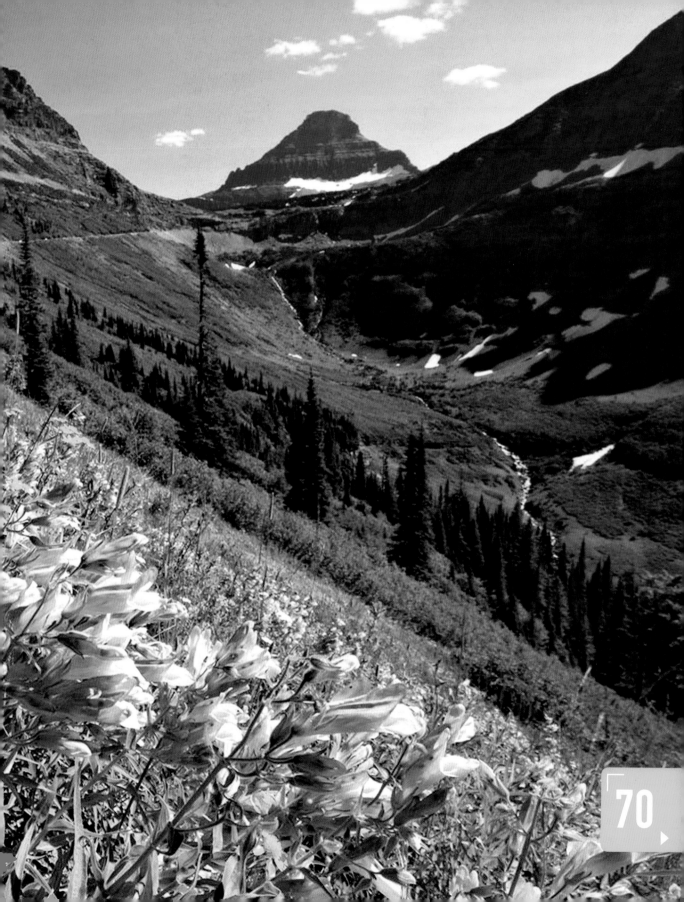

USE FLOWER POWER

RAISE YOUR PHOTOS TO A HIGHER LEVEL WITH A FRESH TAKE ON FLORA.

SHOWCASE BEAUTIFUL BLOOMS

Like bees, photographers seem irresistibly drawn to blossoms. A single flower or a tight bunch make for sculptural still lifes. And a profusion of them can create scenes of sweeping beauty. But because flowers are such popular subjects, they can be tricky to photograph in a distinctive or memorable way.

A discriminating eye improves your odds of getting a compelling shot of flowers. Don't let your picture get overwhelmed by a riot of intense color and varied shapes. Choose and frame your subject with care, as in the photo by Kerrick James on the previous two pages, where the wildflowers are contained within a graphically strong diagonal. If you're going to shoot an entire flowerbed, stick to tightly clustered blooms in a uniform color, or find a landscape element that will lead the viewer's eye through the frame. For close-ups, look for symmetrical or spiraling shapes and even tones, as in the lovely white lilies at top left.

SOFTEN AND SIMPLIFY

Harsh lighting makes blooms look garish, so it pays to shoot under soft and even illumination—overcast yet bright days are perfect. If the sun's strong, use a diffusion panel—or even a white T-shirt—as a translucent shade to ease light shining onto blossoms.

Keep the focus on your delicate subjects with a simple background. Green and sky blue are nature's perfect backdrops, but if you want to bring along your own, consider other colors. White, especially when backlit, will brighten a photo; in a studio where you can control the light, black will sharply delineate flowers.

Another solution is to omit the background entirely. Try cropping in so tight that you don't see much beyond the flower. Or use a large aperture to reduce the depth of field, taking the background out of focus while keeping blossoms sharp. That technique was used for the picture of the daisy at center left, taken with a selective-focus lens for such a shallow depth of field that even the petals are out of focus.

THE GEAR

Macro lens Magnify small flowers with a dedicated macro lens that will give you strong close-ups with creamy, defocused backgrounds, as in the photo at top right.

Wide-angle lens A lens that takes in the full landscape gives your images plenty of sharpness, from the near foreground to deep in the background, as in the lavender field at left.

Telephoto lens An unorthodox but intriguing choice for floral studies, a very long telephoto (300mm or more) will effectively compress and magnify background elements for a disorienting composition.

Diffuser Set up a white screen that spreads—and therefore softens—the light pouring through it. To shoot delicate blossoms on a sunny day, try a light tent (a diffusion box you can fit over plants and poke your camera into).

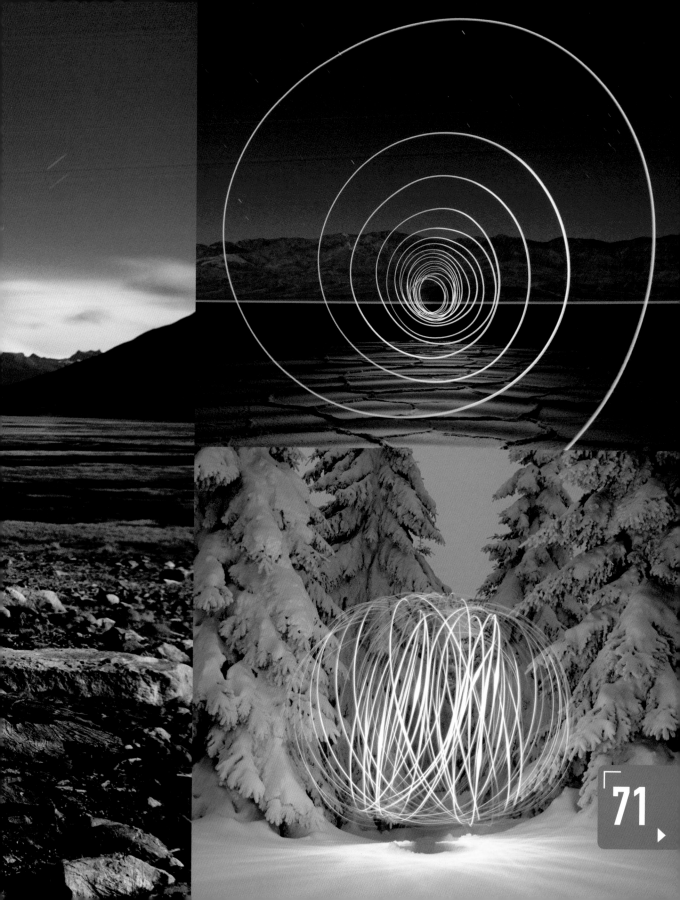

PAINT WITH LIGHT

HEAD INTO THE NIGHT AND LET YOUR CREATIVITY SHINE.

CHOOSE YOUR "BRUSH"

At its root, the word *photography* means "light writing." So why not take that notion literally and use light to compose a picture? The creative possibilities are endless if you've got a tripod, a movable light source, and plenty of imagination. Start with a scene that's nearly pitch-dark, then shine, squiggle, or trace light into it to control precisely what the image reveals.

Any light will do: a flashlight, desk lamp, lantern, LED tape, off-camera flash, spotlight—even a bare bulb on an extension cord. The size and color of the beam (and the way you use it) will determine its effect.

Try painting ethereal shapes as Cenci Goepel and Jens Wernecke did in the photos on the previous two pages. Or doodle with a few different lights as Marcel Panne did for the shot below; use a flashlight to outline a subject as Stephan Kolb did at top right; or cover an accessory flash with colored gels to add hues to a landscape as Ian Plant did at bottom right.

If you wear dark colors and keep moving, you'll stay invisible to the camera. (Of course, you can also "paint" yourself for a ghostly self-portrait.) There's only one rule: Don't shine the beam directly into the camera.

BREAKING IT DOWN

[1] **Seek a little light.** Pick a dark spot, indoors or out, with some ambient light to give your composition depth.

[2] **Frame your scene.** With your camera on a tripod, look through the viewfinder or use live view on the LCD to delineate the boundaries of your frame. Note some landmarks to keep your light painting within bounds.

[3] **Focus the lens manually.** You may need to light up your subject when you do this, or use a stand-in.

[4] **Set the exposure.** In manual mode, set a low ISO and a midrange aperture (f/8 or f/11). You'll have to experiment with the shutter speed, since the timing will depend on how much light you add to the scene. Start with 2 minutes and double the time from there. The photo at right took 20 minutes, with several pops of accessory flash. For exposures this long, use the camera's bulb setting to keep the shutter open until you release it.

[5] **Get in the scene.** You'll need to get out from behind the camera to paint, so use a remote trigger or self-timer.

[6] **Start painting.** Keep moving to stay invisible. To add yourself to the scene, stand still and have someone light you (or part of you), as was done in the photo at left.

GET THE GLIMMER OF GLASS

MAKE A COLORFUL WORK OF ART SEEM TO GLOW FROM WITHIN.

EXPLORE COLOR, SHAPE, AND REFLECTION

Transparent and reflective, glass is a tough material to photograph—especially if you want to capture both its ephemeral quality and a solidly three-dimensional form. With vases, goblets, and other glass vessels, depicting the outer shape and surface texture while also showing the interior is even more difficult.

The desire to overcome these obstacles spurred product and fine-art photographer Kan Nakai to create the picture at left—he wanted to challenge our sense of glass's hardness by depicting it as soft and glowing. To achieve that effect, he chose a crystal bud vase with a fluted, ruffled shape and a rich amber color. The finely ribbed and slightly frosted surface helped diffuse the light, while the shape and color convey softness and warmth.

Nakai made a number of choices that helped make his image so successful. The green object in the background contrasts with the vase's flame color, while the reddish apple at right reinforces it. Placing the vase diagonally toward the camera and using a very shallow depth of field kept most of the focus soft and leads the viewer's eye through the frame.

Try using a macro lens with your DSLR, which will enhance soft detail. And make sure to use a tripod; any jostling of the camera during shooting may cause unwanted highlights in your image from light reflecting off the glass, especially with a form as curving and ridged as the one in Nakai's photograph. Keep experimenting with different surface textures, colors, and backdrops until you're satisfied.

BREAKING IT DOWN

[1] Color your set. A black velvet backdrop (A) creates contrast with the bright highlights coming off the glass. If you want to get more glow, place the vase slightly off-axis on a white table.

[2] Position the main light. Put the brightest light (B) behind the table and to the side, so that it shines through the vase without striking your lens. Use a diffuser (C) to soften the light, and black foam-core panels, called gobos (D), to narrow its beam.

[3] Add a fill light. Place the fill light (E) on the side and slightly below the level of the table, with a reflector (F) directly opposite it on the other side. Diffuse and channel its beam as well—and set its output so it's about one-third of the main light's. To keep the highlights on the glass small and sparkly, position the fill light closer to it than the main one.

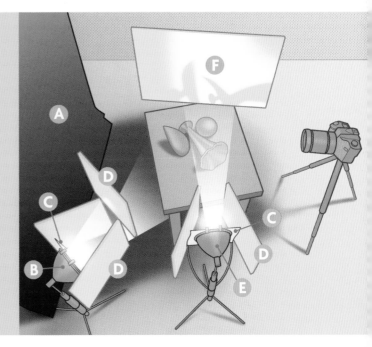

MAKE BEASTLY ABSTRACTS

Find intriguing angles on animals to close in on line, texture, and color.

TAKE PICTURES OF PARTS

Most animal portraits are a lot like ones depicting people: full head or body shots that try to convey the subject's personality. But when you move the lens in closer to a creature that's covered in fur, feathers, or leathery hide, its identity is obscured and the picture becomes an open-ended exploration of texture, color, pattern, and shape.

Pick a body part, find an appealing angle, and frame the shot tightly, leaving out extraneous detail. Whether you do this by cropping your image, zooming in with your lens, or simply positioning the camera really close to the animal depends in part on how friendly—or dangerous—the animal is. You can get right under the muzzle of your dog, but you probably wouldn't want to do that with a wild boar.

Close-ups can evoke emotions— the alligator's snout in the photo at lower left is undeniably menacing. But they also possess an ambiguous, graphic sensibility that offers a subtler and more mysterious impact.

74 CATCH PLANES, TRAINS, AND BIG BOATS

FORM MEETS FUNCTION WHEN YOU SHOW TRANSPORTATION IN ACTION.

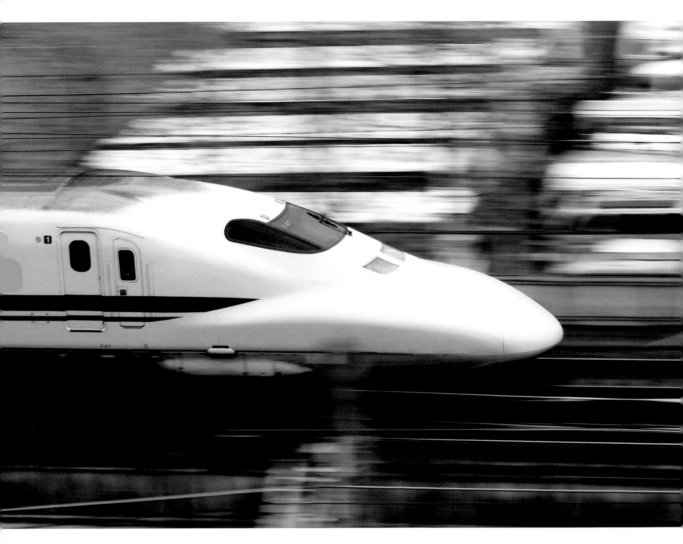

EMPHASIZE SPEED

Conjure a sense of powerful forward momentum by panning along with a fast vehicle as it zooms by, the way Uwe Zimmer did for the picture above. The streaked background and ground under the train suggest motion—the level sweep of the camera created the blur as it kept pace with the vehicle —while the train remains relatively sharp and identifiable. The high vantage point let the photographer reveal the train's distinctive shape,

while the distance made it easier for him to pan along with its motion.

Or take the opposite approach. Another way to depict a train's motion is to turn it into a streak of colors while keeping its surroundings sharp. You can do this by mounting your camera on a tripod, setting a long shutter speed (1 to 5 sec), and tripping the shutter remotely (to keep from jostling the camera) as the train passes through the scene.

You've got lots of options when you're photographing trains, ships, and planes. You can dramatize their impressive speed. Or shoot them in ways that emphasize their imposing forms. Or make the viewer do a double-take with surprising composition.

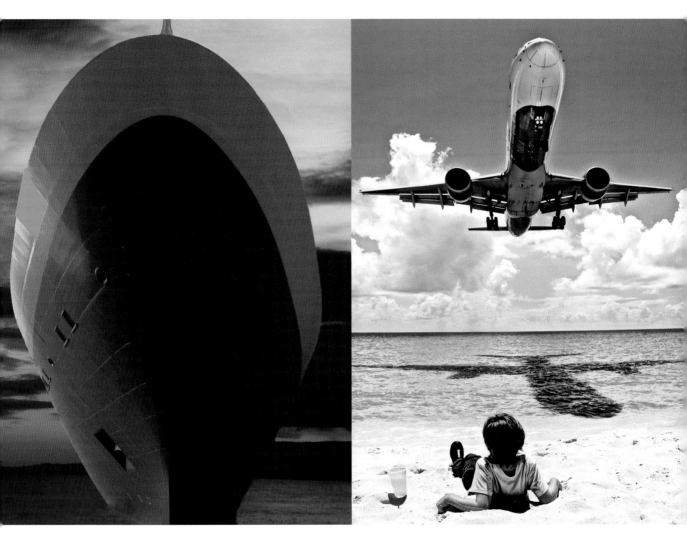

SHOW THE SHAPE

If this picture of a docked ship at sunset reminds you of a vintage travel poster from the 1920s, that's because George Cady photographed it with Art Deco imagery in mind. But getting detail in the ship's black, shadowed hull required an exposure long enough that the light-filled sky was washed out. So he shot two separate exposures to capture each element perfectly, and then created a composite with software.

UPEND EXPECTATIONS

To get this shot, you'll have to visit the Caribbean island of St. Martin—that's where Jesse Diamond took this heart-stopping photo. Shooting in bright midday sun made the striking shadow possible, and he froze the airplane's descent with a fast 1/750 sec shutter speed. Even if you can't make it to St. Martin, you can capture close encounters with aircraft in unexpected situations by staking out other public spaces near runways.

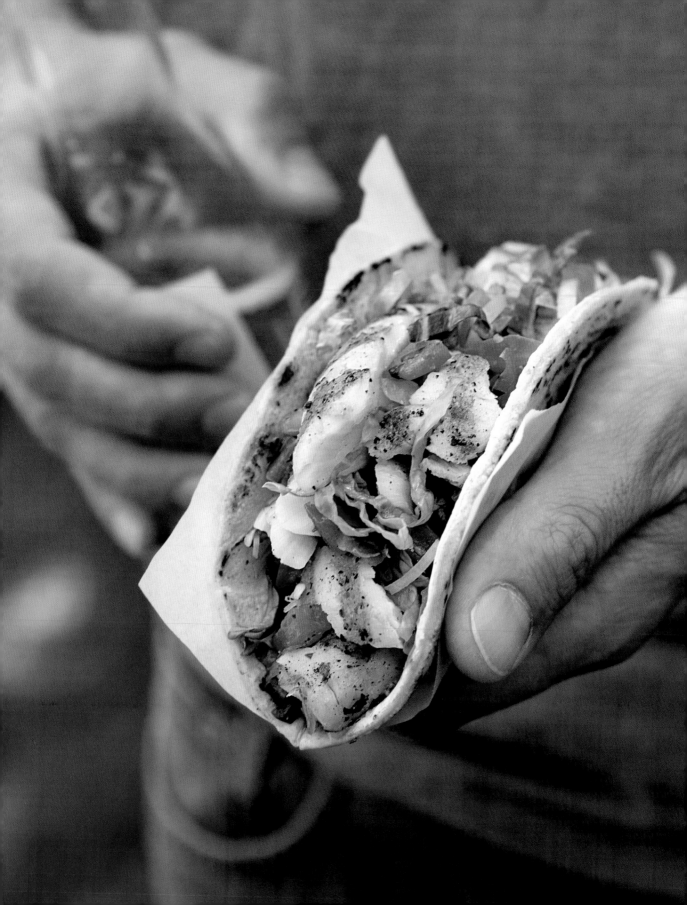

TAKE TASTY PHOTOS

PLAN IN ADVANCE FOR PICTURES GOOD ENOUGH TO EAT.

CLASS UP YOUR FOOD BLOG

In this age of amateur restaurant reviews, you can't sit down to a meal without someone photographing the entrées before picking up a fork. If that someone is you, it's time to take your photos beyond a meal memento and make pictures more like the ones in magazines and cookbooks.

You'll have to shoot quickly—before the soup gets cold or your family riots over waiting for the turkey. And shooting fast takes preparation, even in a restaurant where you can't control the lights.

LIGHT IT RIGHT

Diffuse sun will bring out colors and textures while minimizing glare on the tableware, so try to shoot in a sunlit room or bring your dishes out to the patio or garden. Stay out of direct sunbeams, though—slightly overcast days are best. Of course, you'll probably need to add light at night or in a dim corner of a restaurant: Use off-camera flash, or even a penlight. To diffuse the beam, have a dining companion hold a white dinner napkin up in front of your light source.

Whether you use sun or flash, light from the side and slightly from behind. To bathe the dish in even light, place a reflector on the side opposite your light source—again, a white napkin or tea towel will do. To deepen shadows and enhance shapes, use black cardboard, a black napkin, or even the back of a menu.

CHOOSE A VIEWPOINT

Emphasize the abundance of your table by shooting directly from above, as on the previous two pages. At home, stand on a chair or ladder and point your camera straight down. It's a little trickier in public: Stand up and hold your camera and wide-angle lens out over the table. For more reach, mount your rig on a monopod.

To capture single dishes while blurring the rest of the environment, shoot from a high but oblique angle and use a shallow depth of field to keep the focus on the food, as in both shots at left. Now eat up!

BREAKING IT DOWN

[1] Command a location. For a meal at home, create a little studio in a sunny room or outside in the shade. Once you've set a small table with everything but the food, meter the light and set your exposure. As the meal's on its way to the dining table, divert a serving to be photographed.

[2] Cut back on the meat. Even if you're not a vegetarian, meat can look unappetizing in a photo. To lessen the grisly effect, surround it with vegetables with eye-catching colors and textures.

[3] Use contrasting colors. Place food on dishes and backgrounds that complement or contrast with the food's colors, but don't match or fight them.

[4] Clean it up. Right before you shoot, wipe away smudges around dish edges and tinker with garnishes and other presentation details.

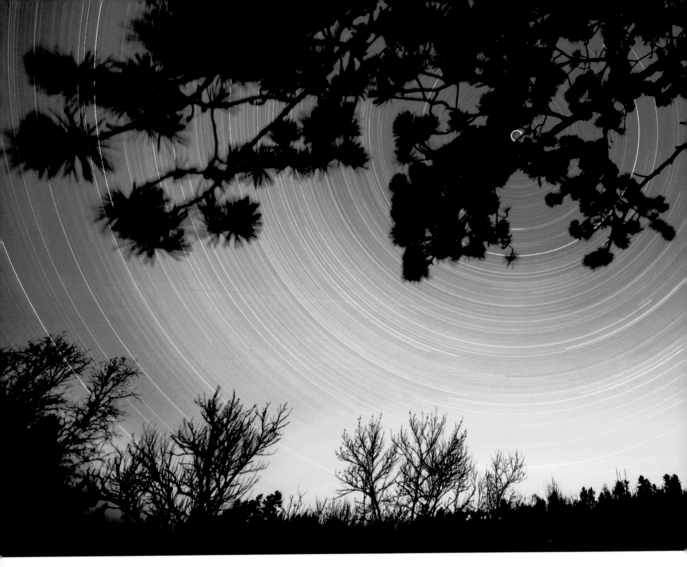

TRACE STAR TRAILS

REVEAL THE EARTH'S MOTION BY FOLLOWING THE STARS.

76

SHOW A LONG NIGHT'S JOURNEY

The first time you see a photo of star trails, you might think it's the most orderly meteor shower ever. But what you're really looking at is the passage of time written in the stars—and captured by a camera with its shutter left open for hours. What your camera is recording is actually the spinning of the earth, which makes those distant lights seem to whirl. To get the shot, you'll need to do a super long exposure—long enough for you to take a nap, or even get a full night's sleep. You'll need at least four hours for impact, and at twelve hours, a photo will show full circular arcs in the sky.

SET UP THE SKY SHOW

Choose a location that's fairly remote to avoid ambient light from a nearby city or highway traffic, which would be exaggerated by the long exposure

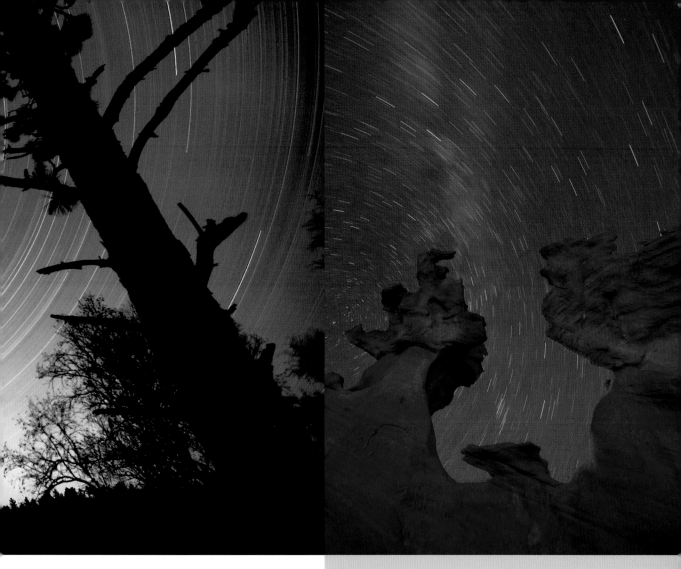

and could overwhelm the starry traces in the sky. As you compose your shot, look for framing elements that will silhouette against the sky and anchor the image to the earth—as well as provide visual context and depth. They could be landscape features (such as the trees and rock formations shown here) or artificial structures like telephone poles.

Think about the weather, too. A clear night is best, since clouds will both obscure the star trails and magnify any traces of ambient light from street lamps or nearby houses. And if you have trees in your frame, shoot on a still night, since wind ruffling the tree branches could smear their outlines—and your photograph will be stronger if the only motion blur comes from the celestial show.

BREAKING IT DOWN

[1] **Set up before dusk.** Mount your camera on a tripod and make sure it's level. Set the lowest possible ISO and a middle aperture (f/5.6 or f/8), and put the shutter on the bulb setting (which leaves it open until you press the shutter button again).

[2] **Frame and focus.** With your wide-angle lens on manual, focus to infinity and tape the focus ring so it doesn't slip. Use an auxiliary battery or outside power source to ensure you don't run out of juice.

[3] **Fire the shutter.** Once it's dark, it's time to click. Longer exposures mean longer star trails.

[4] **Add some effects.** Sweep a flashlight's beam over your foreground to bring out details. Use a colored lamp or gel over the flashlight for a dramatic, surreal effect, as in Ian Plant's photo above.

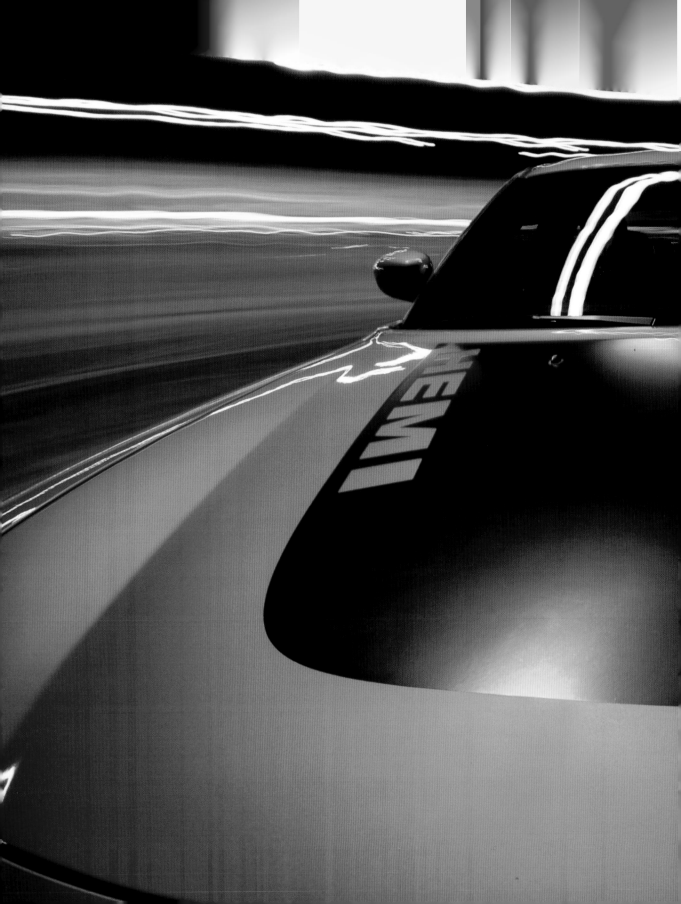

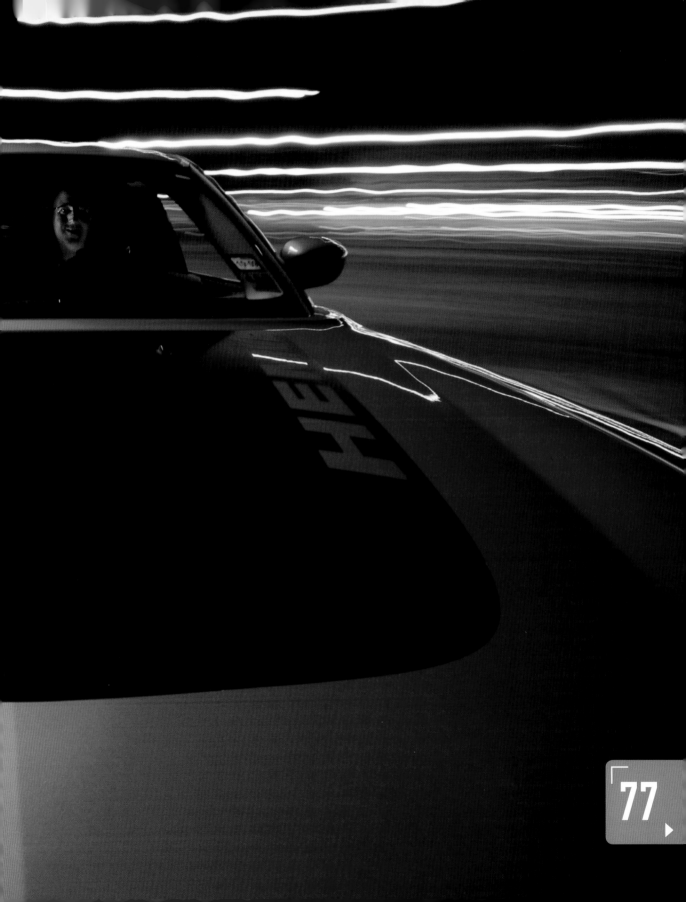

SHOOT SOME CHROME

CAPTURE THE APPEAL OF CARS, TRUCKS, AND MOTORCYCLES.

BE A HIGHWAY STAR

The machines we drive don't just carry us from place to place. They can also carry a host of symbolic meanings: power, freedom, sex appeal, speed, luxury, even waste. Choose the theme you're after, then evoke it through photographic technique.

If it's speed you want to convey, you don't need to drive fast. A slow speed will seem fast if you attach your camera to a vehicle and keep the shutter open for several seconds. For the shot on the previous spread, David Baures mounted his DSLR and ultra-wide zoom lens on an articulated support arm, then attached it to his front bumper using a heavy-duty suction cup. Driving slowly in a circle in a shopping-center parking lot at night, he fired remotely for an exposure of 4 sec. That kept his subject sharp while blurring the illuminated signs nearby into streaks.

MAKE A LITTLE BIT GO A LONG WAY

By coming in close, you allow just one part of the vehicle to stand in for the whole. To do that effectively, pick a distinctive detail such as a grille, a custom trim, or the repeating pattern of a motor, as in the shot at top right. Fill the entire frame with your subject, and let its shape dictate that of your image. You might show off the symmetry of a tire, for instance, by cropping the picture square. A macro lens lets you magnify the smallest parts, while the falloff in focus emphasizes the subject and gives your photo depth.

LIGHT FOR GLAMOUR

When you're shooting in sunlight, position your vehicle so the light rakes across it, bringing out textures and shapes. If you need to, use a reflector to open up the shadows. And shiny machines deserve light that makes them glitter like jewels.

At least, that's the approach to take if you want to convey a luxurious mystique, as Ryan Merrill did in his photograph of the motorcycle at right. To define its shape, he etched it with white highlights. He also used four off-camera flashes and blended their light evenly by placing them behind a huge diffusion panel—much bigger than the motorcycle. The soft light brought out the texture of the leather and created the long lines you see along the lengths of pipe and on the gas tank.

The thing to remember when shooting black on black as Merrill did is to underexpose. Your camera's meter tends to go for a midtone gray, so use exposure compensation to make sure your black stays black.

THE GEAR

Heavy-duty clamps and arms Use these to secure your camera to the vehicle for motion shots so it doesn't tumble. You don't want to damage your camera or your wheels.

Remote trigger You'll be able to trip the shutter from inside the car while in motion. And a flash remote will come in handy if you want to fire out-of-the-way lights while you're at it.

Accessory flash or studio lights One or more of these will allow you to place luminous highlights precisely where you want some extra shine.

Diffusion panel This will spread and soften direct light to throw a perfectly even gleam on chrome. You can use it with sunlight or a flash.

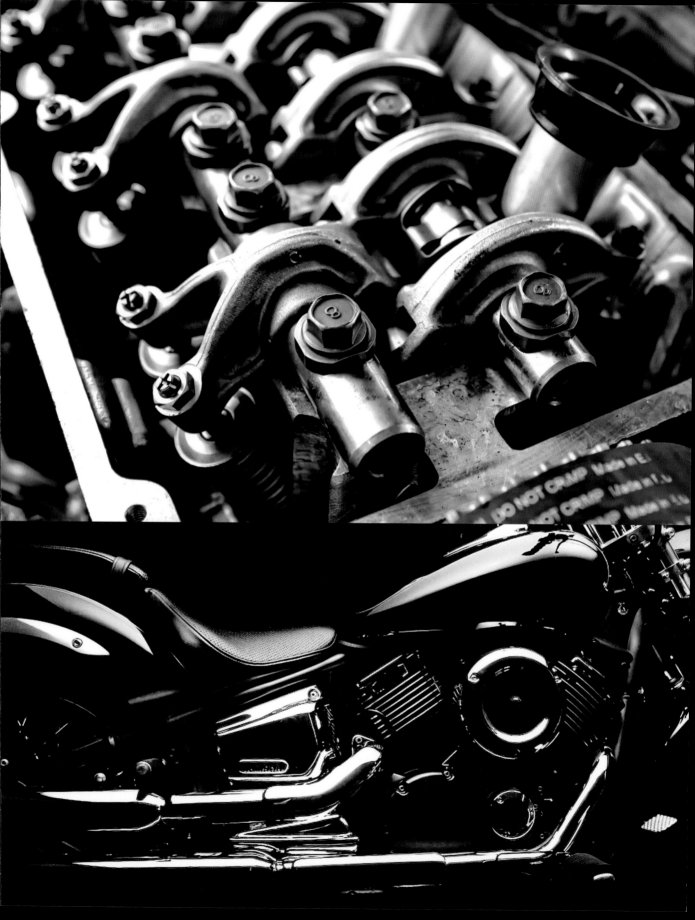

BLOW SMOKE

CREATE PERMANENT IMAGES OF AN EPHEMERAL SUBJECT.

MAKE SMOKING-HOT SHOTS

There's something hypnotizing about smoke: its ever-shifting forms, as well as the sense of mystery it evokes. It exists only in the moment—unless you use your camera to make that moment last.

Making a picture like the one below requires a balance between careful setup and utter randomness. You control the setting and the lights, creating the right environment. But the smoke inevitably does its own thing. You'll likely shoot a lot of frames to get just a few that have appealing shapes and patterns.

PLAY WITH COLOR

When you're photographing with white lights, the smoke will appear white in the highlights and blue

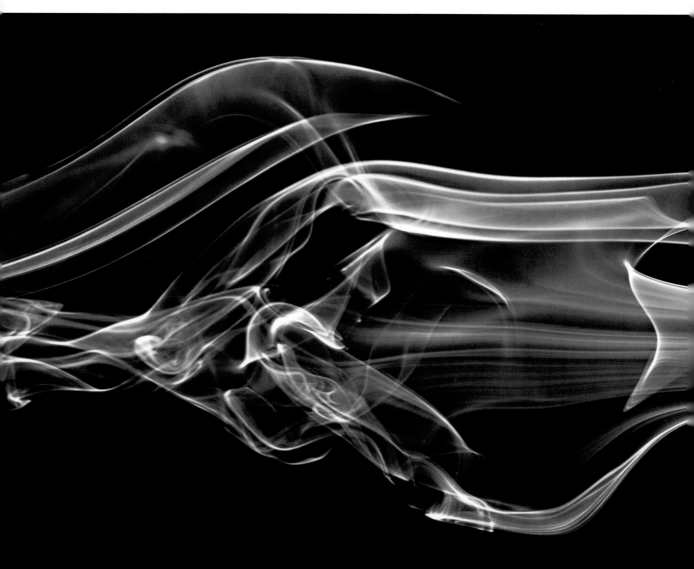

in the midtones. You can emphasize that blue quality by setting your camera's white balance to tungsten. If you want to make the tone of the smoke warm and golden instead, use tungsten spotlights and set your camera's white balance to daylight. Another way to change the shade of the smoke is to put colored acetate sheets, called gels, over your lights.

And if you can't stand the smell of incense—or just want to explore another medium—skip the smoke entirely. You can get a similar amorphous effect by dripping food coloring into a clear, rectangular vase of water. If that's the route you're taking, you'll need a white background instead of a black one, since white will best set off the swirling fingers of color.

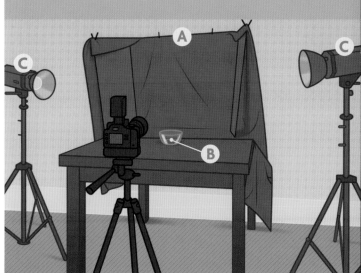

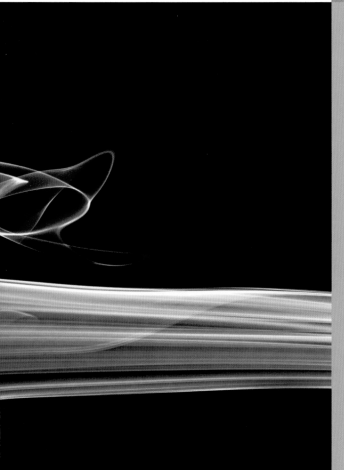

BREAKING IT DOWN

[1] Set the smoky stage. You'll need an absolutely dark room without even the slightest draft. Hang a deep velvet backdrop (A) (preferably clipped to a board or secured around a backdrop frame to prevent light-catching wrinkles) behind a dark table with an incense burner in the center (B).

[2] Position the lights. Set up two strobes (C) on light stands, angled so that their beams do not touch the background. Set them one stop or so below their maximum output.

[3] Calibrate the camera. Place your camera on a tripod and then, in manual mode, set your ISO as low as it will go (usually ISO 100) and set shutter speed to the highest sync speed (check your manual or look at the shutter-speed dial—the sync speed is usually marked in a different color). The f-stop should be f/8 to f/11.

[4] Light the incense. It may take a few minutes for the air to settle so you can start focusing manually on the smoke.

[5] Take some test shots. If you don't have enough depth of field, increase the flash power or ISO to get there—but don't overexpose, or you'll lose detail.

SET UP A STILL LIFE

CREATE A SCENE STRAIGHT OUT OF AN OLD MASTER PAINTING.

MIMIC THE MASTERS

Start by examining still-life paintings whose style inspires you. Classic ones generally depict a rich variety of natural and artificial objects encompassing a range of textures, tones, and shapes. The best still lifes carry a good deal of symbolic resonance as well.

Look at the lighting: Do you prefer the diffuse sunlight of a Vermeer or the dramatic interplay of light and dark in a Caravaggio? Both Old Masters used highly directional light and the shadows it produces to define shapes and bring out color—with very different results.

Start by keeping your subject and lighting simple, then layer in objects that resonate with one another (and with you) to make a harmonious whole. Add the lighting you need to keep each element distinct and appropriate for the style you've chosen.

CHOOSE A MOOD

You can either use sun pouring through a window or set up an artificial light with a modifier such as a diffuser. Either way, the breadth and softness of the light and the amount you allow to bounce back off a wall or reflector into the scene will determine the effect of your photograph. A diffuse wash of light from upper left was key to the Vermeer-like still life here featuring a pitcher. For a darker mood, use a black background and harder-edged light with less bounce to create a chiaroscuro effect, as in the shot at far left.

For the autumnal still life on the previous two pages, Emanuela Carratoni used just a pair of candles and a flashlight to light the scene. You can see one candle; the other glows behind the roasting pan in the background. She set her camera to its lowest ISO, the aperture to its smallest f-stop, and the shutter speed to a long 15 sec. Then, with the shutter open, she used the flashlight to "paint" her still life with light, carefully passing the beam over each item and controlling the placement of highlights and shadows. A neutral-density filter cut the light through her lens to prevent overexposure.

BREAKING IT DOWN

[1] **Set up a still life.** Pick objects in keeping with your painterly sources—fruit, flowers, and household items—and arrange them against a neutral background. Set your camera on a tripod directly in front of your tableau.

[2] **Place lights and reflectors.** The main light, traditionally from a window, comes from the side and slightly above. In the brighter picture above, it's slightly more frontal than in the sidelit photo at left. To open up the shadows and show the texture of the wooden furniture supporting your still life, place a reflector opposite your light.

USE PRETTY LENS TRICKS

BLUR, FLARE, AND *BOKEH* TURN ORDINARY SCENES INTO POETRY.

GET BEAUTIFUL *BOKEH*

All you need to create smooth *bokeh* is a tripod, a shallow depth of field, and a lens whose aperture's opening has many blades (usually, more expensive lenses have more blades). The clean, wide aperture turns highlights into soft polka dots and lines into streaks. That kind of "melted" background acts as a foil for a sharply focused subject, adding interest to a picture without competing for attention. It's great for portraits and simple still lifes, as above.

PUT A RING ON IT

New lenses have special coatings to reduce flare (the colored ring you often get when light hits the lens). But, along with yellowed-out overexposure (the "sun-kissed look"), flare has come back as an aesthetic choice for those who want to capture the look of circa-1970 snapshots. Flare can be hard to predict, but one way to get it is to shoot into the sun when it's partly obscured. And to give the sun itself a starburst shape, keep your aperture small.

A photographer's traditional goal is a sharp subject and a creamy, unfocused background (called *bokeh*, from the Japanese word for "fuzziness"). But mistakes and variations such as lens flare and total defocus can also be striking.

AMP UP THE BLUR

For a dreamlike image that hints at your subject but doesn't render it literally, try defocusing your lens. Just set it for manual focus, start with a sharp image in your viewfinder or LCD, then slowly turn the focusing ring until everything's a blur. When to stop? When the picture looks best to you—try it a few different ways until you like the results. For extra fuzz, handhold the camera for a long exposure with image stabilization turned off.

Change the quality of your *bokeh* by using different lenses, especially inexpensive ones. For instance, the octagonal spots in this picture come from an inexpensive lens with fewer aperture blades. Paradoxically, the *bokeh* from that lens creates the only hard lines in the image, giving it a jazzy energy. Another type of cheap telephoto, called a mirror lens, produces a distinctive donut-shaped *bokeh* that turns ordinary white lights into tiny rings.

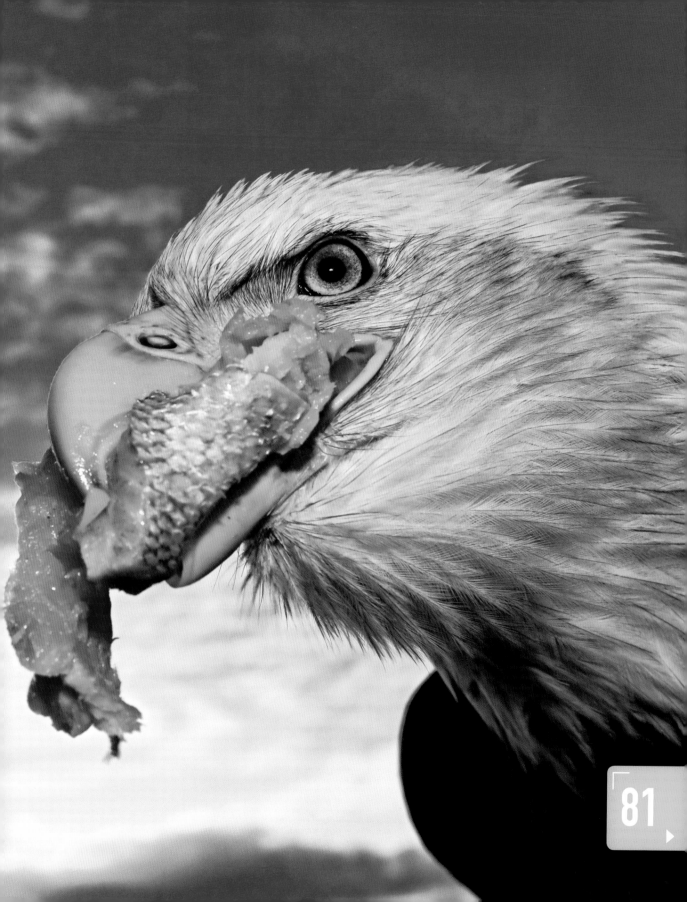

CAPTURE BEAUTIFUL BIRDS

WHETHER ON THE WING OR FEATHERING THEIR NESTS, BIRDS MAKE FANTASTIC SUBJECTS.

WATCH AND WAIT

For nature-loving photographers, catching birds in action is a serious thrill. The details in their feathers, their expressive body language, the exhilaration of flight—all can be captured in a split second.

Before you pack up your DSLR, you need to know where and when to seek your feathered models. Learn about the species in your area and venture out with binoculars and a field guide as often as you can. Get to know birds' habits, migration patterns, and most active seasons. Start by photographing slower-moving birds, such as gulls, herons, and waterfowl. You'll be rewarded for patience and practice. The first will allow you to see more avian action; the second will help you catch it with your camera.

Plan according to the time of day and the weather. Luckily, many birds are most active when the light is best—in early morning and late afternoon. With the sun coming from the front or side, you may even capture a gleam of reflected light in an eye.

Mild, calm days provide more opportunities than windy or stormy ones, since many species lay low in gusty conditions. And pay attention to the direction of the breeze: Birds always fly into the wind when they land, so keep the wind at your back if you want a bird to face you as it alights.

LOOK IN YOUR BACKYARD

You don't have to trek into the wilderness to photograph birds—you can find great avian subjects wherever you live. For instance, Cheryl Molennor spotted the plumed great egret, at far right, at a pond behind a strip mall in Florida. (She later used software to darken out the background of her image.)

When you're heading off to photograph birds, bring along a telephoto lens and a teleconverter (to extend focal length even more) so that you can get detailed images from afar; you may scare them away if you get close. Prepare to handhold your camera—a tripod will just get in your way. That said, you may want a monopod to help you steady your large lens.

BREAKING IT DOWN

[1] **Set exposure.** Manual exposure works best. To stop birds in flight, the shutter speed should be at least 1/1000 sec—faster is better—with an aperture of f/5.6 to f/11. Use evaluative metering (to meter the whole scene's ambient light) with the sky, grass, or shrubs standing in for your subject.

[2] **Position yourself.** Stand with your feet shoulder-width apart and maintain a firm but relaxed grip on the camera. Pan smoothly with the bird as it flies, aiming slightly ahead of your subject and following it with your eye, not through the camera (to help you keep sight of it).

[3] **Shoot in continuous mode.** If your camera offers it, also use continuous or predictive autofocus, which helps you track the bird.

[4] **Lock focus.** When a bird is flying toward you, position your autofocus point at its head, press your shutter button halfway, and keep holding it in place until you're ready to fire.

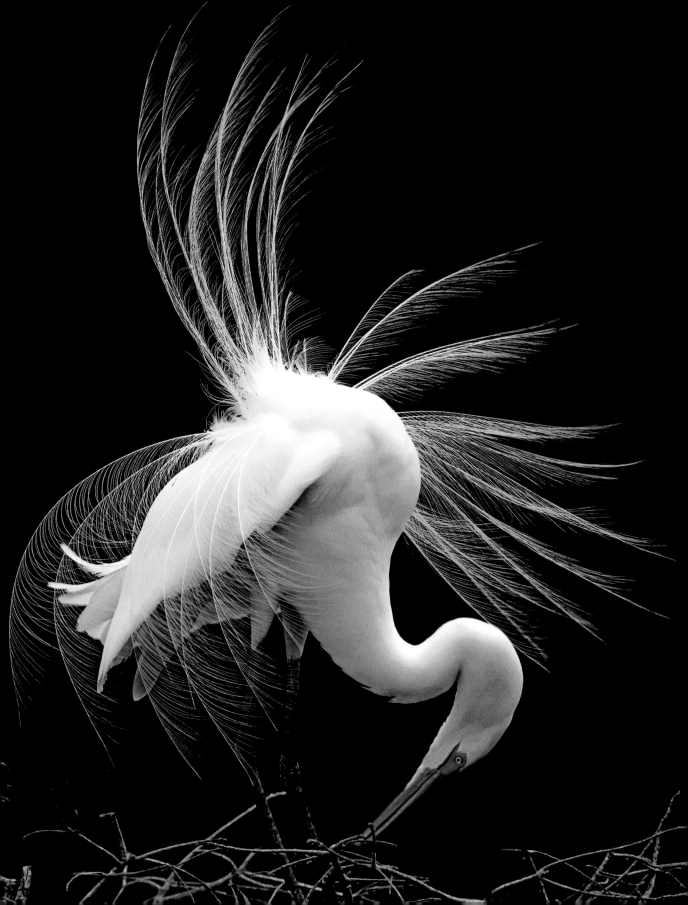

SHOOT FOR THE MOON

As your subject or just a compositional element, make the earth's neighbor stand out.

CAPTURE A SKYSCAPE

A photo that makes a viewer feel close to a celestial body can be mesmerizing. The best way to get a luminous, detailed moon in your picture is to mount your camera on a tripod and use a telephoto lens—the longest you can find. Extend the reach of your lens's focus even farther if you like with a teleconverter. But both reduce the amount of light coming through the lens, so expose longer.

You can try autofocus, but your camera may get confused and focus on something between you and the moon. Instead, focus manually to infinity.

You'll also need to expose manually. Start with 1/125 sec at f/11, ISO 100, and change your shutter speed as necessary to capture detail. Don't go slower than 1/15 sec, or you'll start to capture motion blur as the moon travels across the sky—unless that's your goal. Is the moon not where you want it in the composition? Shoot it with the same lens and exposure as the landscape, then composite the shots later, as Ian Plant did here.

PERFECT YOUR SHOTS WITH SOFTWARE

Clicking your shutter button captures an image, but you may still have a few steps ahead to create a finished photo that you can share online and in print. Software can help you perfect your favorite shots or improve the ones that didn't come out quite right.

PLAY AROUND IN THE DIGITAL DARKROOM

If you take a lot of photographs, you'll have plenty of snapshots that you don't want to labor over—and the more you get right when you take a picture, the less work you'll have to do later. But you may decide to use image-editing software to make adjustments to your keepers—such as your favorite photo projects and photos of big events that you'll want to enjoy for years. Of course, editing software is also handy when your pictures have potential for improvement.

START WITH RAW INGREDIENTS

You'll gain much better control over your finished images by setting your camera to capture RAW files, which contain the full array of data gathered by the camera's sensor rather than doing any in-camera processing. This does leave a bit more work for after shooting, but since RAW files have so much more flexibility, you may find that the adjustments you make in your RAW conversion software are all you need to get your picture to look the way you want it to. And if you want to do further retouching, conversion is a necessary first step to opening your file in an image-editing program. After you're finished converting and editing, you can save your file as any file type.

If you don't want to bother with RAW, use the highest possible quality setting for JPEG capture. These files are also editable. For extensive editing of a JPEG file, it's best to save it as a file type that can be saved with lossless compression (such as a TIFF—a file type supported by more sophisticated editing programs).

EXPERIMENT WITH SOFTWARE

As you grow as a photographer, you'll probably want to do increasingly sophisticated editing with your image-editing software to get ideal finished images.

This post-shooting editing is called *post-processing* (or *post* for short), and you'll probably need to upgrade to better software than the program that came bundled with your computer.

Besides the stand-alone image-editing programs, you can find a number of excellent plug-in programs designed for specific tasks, such as working in black-and-white, correcting lens distortion, and making high-dynamic-range (HDR) images.

Here, in rough order of how frequently you're likely to use them (and their level of complexity), are some types of editing and alteration you can do to your pictures with software. You'll also find tips on employing these tools to downsize images for photo-sharing sites, adjust color, combine with multiple photographs into a single amazing image, and more.

RAW CONVERSION

If you shoot in RAW mode, processing your images by converting them into an editable file will always be your first step. You'll find the necessary software on a disc that comes with your camera, though if you want a range of capabilities and interfaces, you can buy RAW converters from independent software vendors. Either way, your RAW converter will let you make all kinds of adjustments, including white balance, noise reduction, and (to some extent) exposure values. It may let you make some of the fixes you'd otherwise do in an image editor, and with most programs you'll be able to apply your settings to a whole batch of images at once, instead of dealing with each image individually.

Another benefit: Any settings you apply in conversion affect only the images you create in that session. Like a film negative, your original RAW file remains untouched, so you can keep it on file and process it again using other settings if you want to keep exploring your options.

Jimmie Yoo's photo on the previous two pages is a panorama created by compositing multiple images.

SHARPENING

Most digital images benefit from a touch of sharpening. It won't make up for bad focus or too little resolution for the image size you want, but it will help define lines and edges. Don't over-sharpen—this can cause visual noise and other distractions in the photo to become more distinct.

IMAGE SIZE

DSLRs produce large image files. That's a good thing, but it makes it hard to email your pictures straight from the camera. Rather than using JPEG compression to make your picture files small enough to email or upload quickly, preserve your image quality by creating a dimensionally smaller copy. You need a resolution of only 72 pixels per inch for the typical computer screen, but at least 240 (preferably 300) for printing. Don't forget to change your document size or your pixel dimensions when you shrink your file. Rename your new image file with the word *small* or *email* so you can see at a glance which version it is.

CROPPING

The frame you capture may not be the optimum version of the scene in terms of composition, aspect ratio (the proportion of the frame), or even orientation (horizontal, vertical, or square). To get the best picture, use the crop tool, found in most image editors, to change the size and/or shape of your frame. Note that when you crop, you'll lose resolution, so if you make extreme crops, you'll limit the size at which you can print your finished photo.

CONTRAST

The range and distribution of tones between the darkest and brightest point makes a tremendous difference in a photo. A lot of contrast can give it graphic boldness, especially in black-and-white, but if sloppily applied, it can also wipe out details in the highlights and shadows. Very low contrast can give your photo a moody or old-fashioned feel, but it can also make it simply seem flat and dull. Adjusting the contrast to achieve the effect you want is one of the basic editing skills you need to master.

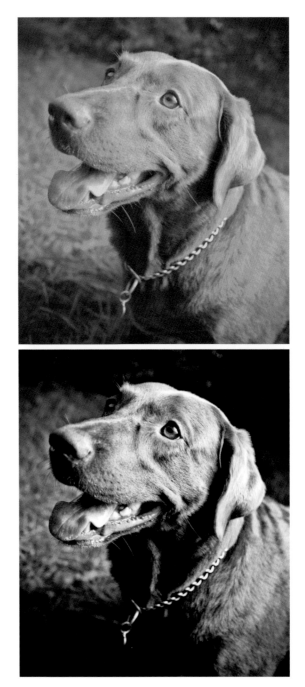

The top photo shows a low-contrast image—its bright and dark tones are closer together in range than are the tones in the high-contrast image (bottom).

COLOR

The pixels (light-gathering cells) on a digital sensor gather light in three channels: red, green, and blue. Their opposites—cyan, magenta, and yellow, respectively—combine to make up the visible color spectrum in an image. Software allows you to adjust each of these channels separately to get rid of unwanted color casts, add warmth, or deepen tones. You can also adjust overall color saturation, but use a light touch: There's a fine line between vivid and garish.

BLACK-AND-WHITE

The best way to make a monochrome image is to use software to transform a color original, rather than setting your camera to shoot in black-and-white. Allowing your camera to capture an image's full color data means you have more control over the end results because you'll have as much information as possible to work with. Most image-editing programs have simple, automated black-and-white conversion, but you'll be able to finesse the results using more-specialized

programs. And monochrome doesn't have to mean gray—with some programs, you can imitate a cyanotype, sepia-tone, or split-tone photo, too.

EXPOSURE AND HDR

You can brighten or darken an image—either overall or in particular sections—in editing. While this won't make up for mistakes in your original exposure, it may help you recover detail in highlights or shadows that your sensor recorded but that weren't evident in your unedited picture. To create an image that displays a wider range of tones from the very darkest to the very brightest, try HDR imaging, in which you combine several versions of the same picture taken at different exposure values. (Some cameras will do this for you,

The full-color image at bottom left gains an antique, nostalgic feel after being converted to resemble a sepia-tone print (shown below at right). This type of conversion and other kinds of color alteration can be achieved with image-editing software.

but you'll have better control of the results if you do it yourself.) More-sophisticated image editors have HDR built in, but specialized, stand-alone software is often necessary.

Wolfgang Gunther created the striking photo above by piecing together many separate exposures of the same woman sweeping. Combining multiple images into a single image using image-editing software is a technique called *compositing*.

RETOUCHING

Using precision tools in software, you can do everything from get rid of imperfections left in your images by dust on your lens or sensor to perform the equivalent of plastic surgery on your models. How far you want to to go depends on your taste, your skill, and how you plan to use your photo: as an artwork, an accurate record of events, propaganda, or some combination of all three. As your skills increase—and with the right software—you can fix lens distortion, create the illusion of shallow depth of field, remove unwanted elements from the frame, and make other changes to your images. Even simple editing software has tools for getting rid of dust or blemishes.

COMPOSITING

Besides HDR, you can combine images for all kinds of other reasons. To make a panorama, for instance, you'd shoot an overlapping sequence of images that together take in a much wider or taller view than you could fit in a single frame, then stitch all of them into a single picture. (Again, some cameras will do this for you, saving time but not necessarily yielding precisely the photo you want.) You can also combine pieces of images shot separately to invent an entirely new picture. However, creating an image that goes beyond a simple cut-and-paste collage to become a convincing approximation of reality takes a whole lot of skill and plenty of practice.

These days, most of us show our pictures to other people mostly on glowing screens, whether through email, social networking and photo-sharing sites, or on our own Web sites. Still, the pictures we love the most are the ones we print (or have printed for us) to cherish as artifacts.

GO FROM DIGITAL PHOTOS TO ANALOG ART

Getting prints that perfectly match the image you have in mind or the one you see on your computer can be a complicated and sometimes frustrating experience. Setting up your computer to match the colors in your camera and printer in order to print precise tones will take some time—but you can always have your images printed at a lab to save yourself the headache of trying to get super-high-quality prints at home. Here are a few things you can do to take control of your prints, whether you do it yourself or send them out.

SEND YOUR PHOTOS OUT

If you're not ready to invest in a good photo printer—or if you want to make really big enlargements, print on unusual media (such as aluminum or fabric), or get stacks of 4 by 6 prints—send your images to a local or online lab for printing. Their processes tend to be uniform and relatively simple to use, which can be a blessing when you're in a hurry, but may wreak havoc on your carefully edited images (unless you work with a custom photofinisher who's used to dealing with pro photographers—a good idea for your best pictures).

Many online photo processors and kiosk operators give you the option of automatic fixes to your images. If you've already edited them yourself, decline this offer. Most also accept only JPEG files, not TIFFs, and only those in the sRGB color space. Because it has a narrower color range, we suggest that you shoot your photos in the Adobe RGB space instead. If you've done so, you'll have to convert your images before sending them out. (Make this change—and any others done solely for the purposes of printing—on copies, never on your original files.)

Ordering standard-size prints without borders? Dimensions such as 8 by 10 and 5 by 7 have a different aspect ratio from the typical DSLR frame, so the lab may crop your photo to fit. Do the cropping yourself to match the print size you're after and ensure you get the composition you want.

PRINT AT HOME

For more control over your prints—or simply for the satisfaction of doing it yourself—buy a good inkjet printer and learn everything you can about how to use it. Color management, the process of producing prints that match what you see on your computer, involves a number of steps. You'll want to make sure that your monitor is set at the highest resolution possible and is in high color mode, then use one of a number of available devices and software programs to calibrate it.

Follow your color management or image-editing program's instructions for profiling your printer and paper, which lets you match their characteristics to the color you see on your screen. (You can obtain custom profiles for still more-precise management.)

Pigment-based inks will last longer than dye-based inks, and the more colors in your ink set, the better your prints will look. If you plan to print primarily in black-and-white, consider buying a set of high-quality monochrome inks for a wide range of grays and blacks.

CHOOSE YOUR PAPER

Glossy papers will make your colors look more vibrant and your blacks more rich, and they're often more durable, though they show fingerprints more readily. Many photographers prefer fine-art papers with a matte finish, which minimize reflections when framed. Pearl finishes fall somewhere between these two extremes.

Which kind of surface to use depends in large part on your own aesthetic—experiment by printing the same images on several different papers to see what works best for your photos.

You can also print (or order prints) on a wide variety of other media, including canvas, aluminum, and vinyl panels. Each will portray your pictures very differently, and you may need to make changes to contrast, tonality, and other factors in your images before having them printed on different surfaces.

Memory is cheap; your images are irreplaceable. If you've ever had a computer crash, you know just how vulnerable your data can be. Start protecting your photos from the moment you take them by using brand-name memory cards, bought from a reputable retailer.

PROTECT YOUR PICTURES

For starters, get several memory cards in fairly low capacities—no greater than 8GB—rather than just one very high-capacity card. That way, if one card gets corrupted (or you leave it in a hotel room), you won't lose a whole vacation's worth of photos.

If your camera has slots for two memory cards (which is handy when you record RAW and JPEG files simultaneously), you can set it to put all of the RAW files on one card and all the JPEGs on the other. Not only will that give you two versions of each frame from the get-go, but it will also make it much easier to sort the images that you'll work on later from the ones that are ready to share immediately.

PUT YOUR FILES IN ORDER

If you've already got a ton of photos scattered around your computer, you'll have to find them and then take the time to create a file structure that will help make them easy to sort and locate for years to come. Chances are your computer has stashed most of your images in a folder called Pictures or My Pictures, so that's the place to start.

Here's the file structure I use: I keep the photos that friends and family send me in separate folders labeled with the senders' names. For my own images, I create folders for each year. Within each of these, I have subfolders dedicated to particular events, projects, or places, also labeled with the year, such as Reunion2011 or Rome2010. (If you shoot a lot of pictures and you're shooting every day, it may be better to set up subfolders for each month of the year, then put your projects in the appropriate months.)

For even faster browsing—and to help in backup (see below)—copy your favorite images of the year into their own folder, labeled something like Best2012. Once you have a file structure in place, every time you transfer images from your camera or card to your computer, download the files into the corresponding folder in your system.

"READ" YOUR PICTURES

Get a jump on organizing your files by setting the date and time on your camera. That way, no matter how you store your images, at least you'll have accurate information about when you shot them.

The time and date will be embedded in the file information, also called EXIF data (or metadata). This info will also include things like the model of the camera and lens you shot with, the focal length and exposure settings you used, and a brief record of any image editing you did. Here you can also add captions, searchable tags, and vital contact and copyright details that you want to make sure always stay with your pictures in the future.

BACK UP YOUR FILES

The secret of good backup? Multiple redundancy. Not only should you routinely copy your crucial files—that is, all of your photos—onto an external hard drive, but you should also keep another copy off the premises (at your office, your parents' house, wherever). Update this second copy once a month or whenever you've made significant changes to your files.

For your primary backup, consider a mirrored drive, also called RAID 1. This is a storage device with two hard drives, both containing the same files. Every time you back up your computer, this will store the data on both drives at once, so if one drive fails, you haven't lost anything. The software that comes with your storage device should walk you through the setup.

Depending on how much you shoot, it may be enough backup to take only your favorite photos—the ones in that Best2012 folder—off-site. The easiest way to do this is through online (also called cloud) storage. Some backup services give you unlimited space for an annual fee; others are free but let you store only, say, 5GB of data. That won't go far when it comes to image files, and uploads can be mind-bendingly slow, even when you're using a fast DSL or cable connection.

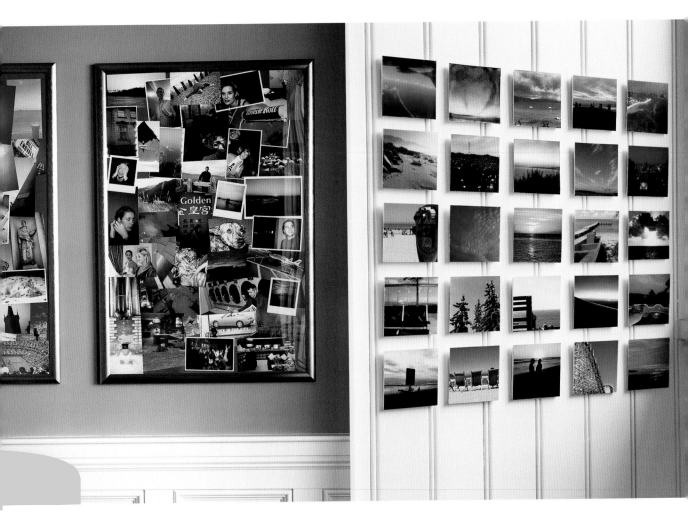

CRAFT A COLLAGE

For a charmingly haphazard feel, try arranging many photos within a frame together so that their corners and edges overlap. Explore different angles by setting some photos diagonally. Your collage will look best if you print your pictures in different sizes and crop them into a variety of shapes to emphasize their unique features. Include some with borders if you like. This technique is a great way to unify images from different shoots or locations into a cohesive display.

GO MINIMAL

For a simple display that doesn't detract from the crisp and clean style of a modern space, explore options for hanging photos without frames. Using invisible rigging enhances the effect. For starters, you can mount photos onto foam board, and then attach adhesive Velcro strips to hold them to the wall. Arrange your photographs in rows or in a grid to highlight their shared patterns, colors, or pictorial elements for added impact.

Most photographers are drawn to the hunt for the perfect picture. But every now and then, you should put down the camera to savor and share what you've done. Here are some ideas for doing your photos justice with the right display.

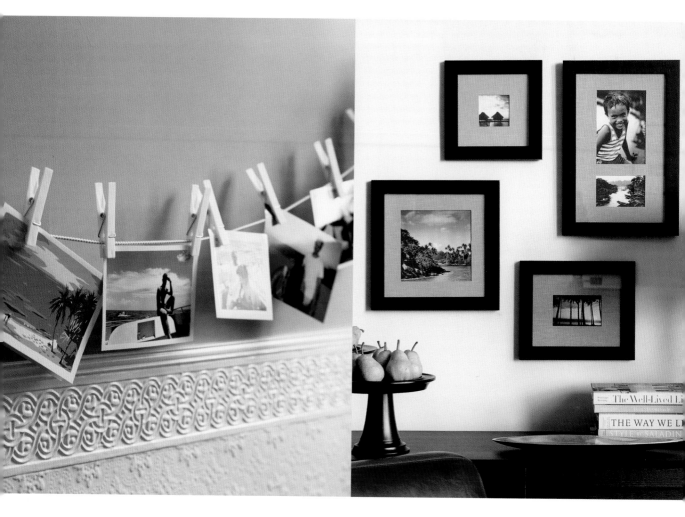

STRING IT TOGETHER

You may be on a budget and need to use inexpensive materials, or you may want to create a display that adds a laid-back and casual element to a room while showcasing your shots. Either way, you don't have to look any further than clothespins and string or wire. Place two nails at the points between which you want your display (or use adhesive hooks to avoid nail holes), attach your line, and clip on your photos. Try stacking multiple strands of varying lengths.

FRAME YOUR BEST

Making the effort to frame your photographs will not only draw attention to them as individual works of art and give each one visual weight, but will also keep them well protected from everyday bumps and spills. So frame the photos that you're proudest of or that you've printed with the highest-quality materials. Arrange frames on the wall in a random configuration, and try framing some photos in pairs. The variety will keep the display looking classy but not stuffy.

PERMISSION FOR PHOTOGRAPHY

For valuable consideration received, I grant to _____ ("Photographer") the absolute and irrevocable right and unrestricted permission concerning any photographs that he/ she has taken or may take of me or in which I may be included with others, to use, reuse, publish, and republish the photographs in whole or in part, individually or in connection with other material, in any and all media now or hereafter known, including the internet, and for any purpose whatsoever, specifically including illustration, promotion, art, editorial, advertising, and trade, without restriction as to alteration; and to use my name in connection with any use if he/she so chooses. I release and discharge Photographer from any and all claims and demands that may arise out of or in connection with the use of the photographs, including without limitation any and all claims for libel or violation of any right of publicity or privacy. This authorization and release shall also inure to the benefit of the heirs, legal representatives, licensees, and assigns of Photographer, as well as the person(s) for whom he/she took the photographs. I am a legally competent adult and have the right to contract in my own name. I have read this document and fully understand its contents. This release shall be binding upon me and my heirs, legal representatives, and assigns.

X

SIGNATURE DATE

NAME

ADDRESS (Line 1)

ADDRESS (Line 2)

X

PHOTOGRAPHER'S SIGNATURE DATE

PHOTOGRAPHER (Print Name)

ADDRESS (Line 1)

ADDRESS (Line 2)

PERMISSION FOR PHOTOGRAPHY OF PROPERTY

The undersigned, being the legal owner of, or having the right to permit the taking and use of photographs of certain property, does irrevocably grant to _____ ("Photographer"), his/her heirs, legal representatives, agents, and assigns the full perpetual rights to take and use such photographs for any purpose. The undersigned also consents to the use of any printed matter in conjunction therewith. The undersigned hereby waives any right to inspect or approve the finished product or products or other published matter that may be used in connection therewith. The undersigned hereby releases, discharges, and agrees to save harmless and defend Photographer and all persons acting under his/her permission or authority, or those for whom he/she is acting, from any liability by virtue of any blurring, distortion, or alteration that may occur or be produced in the taking of said picture or in any processing or publication thereof. The undersigned hereby warrants that he/she is a legally competent adult. The undersigned states further that he/she has read the above authorization, release, and agreement, prior to its execution, and is fully familiar with the contents thereof. This release shall be binding upon the undersigned and his/her/its heirs, legal representatives, successors, and assigns.

X _____

SIGNATURE DATE

NAME

ADDRESS (Line 1)

ADDRESS (Line 2)

X _____

PHOTOGRAPHER'S SIGNATURE DATE

PHOTOGRAPHER (Print Name)

ADDRESS (Line 1)

ADDRESS (Line 2)

STATE OF _____ :

 : SS

COUNTY OF _____ :

On this _____ day of _____, 20 _____, before me, a notary public for the state of _____, the undersigned officer, personally appeared _____, known or satisfactorily proven to me to be the person whose name is subscribed to the foregoing instrument, and acknowledged that he executed the same for the purposes therein contained.

In witness whereof, I have hereunto set my hand and notarial seal.

NOTARY PUBLIC

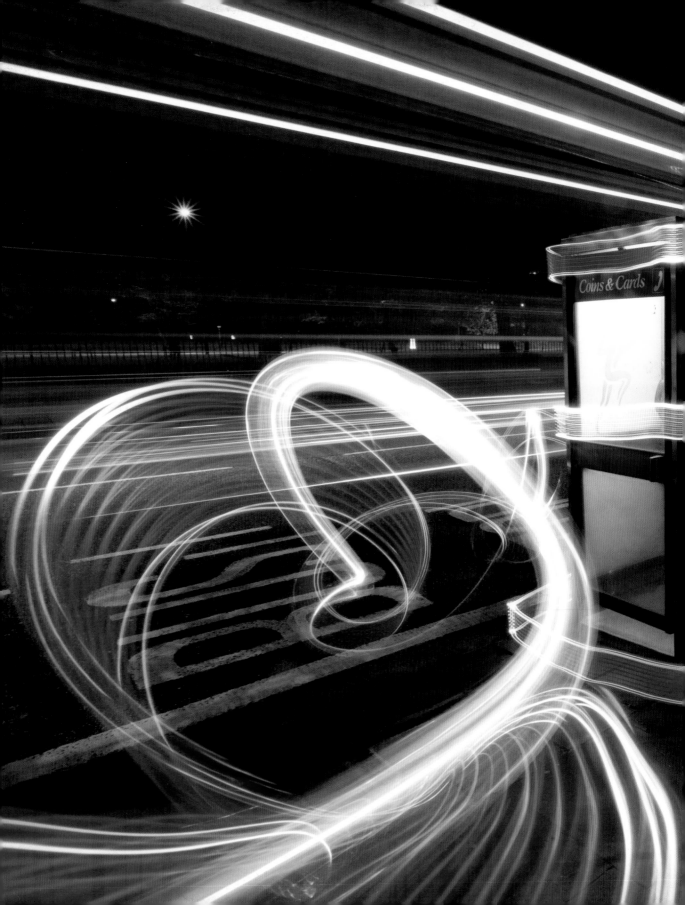

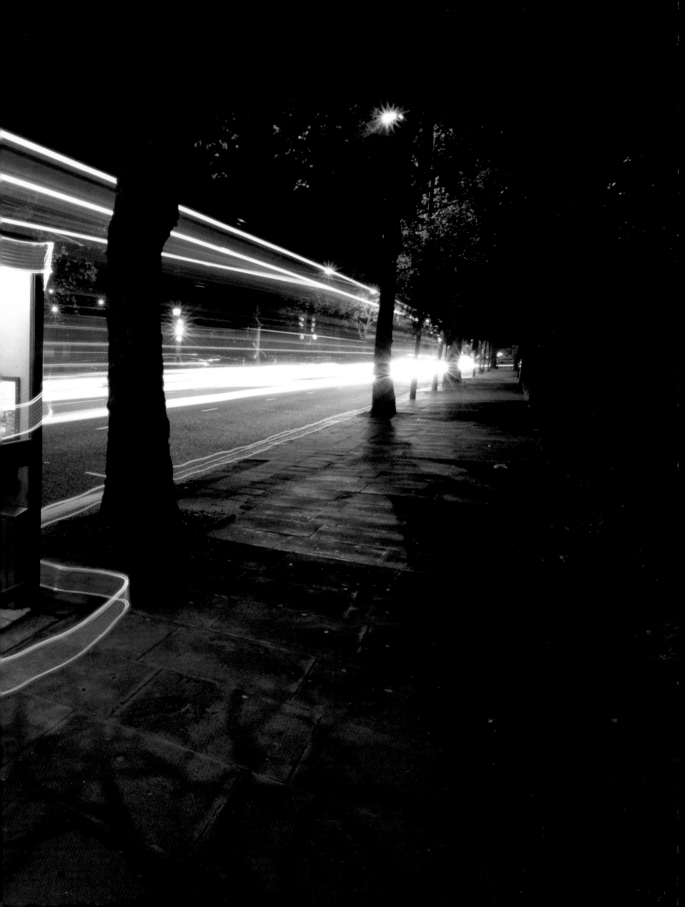

GLOSSARY

AMBIENT LIGHT The available light in a scene, whether from natural or artificial sources, that is not explicitly supplied by the photographer for the purpose of taking pictures.

APERTURE The adjustable opening inside the lens, the aperture determines how much light passes through to strike the image sensor. The size of the aperture is measured in f-stops, and higher numbers signify a smaller opening.

APERTURE-PRIORITY MODE A camera mode in which the photographer chooses a specific aperture setting, and the camera automatically selects a complementary shutter speed to achieve a proper exposure.

APS-C An image sensor format used in many DSLRs that's smaller than a full-frame format sensor (and thus captures a smaller angle of view).

ARTICULATED LCD A flip-out image screen that can rotate and swivel away from the camera body, giving the photographer flexibility in the angle of view.

AUDIO FLASH TRIGGER This device allows you to sync your camera with a microphone so that the shutter is triggered by sound rather than the pressing of the shutter button. Useful for capturing very fast action because it eliminates the photographer's reaction time from the process.

AUTOEXPOSURE A mode in which a camera automatically calculates and adjusts exposure settings in order to match an image with the subject as closely as possible.

AUTOFOCUS A mode in which the camera automatically focuses on the subject in the center of the LCD or viewfinder.

BACKGROUND The elements in an image that appear farthest from the viewer.

BARREL DISTORTION Distortion in which straight lines curve outward in the image. These barrel-shaped lines are most noticeable along the edges of a photograph.

BOKEH Describes the rendition of out-of-focus sections in an image. The word bokeh comes from the Japanese word boke for "fuzziness" or "dizziness."

BOUNCE Light that is redirected toward a subject by a reflector or other reflective surface. Usually soft light, it helps spread light and fill shadows.

BRACKETING The technique of taking a number of pictures of the same subject at different levels of exposure, usually at half- or one-stop differences.

CENTER-WEIGHTED METERING A metering system that concentrates the light reading mostly in the central portion of the frame and feathers out to the edges.

CHIAROSCURO The interplay or contrast of light and shadow in a work of art.

COLOR FRINGING Also known as chromatic aberration, this is a type of image disruption that occurs most frequently at high-contrast edges and often appears as bands of color, especially purple.

COMPOSITE A picture made of multiple, separate images that have been pieced together with software.

CONTINUOUS (HOT LIGHTS) Traditional tungsten or halogen lights that stay on continuously during shooting.

CONTINUOUS MODE Also known as burst mode, this is the digital camera's ability to take several shots in less than a second with just one press of the shutter button. The speed and total number of frames differs between camera types and models, and is sometimes adjustable.

CONTRAST The range and distribution of tones between the darkest and brightest points in a photograph.

CYANOTYPE A photographic process that was discovered in 1842 and produces a print in cyan-blue tones, a color sometimes mimicked by software in processing digital photography.

DEFOCUS Defocusing a subject seen through the camera's lens makes it appear softened and less defined.

DEPTH OF FIELD The distance between the nearest and farthest objects that appear in acceptably sharp focus in a photograph.

DIFFUSER Any material that softens and scatters light that passes through it.

◀ To learn how to paint with light as in Marcel Panne's photo on the preceding two pages, see 71.

EXIF DATA Information (such as the date, settings and gear used, and so on) that your camera stores for each image it captures.

EXPOSURE The total amount of light allowed to fall on the photographic medium (determined by aperture, shutter speed, and ISO) during the process of taking a photograph. Also refers to a single shutter cycle (that is, a frame).

EXPOSURE COMPENSATION A feature that lets you increase or decrease your camera's exposure settings in small increments to achieve proper exposure. Usually controlled by a button marked with plus and minus symbols.

FILL LIGHT A technique usually used to soften the contrast in a scene by shining a light that's softer than the main light into a scene's shadows to erase them.

FILTER A camera accessory that can be attached (either screwed on or clipped) to the end of a lens to alter or enhance its effect.

FLASH The brief illumination of a subject during the moment of exposure.

FLUORESCENT LIGHT A type of continuous lighting that produces a cool-toned light, the effects of which can be warmed with the corresponding white balance setting.

FOCAL LENGTH With a lens focused at infinity, this is the distance from the point in the lens where the path of light rays crosses to the film or sensor. Longer focal lengths magnify images, while shorter focal lengths reduce magnification and show a wide angle of view.

FOCUS When an element in an image is distinctly defined and its outlines are clearly rendered, it is said to be "in focus."

FOCUS RING A ring on the lens barrel that a photographer rotates to adjust focus manually.

FOCUS TRACKING A camera feature that can calculate the speed of a moving subject in order to properly focus and position the camera's lens to capture it.

FOREGROUND The elements of an image that lie closest to the picture plane, appearing nearest the viewer in a photograph.

F-STOP A number that indicates the size of a camera's aperture. The larger the number, the smaller the lens opening, which works in conjunction with shutter speeds to accomplish correct exposure.

FULL-FRAME A camera sensor format that has the largest sensor (measuring 36 by 24mm) commonly found in DSLRs.

GOBO A plate or screen used to shield light from a lens.

HARD LIGHT Light that has a narrow focus and falls off quickly into shadow on striking a subject.

HIGH-DYNAMIC-RANGE (HDR) IMAGING A technique in which several versions of the same picture taken at different exposure values are overlaid to get an image with the widest range of tones possible.

HIGH-KEY A very brightly lit photo that contains large areas of white and bright tones, and few midtones or shadows.

HISTOGRAM An electronic graph on a digital camera showing the distribution of tones in an image, from completely dark (on the left) to completely light (on the right). Displayed on the camera, it's a useful tool for determining whether an image contains the correct range of tones for a proper exposure.

HOT SHOE A connector on top of the camera, where accessory flashes and other devices can be mounted to sync with the camera.

HYPERFOCAL DISTANCE The closest distance at which a lens can focus while keeping objects at infinity in acceptably sharp focus. It varies with f-stop. Landscape photographers exploit hyperfocal distance to create the feeling of deep space in photos.

IMAGE SENSOR The medium in the camera that captures an optical image and converts it into an electric signal.

IMAGE STABILIZATION A camera or lens function that can be switched on to reduce blurring created by the movement or jostling of a camera during an exposure.

INFRARED TRIPWIRE A device that extends an invisible beam between a transmitter and receiver. When the beam is broken, the device automatically fires your camera's shutter. Useful for capturing fast-moving subjects.

ISO The sensitivity of a digital camera's sensor to light. The higher this number is, the more light-sensitive the sensor becomes.

JPEG The most common type of image file, useful because it can compress images into smaller file sizes. JPEGs can be saved at a range of compression levels; high levels of compression will cause more data loss and image degradation, especially when the image is resaved multiple times. Suitable for emailing and web use because of their small size, JPEGs are not recommended for image editing.

LCD (liquid crystal display) A thin, flat display screen on a digital camera that provides a live feed of what the camera is seeing, allows you to play back images after shooting, and offers access to menus and information such as exposure settings, autofocus points, and histograms.

LED (ight-emitting diode) A type of light often used in video and studio lighting—for instance, in ring flashes used for macro photography. Long-lasting and cool, they can serve as an alternative to fluorescents.

LENS FLARE Light scattered inside the camera can cause unwanted distortion in an image, including odd rings, bands, and reflections known as lens flare.

LIVE VIEW A function that sends the image through the lens to the LCD rather than the optical viewfinder. Using this function affords a larger view of the frame, easier depth-of-field preview, magnification for manual focusing, and other benefits. But it can be hard to use in bright light and when shooting handheld.

LOW-KEY An image in which the tones are mostly dark and have few highlights.

MACRO Close-up photography of very small subjects. The image on the sensor is close to the size of the subject or even larger.

MIDGROUND The elements of a photo that appear to lie in the middle of the space relative to the viewer.

MOTION BLUR The streaking in an image that results when either the subject or the camera moves during exposure.

NOISE Undesirable graininess and flecks of random color in a portion of an image that should consist of a single smooth color. Noise in an image generally increases with higher ISOs.

OPTICAL VIEWFINDER A glass eyepiece used to frame and focus before taking a picture. Most compact cameras lack an optical viewfinder and rely on LCDs only.

OVEREXPOSURE When too much light strikes the sensor, the image is overexposed, meaning its colors and tones appear very bright or white, and highlighted areas are washed out.

PANNING The horizontal movement of a camera along with a moving subject. The technique is used to suggest fast motion, and brings out the subject from other blurred elements in the frame.

PANORAMA An image that depicts an extremely wide angle of view, typically wider than the human eye can see and than most lenses can capture. Often created through compositing.

PENTAPRISM A multisided device built into a DSLR that corrects the orientation of the image and directs it to the viewfinder.

PIXEL The smallest single component of a digital image. Also refers to the light-gathering cells on a camera's sensor.

POST-PROCESSING The work done with software on an image after a camera has captured it. It ranges from converting the image into a different type of digital file to editing and altering the picture.

PRIME LENS Any lens that has a fixed focal length, as opposed to a zoom lens, which has a variable focal length.

RAW FILE Also known as a *digital negative,* losslessly compressed RAW files are created in your camera. To output them, you must modify them with a converter, such as the one provided with your camera. RAW files allow you to alter camera settings, such as white balance, after the fact, and provide the most possible original data in an image.

REFLEX MIRROR A mirror that reflects light coming through the lens upward to the pentaprism for viewing through the optical

viewfinder. It then pivots up when the shutter is pressed, creating a path between the lens and the image sensor.

RULE OF THIRDS A compositional guideline stating that visual tension and interest are best achieved by placing crucial elements of a photograph one-third of the way from any of the frame's edges.

SATURATION The intensity of color in an image. A saturated image's colors may appear more intense than the colors did in the actual scene, an effect that can be achieved with software.

SELF-TIMER A camera mode that gives a predetermined delay between the pressing of the shutter release and the shutter's firing. Can be used on a tripod-mounted camera for self-portraits or to eliminate the effects of camera shake when you press the shutter.

SEPIA A warm brown tone, originally achieved by dipping a black-and-white photograph into a sepia bath. It can be imitated by software.

SHUTTER A mechanical curtain that opens and closes to control the amount of time during which light can reach the camera's image sensor.

SHUTTER LAG Any delay between fully pressing the shutter button and the moment when the image sensor actually records the image. Though it's only a fraction of a second most of the time, it can cause photographers to miss spontaneous shots.

SHUTTER-PRIORITY MODE A camera mode in which the photographer chooses the shutter speed, while the camera automatically adjusts aperture to achieve a proper exposure.

SHUTTER SPEED The amount of time during which the shutter stays open to light, generally measured in fractions of seconds. (1/8000 sec is a very fast shutter speed, and 1/2 sec is very slow.)

SINGLE-AREA AUTOFOCUS A shooting mode in which the camera focuses on a specific element or point within the frame.

SOFT LIGHT Whether diffused or coming from multiple or broad sources, this light falls on a subject without casting deep shadows or creating much contrast.

SPOT-WEIGHTED METERING A camera function that measures the light in only a small area, generally in the center of the frame. Use this feature when you want to precisely meter a particular point or element, and don't want other areas of the scene to affect the exposure.

STROBE Another term for flash (as opposed to a continuous light). Can refer to large studio lights or portable accessory flash units.

TIFF A type of digital image file that is great for editing with software because it retains image quality and doesn't compress files.

TUNGSTEN LIGHT An incandescent type of continuous lamp that gives warm-toned light.

UNDEREXPOSURE When too little light strikes the sensor, the overall tone of an image is dark, shadows are dense, and colors are muted.

VIEWFINDER The opening the photographer looks through to compose and (if using manual focus) to focus the picture. A viewfinder can be electronic or optical.

WHITE BALANCE This camera setting defines what the color white looks like in specific lighting conditions and corrects all other colors accordingly.

ZOOM LENS Any lens that is constructed to allow a continuously variable focal length, as opposed to a prime lens, which has a fixed focal length.

ZOOM RING A ring on the barrel of a lens that, when rotated, changes the focal length of the lens.

INDEX

CREDITS

Half title: Guy Tal **Title:** Scott Linstead
Introduction: Joshua Cripps **5:** Alex Fradkin **6:** Guy Tal
7: Ray Kachatorian **8:** Christopher Stewart (right)
11: Casey Lee **13:** Chris McLennan

14: Tim Calver **15:** Gunnar Conrad (top right)
17: Randall Cottrell **18:** Koy Kyaw Winn (first spread);
Michelle Arnwine (second spread, left); Lester Weiss
(second spread, top right); Li Chengzhi (second spread,
bottom right) **19:** Jeremy Harris **20:** Catherine Dunn (left)
21: Ben Bergh **22:** Thayer Gowdy (left); Gia Canali (middle);
Gabriel Ryan (right) **23:** Peter Kolonia **24:** Arnel Garcia
25: Chris McLennan (left, right); Chet Gordon (middle)
26: Faisal Almalki **27:** Emmanuel Rigaut (top); Zach Dischner
(bottom) **28:** Amy Perl **29:** Chris Pethick (left); Darwin
Wiggett (right) **30:** Adam Elmakias **31:** Mark Peterson (left);
Alexandra Dicu (right) **32:** August Bradley **33:** Helmi Flick
34: Todd Klassy (left); Phil Ryan (middle) **35:** Amy Perl
36: Anna Kuperberg (left); Miriam Leuchter (right)

37: Kyle Jerichow (first spread); Ian Plant (second spread)
38: Dave G. Roberts **39:** Peter Kolonia (first spread);
Alexander Viduetsky (second spread, left); Mike Saemisch
(second spread, top right); Miriam Leuchter (second spread,
bottom right) **40:** Dan Bracaglia (left); Melissa Molyneux
(right) **41:** Kevin Cantor **42:** Ian Shive (first spread); Guy Tal
(second spread) **43:** Ben Hattenbach (bottom right)
44: Kah Kit Yoong **45:** Patrick Smith (second spread, left);
Joshua Cripps (second spread, top right); Horia Bogdan
(second spread, bottom right) **46:** Dina Goldstein
47: Matea Michelangeli (left); Miguel Angel de Arriba
(middle); Partha Pal (right) **48:** Steve Bingham (first spread);
Philip Buehler (second spread) **49:** Mark Adamus
50: Tim Kemple **51:** Jim Goldstein (bottom left); Timothy
Edberg (top middle); Ed Callaert (top right); Frank Fennema
(bottom right) **52:** Emmanuel Panagiotakis (first spread);
Skip Caplan (second spread, bottom left); Jordan Edcomb
(second spread, top right) **53:** Lowell Grageda
54: Francesca Yorke, courtesy of Williams-Sonoma (left);
Matthijs Borghgraef (right) **55:** David Clapp (first spread);
Loren "Tad" Bowman (second spread) **56:** Roni Chastain
(bottom left); Don Komarechka (top right); Alex Braverman
(bottom right) **57:** Aaron Feinberg (left) **58:** Phil Ryan (first
spread, left); Jay Fine (first spread, top right); Alex Fradkin
(first spread, bottom right); Alex Fradkin (second spread)

59: Chip Phillips **60:** Frank Melchior **61:** Jim Patterson
(first spread); John L. Hodson (second spread, top left)
62: Stephen Oachs (left); Darwin Wiggett (right) **63:** Saul
Santos Diaz (first spread); Jon Cornforth (second spread)

64: Mark Watson **65:** Thomas Shahan (first spread);
Martin Amm (second spread) **66:** Harrison Scott
(left); George Hatzipantelis (middle); Phil Ryan (right)
67: Jim Patterson **68:** Vilhjálmur Ingi Vilhjálmsson
69: Scott Linstead **70:** Kerrick James (first spread);
Debby Barich (second spread, top left); Sara Wager
(second spread, middle right) **71:** Jens Warnecke and
Cenci Goepel (first spread); Marcel Panne (second
spread, left); Stephen Kolb (second spread, top right);
Ian Plant (second spread, bottom right) **72:** Kan Nakai
73: Sam Dobrow (top left); Joachim S. Mueller (bottom
left); Andrew Morrell (top middle); Marina Cano (right)
74: Uwe Zimmer (left); Andrew Tobin (middle); Jesse
Diamond (right) **75:** Petrina Tinslay, courtesy of
Williams-Sonoma (first spread, right); Ray Kachatorian,
courtesy of Williams-Sonoma (second spread, left);
Maren Caruso, courtesy of Williams-Sonoma (second
spread, right) **76:** Jim Brandenburg (left); Ian Plant
(right) **77:** David Baures (first spread); Ryan Merrill
(second spread, bottom) **78:** David Boehm
79: Emanuela Carratoni (first spread); Matthew Lowery
(second spread, left); Stephanie Frey (second spread,
right) **80:** Kendall Karmanian (left); David Cisowski
(middle); Phillip Genochio (right) **81:** Hector Martinez
(first spread); Scott Linstead (second spread, left);
Cheryl Molennor (second spread, right) **82:** Ian Plant

Back matter opener: Jimmie Yoo **83:** Wolfgang Gunther
(second spread, right) **86:** David Matheson **Glossary
opener:** Marcel Panne **Index opener and closer:**
David Matheson **Back matter closer:** Jamie Felton

Front cover: Jim Patterson (sunset); Emmanuel Panagiotakis
(lions); Lowell Grageda (tunnel); Ben Bergh (skateboarder)
Back cover: David Clapp (forest); Amy Perl (portrait);
Ben Hattenbach (Northern Lights); Darwin Wiggett (truck)

All other images courtesy of Shutterstock Images. All
illustrations courtesy of Francisco Perez. Endpaper image
courtesy of Alex Fradkin.

ABOUT MIRIAM LEUCHTER

Miriam Leuchter is the editor of *Popular Photography,* the world's largest imaging magazine. She has juried many international photography competitions, and her own photography has been published and exhibited in magazines, newspapers, and art galleries in the United States and Europe.

ABOUT *POPULAR PHOTOGRAPHY*

With more than 2 million readers, *Popular Photography* is the world's largest and most noted photography and image-making publication. The magazine brings almost 75 years of authority to the craft, and in advice-packed issues, its staff of experts focus on hands-on how-to hints and inspiration for everyone from beginners to top-notch professionals.

ACKNOWLEDGMENTS

MIRIAM LEUCHTER

This book would not have been possible without the commitment and hard work of the editorial and design staff at Weldon Owen.

Nor could I have written all of this without relying on the expertise, enthusiasm, and reporting help of my colleagues at *Popular Photography*: senior editors Dan Richards, Debbie Grossman, and Peter Kolonia; technical editor Philip Ryan; and assistant editor Lori Fredrickson. Our art director, Jason Beckstead, and his deputy, Linzee Lichtman, chose and edited almost every photo you see here first for the pages of *Popular Photography*. Invaluable support also came from Jae Segarra and Julia Silber.

Finally, my deepest appreciation goes to the many photographers throughout the world, from seasoned pros to avid newcomers, who shared their stories, tips, and most of all their photos for this book. I hope their work has inspired you as much as it inspired me.

WELDON OWEN

Weldon Owen would like to thank Jacqueline Aaron, Kendra DeMoura, Marianna Monaco, Katharine Moore, Gail Nelson-Bonebrake, Michael Shannon, Charles Wormhoudt, and Mary Zhang.

POPULAR PHOTOGRAPHY

P.O. Box 422260
Palm Coast, FL 32142-2260
www.popularphotomagazine.com

415 Jackson Street
San Francisco, CA 94111
www.weldonowen.com

A division of
BONNIER

WELDON OWEN, INC.

President, CEO Terry Newell
VP, Sales Amy Kaneko
VP, Publisher Roger Shaw
Executive Editor Mariah Bear
Editor Lucie Parker
Project Editor Emelie Griffin
Consulting Editor Maria Behan
Creative Director Kelly Booth
Art Director Marisa Kwek
Senior Designer Meghan Hildebrand
Image Coordinator Conor Buckley
Production Director Chris Hemesath
Production Manager Michelle Duggan
Color Manager Teri Bell

A WELDON OWEN PRODUCTION

© 2011 Weldon Owen Inc.

Library of Congress Control Number:
2011932544

ISBN 13: 978-1-61628-121-2

ISBN 10: 1-61628-121-9

10 9 8 7 6 5 4 3 2 1

2014 2013 2012 2011 2010

Printed by Toppan-Leefung in China.

For tips on getting up-close shots of critters like Jamie Felton's on the following page, see Martin Amm's shots (65). ▶